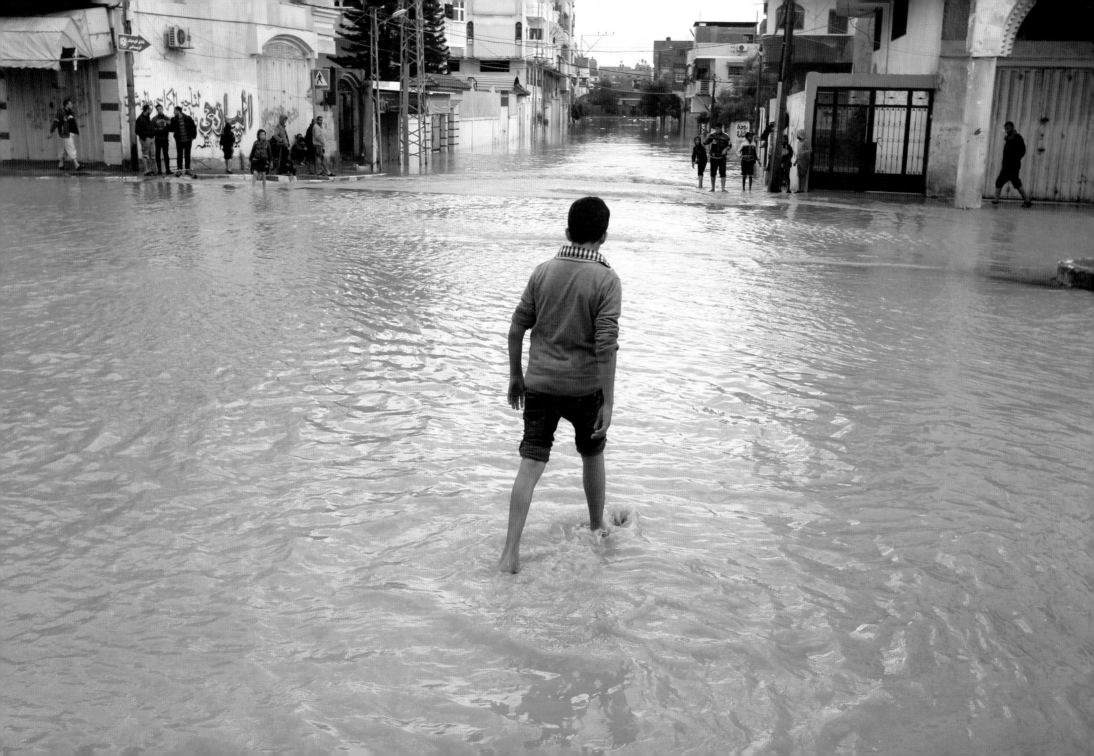

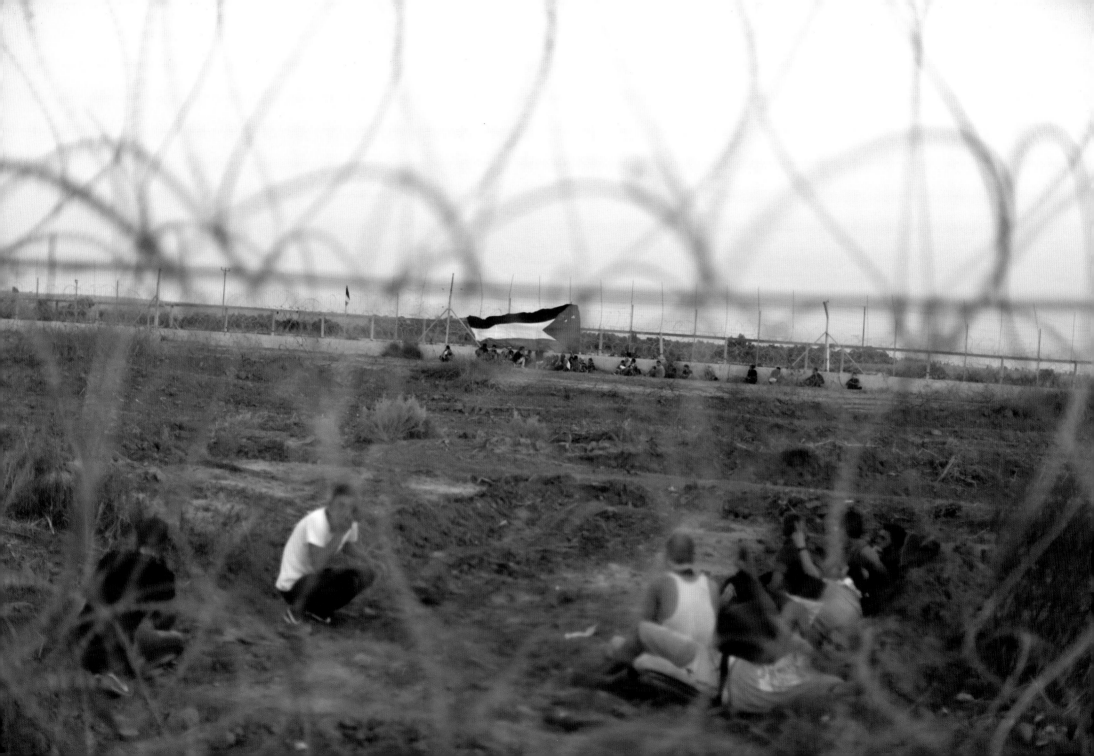

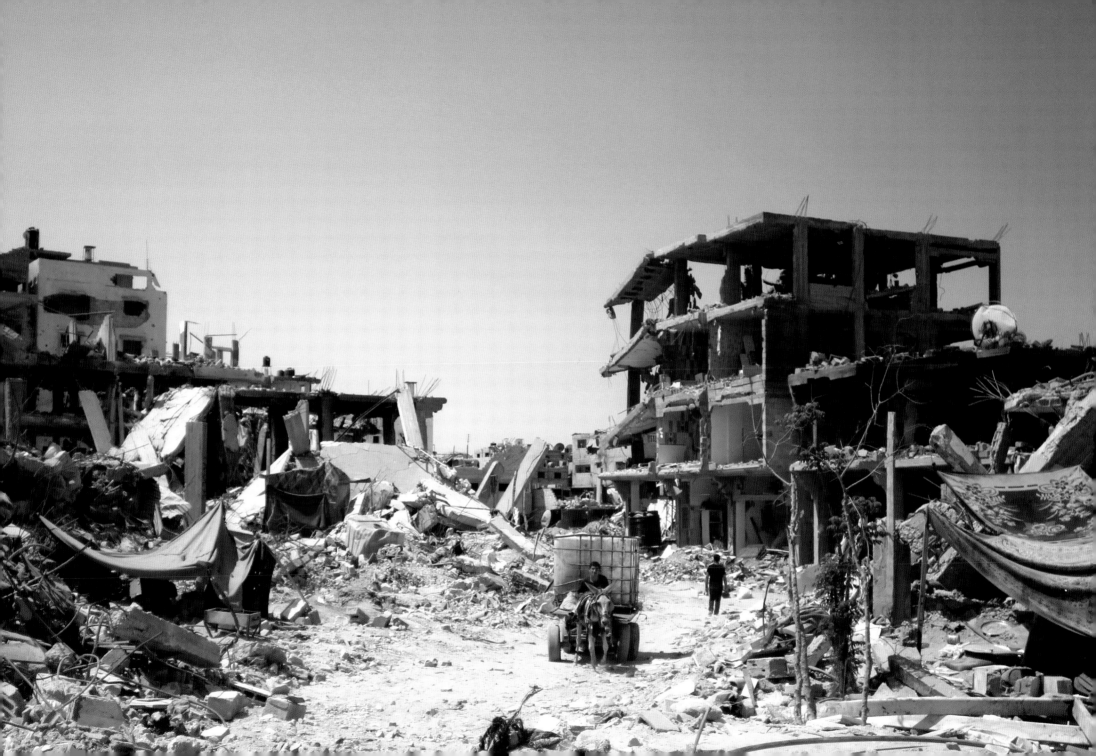

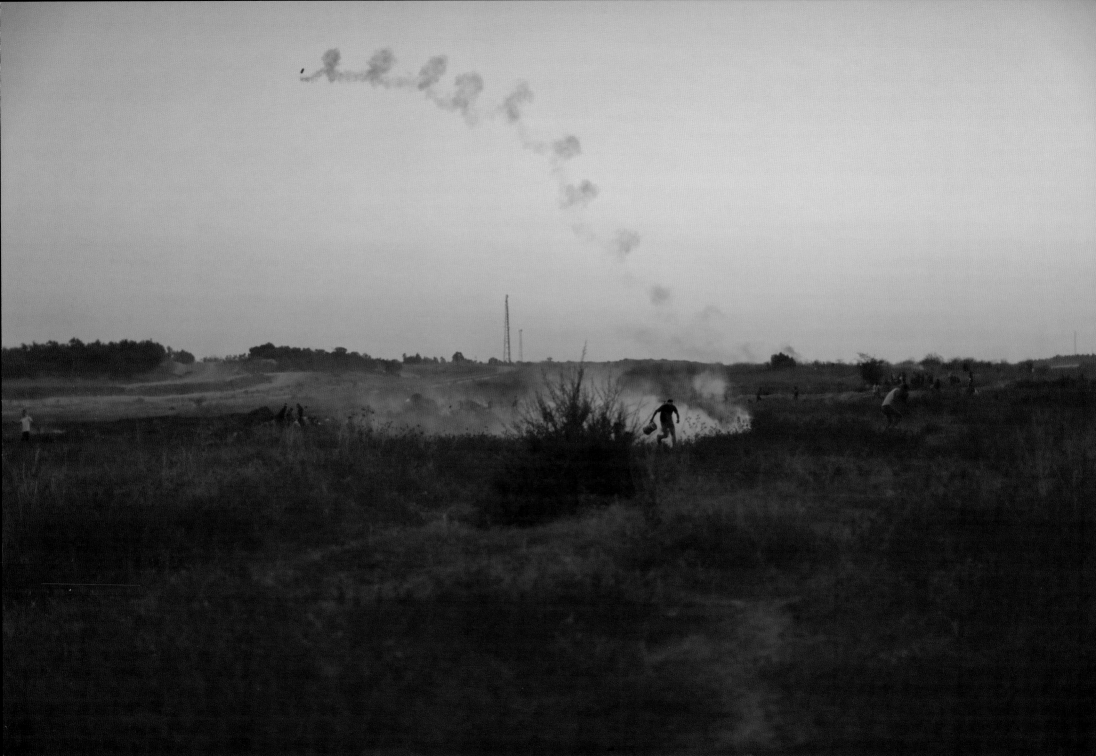

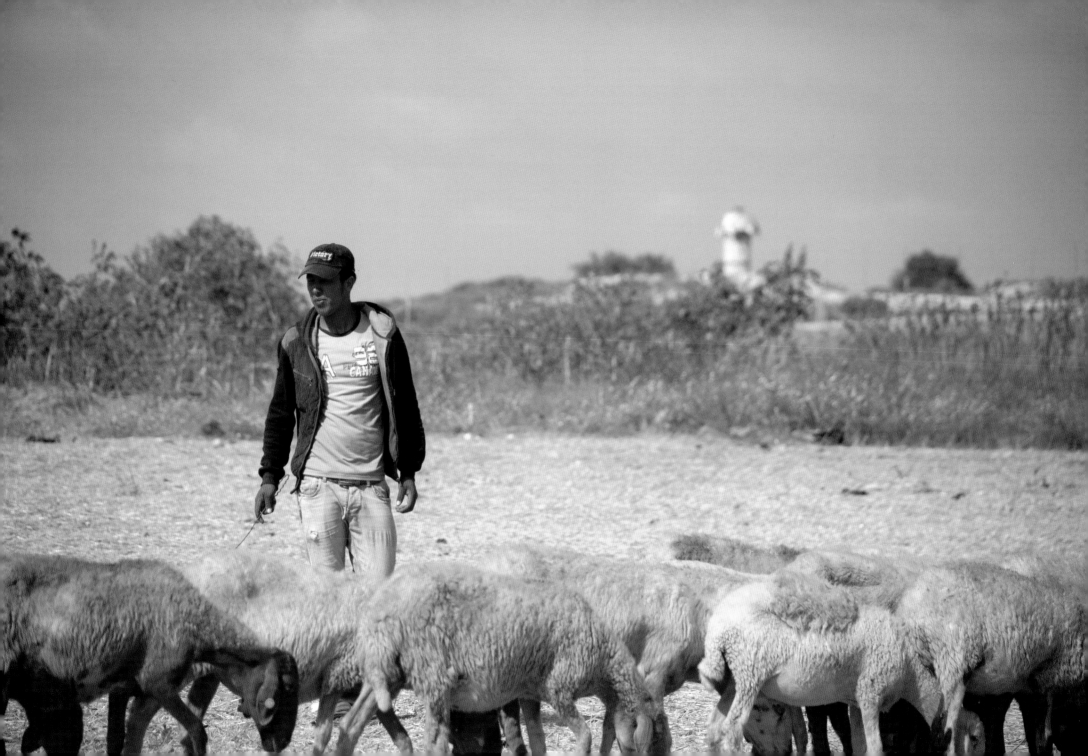

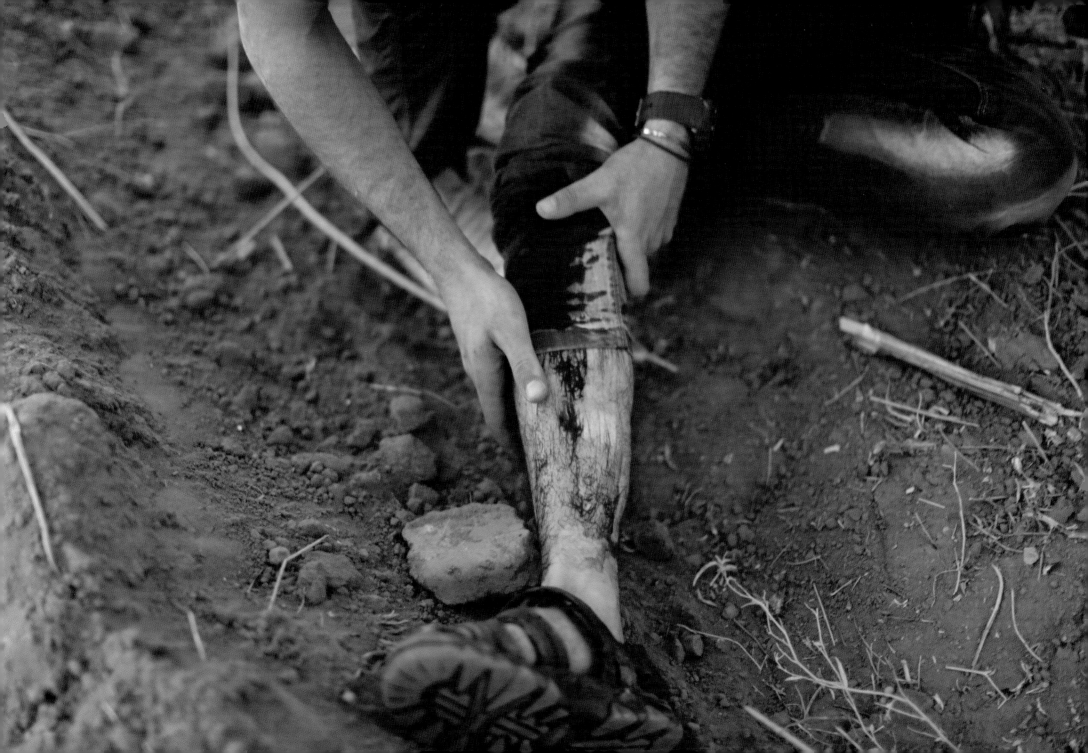

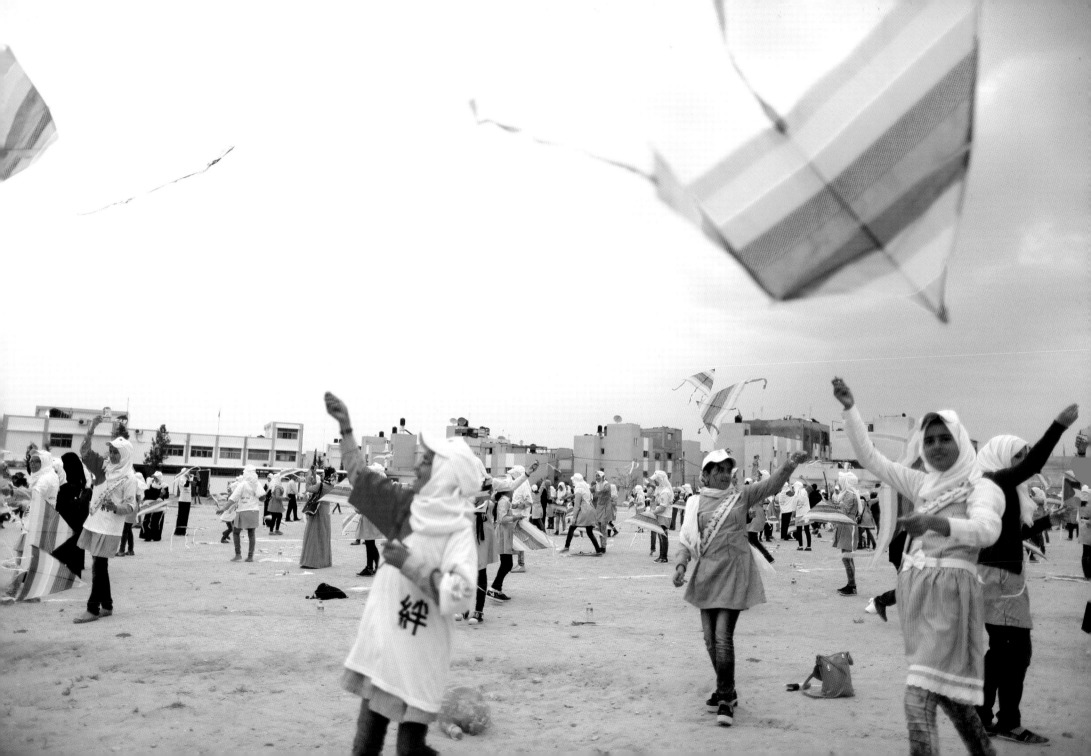

McSWEENEY'S
SAN·FRANCISCO

Thanks to Juan Cole, Cara Jobson, Amy Sumerton,
Caitlin Van Dusen, and Alvaro Villanueva.

McSweeney's and colophon are registered trademarks of
McSweeney's Literary Arts Fund, a nonprofit organization
with wildly fluctuating resources.

ISBN: 978-1-944211-97-4

10 9 8 7 6 5 4 3 2 1

www.mcsweeneys.net

My Gaza:
A City in Photographs

Jehad al-Saftawi

This book is about my home, Gaza. I've put my memories and dreams into these pages. I've shared with you the view from my window. This body of work contextualizes Gaza's everyday realities, offering an exploration of home, politics, and identity.

There is no free press in Gaza. Most of the news channels cater to political parties that use violence to silence opponents. This book exposes many horrifying experiences I would never have been able to speak about had I not left home.

For years, I clung to the idea of fleeing my country for the Western world. In 2016, I managed to leave the Gaza Strip for New York, and, soon after, I began the process of seeking asylum in Berkeley, California. People wanted to know how they could help my wife and me, aside from offering financial assistance. Then I received the opportunity to publish my photographs. It's an opportunity so many of the refugees arriving in the US every day aren't afforded: the chance to share one's experience.

My experience is one of a Palestinian, the son of a jihadist who killed and contributed to the killing of innocent Israelis. I condemn these actions. However, many in Gaza consider my father a Palestinian hero—one who carried out valiant operations for the sake of his country and religion. I come from a place overflowing with weapons, where my father could easily buy a pistol and shoot it into the air while cruising the streets of our city. A place where on any night you could be awoken by a bomb exploding in your neighbor's home, stored there by a member of their family who belonged to an armed faction. Today, after years of desperate and unyielding attempts to leave, I am in California, far from my family and society. My name is Jehad al-Saftawi. I am a photographer and journalist who came to the US at age twenty-five. I am the second son of five children.

My story is in part the story of my father, Imad al-Saftawi, who raised me with violence and fear, and who, after his eighteen-year imprisonment in Israel, was set free in December of 2018. While he was imprisoned, he frequently called our house and forced religious and societal instructions upon me and my siblings, threatening us in the event of noncompliance. My siblings and I lived with my father's family at the time, constantly feeling the weight of his reputation as a hero, and his community's disapproval that we weren't following his lead.

My father grew up in an ultraconservative middle-class family that was largely influenced by the Muslim Brotherhood. His father, Asaad al-Saftawi, was a former Muslim Brother, an Islamic senior official within the Palestine Liberation Organization, and a cofounder of Fatah as well as its leading activist in Gaza. Asaad had three daughters and six sons, four of whom spent time in Israeli prisons, as Asaad himself did. He survived several assassination attempts, until he was eventually killed after formulating a Palestinian peace plan with Israeli prime minister Yitzhak Rabin. In his book *Gaza: A History*, Jean-Pierre Filiu writes of my grandfather: "Forty years before, he had been inducted as a militant alongside Abu Iyad [Salah Khalaf, the second most senior Fatah official] and had lived through every kind of trial and danger, until at last, peace or its prospects, had cut him down."

My father spent many years participating in armed struggles, both within and outside the framework of Palestinian armed organizations, which he believed to be justifiable resistance to the Israeli occupation. In mid-December 1986, with Gaza still under the direct rule of the Israel Defense Forces, my father was arrested for the second time, while at his home in the Sabra neighborhood in Gaza City. He was twenty-three, a student at the Sharia college at the Islamic University of Gaza. He was charged with joining the Islamic Jihad movement and training with weapons, possessing a firearm and a grenade, and being a member of a group that killed Israeli citizens. My father was detained and questioned for five months. An Israeli military court accused him of the murder of three Israeli citizens. He pleaded guilty to

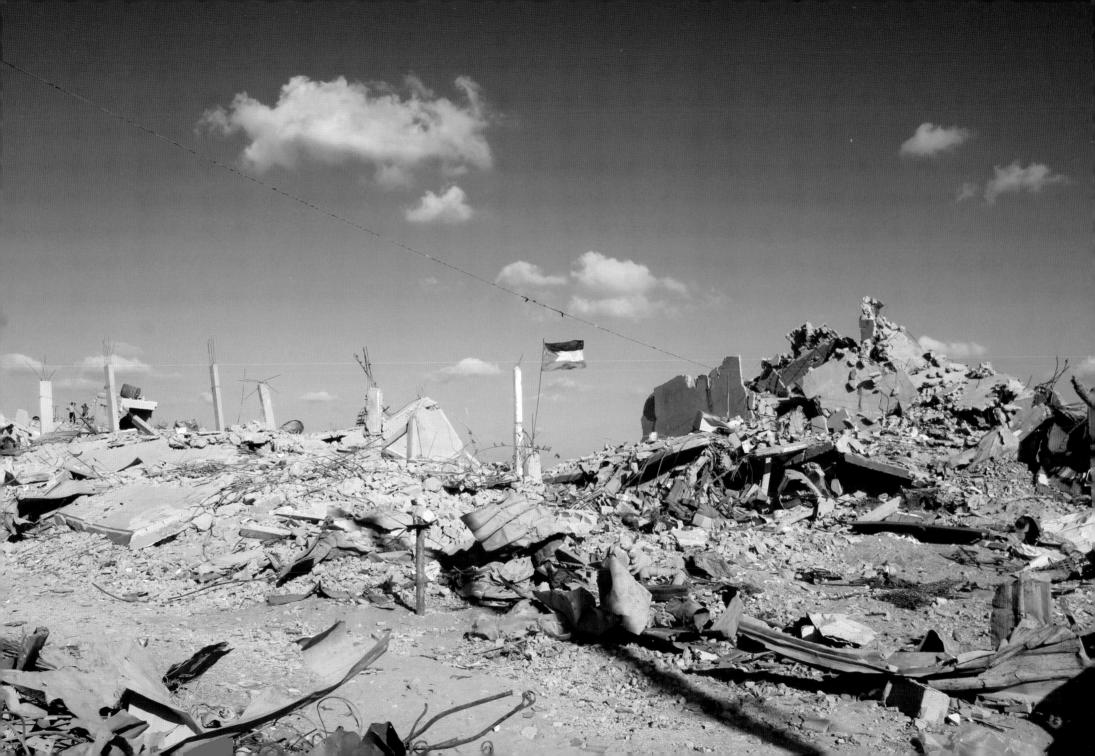

some of the charges but denied participation in the killings.

A few days before his court session, my father and five other prisoners escaped from the notorious central Gaza prison, the headquarters of the Israeli military governor in the Gaza Strip. In the weeks following their escape, the Israeli army killed three of the escaped prisoners and arrested a fourth. My father and the last escapee, Khaled Saleh, managed to make it to the Sinai Desert, in Egypt. My father returned to his activities with the Islamic Jihad movement, traveling between several Arab countries before finding himself in Syria in 1989, where he married my mother, Sadeya al-Hourrani, a Palestinian refugee. As happens with most Arab marriages, my father proposed to my mother without ever having met her. He had arrived just a month earlier, from Algeria. My mother's father had promised himself that, in order to preserve their right of return, he would marry his daughters only to Palestinians. And so, as the decision was my grandfather's rather than

my mother's, my grandfather gave consent for the marriage directly to my father.

My own story began in 1995, when I was four years old, and my parents returned to the Gaza Strip to settle near my father's family. Two years prior, the Israeli army had partially withdrawn from the Gaza Strip's neighborhoods, forfeiting its control of the crossings between Gaza and Israel in compliance with the Oslo Accords. My father was returning from abroad as a hero in the eyes of his family and community. We moved into a flat on the fifth floor of a building owned by the al-Saftawi side of our family. My father worked for the Ministry of Awqaf and Religious Affairs, which, in practical terms, meant he worked in the management of mosques. On top of his professional duties, he acted as the khateeb (orator) on Fridays in various mosques around the Gaza Strip, where he would lecture about religion. My mother was a housewife, seeing to our education and raising us according to our father's methods and rules.

My parents cared for their children and wished us the best, but we were constantly berated. My siblings and I were made to feel guilty about our soft hands. We were threatened and punished if we didn't go to the mosque for the five daily prayers. We were forced to wake at 5 a.m. to go with my father to pray the Fajr (dawn prayer). We were beaten for doing normal things children do. We were beaten if they heard from one of the sheikhs at the mosque that we hadn't attended prayers or studies. Our flat was the lens through which I observed life. Hadith (the Prophet's quotes) lined the walls. Islamic books filled the shelves, along with animal statues my father had broken the heads off of in accordance with the Islamic rule prohibiting the portrayal and embodiment of spirits. Our lives went on like this until I reached age nine, in 2000, and my father was arrested by the Israeli army again, at the Rafah border crossing between the Gaza Strip and Egypt. He remained in prison for the next eighteen years. Since his recent release, he has

served as a brigadier general in Hamas's ministry of interior.

I'm now seven thousand miles away from him, from Gaza, and I walk as a free man.

Working as a journalist in Gaza is like walking barefoot in a field of thorns. You must always watch where you step. Each neighborhood comprises its own intimate social network, and traveling through them with a camera makes you a significant cause for suspicion. You're caught between the two sides of the conflict: The rulers of Gaza limit what you can photograph and write about, imprisoning and torturing those who disobey. At the same time, the Israeli army sees you as a potential threat that must be eliminated, as has been the fate of many Palestinian journalists.

Standing behind the camera, your hands shake as you document the suffering.

These photographs are visual memories that explore the lives behind the headlines. This work is dedicated to all those trapped in the hardships of this life, surviving in the hopes of a better tomorrow.

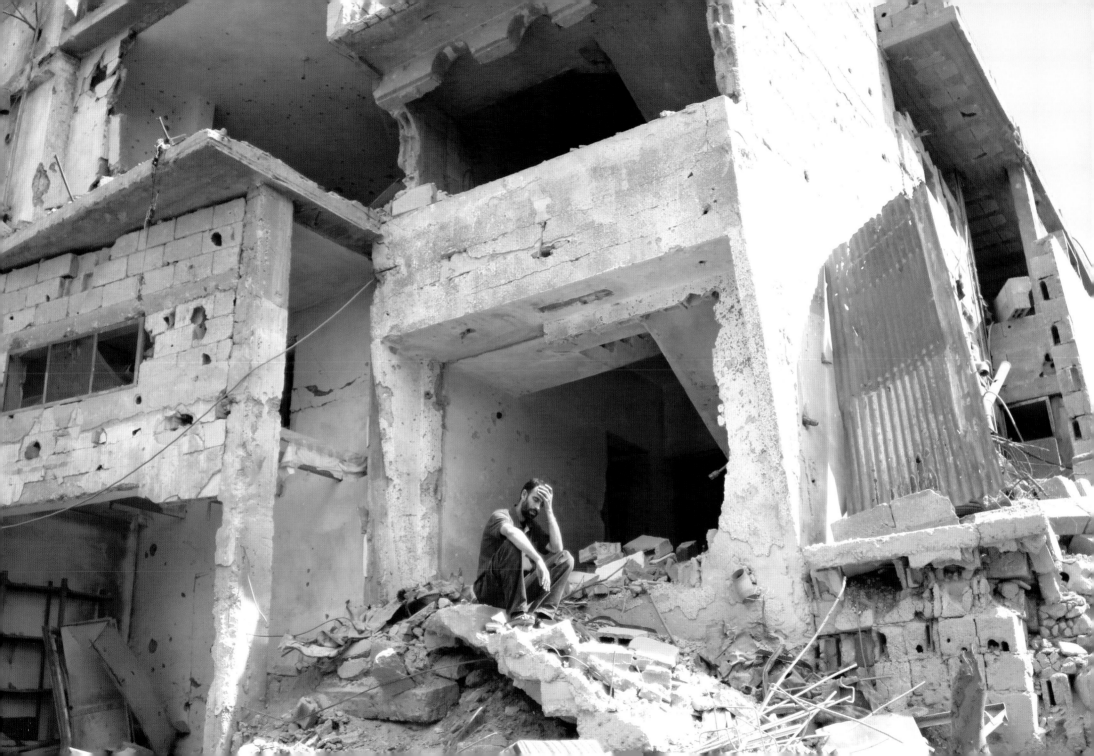

[1] **April 25, 2010, 10:49 a.m.** A young Palestinian drives his donkey cart on Salah al-Din Road, in the southern Gaza Strip.

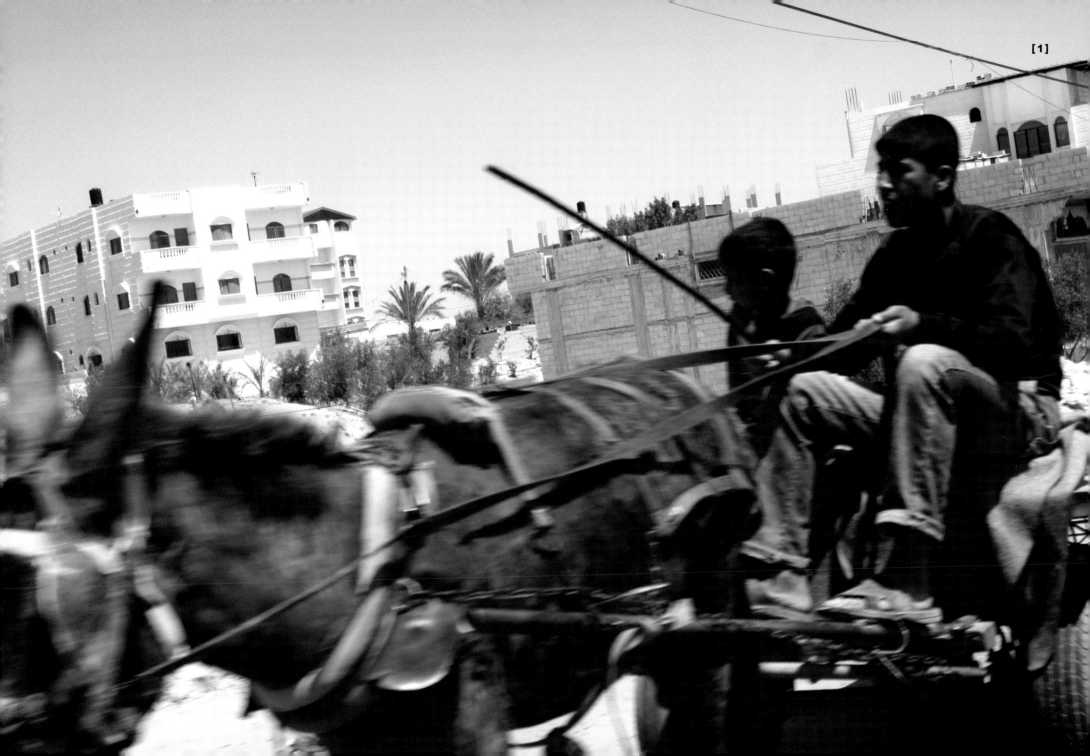

[2] **July 13, 2010, 1:25 p.m.** A memorial billboard for Tariq Diab Humeid is on display beside Salah al-Din Road. In 2004, twenty-four-year-old Tariq blew up his car among an Israeli army patrol, injuring four soldiers. The billboard displays scenes from the operation and the words "Here has risen the spirit of the al-Qassam martyr commander."

Following pages:

[3] **December 31, 2011, 11:45 p.m.** Gazans celebrate New Year's Eve at the Beach restaurant in Gaza City.

[4] **September 27, 2010, 1:07 a.m.** The view from the roof of the six-story house in the al-Saftawi neighborhood where I spent most of my childhood. In 1995, my parents returned to Gaza from Sudan, where my father had worked for the local Islamic Jihad office. My siblings and I grew up in this house with four ultraconservative uncles who pressured us to go to the mosque five times a day. During frequent clashes with the Israeli army, Palestinian militant factions used a field in front of our house as a base to fire rockets at Israel. When Israeli tanks invaded, the militant factions erected sand hills in the middle of our street and the surrounding ones in preparation for street fights.

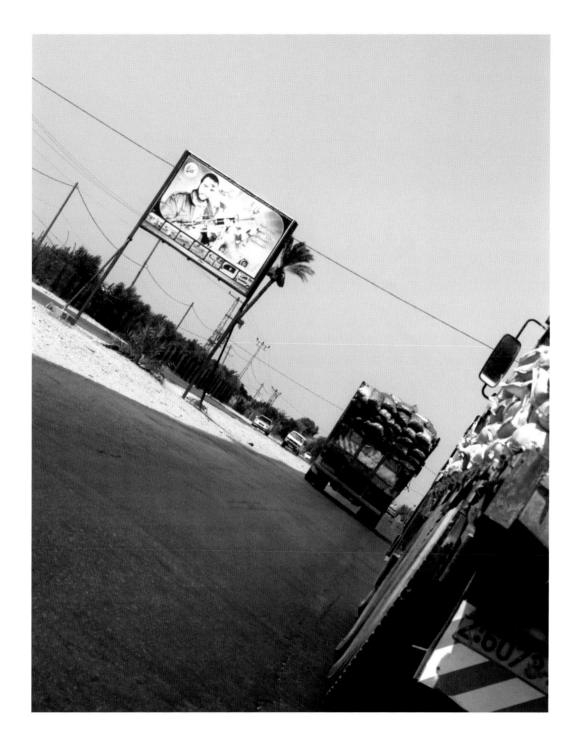

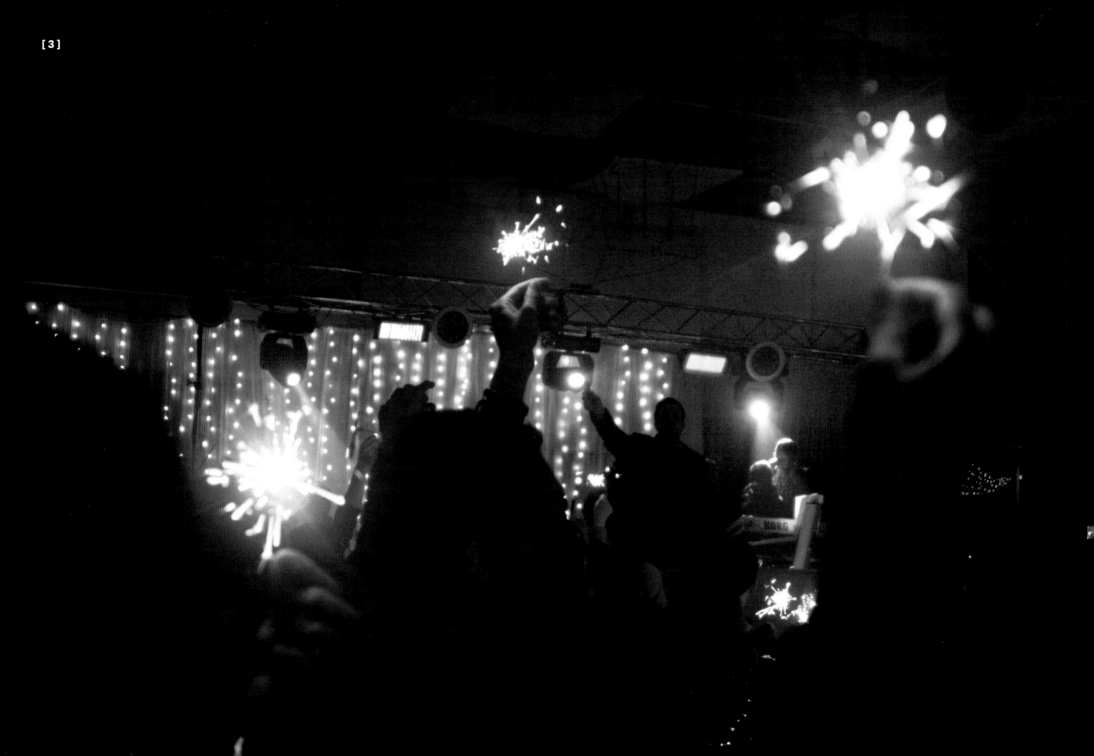

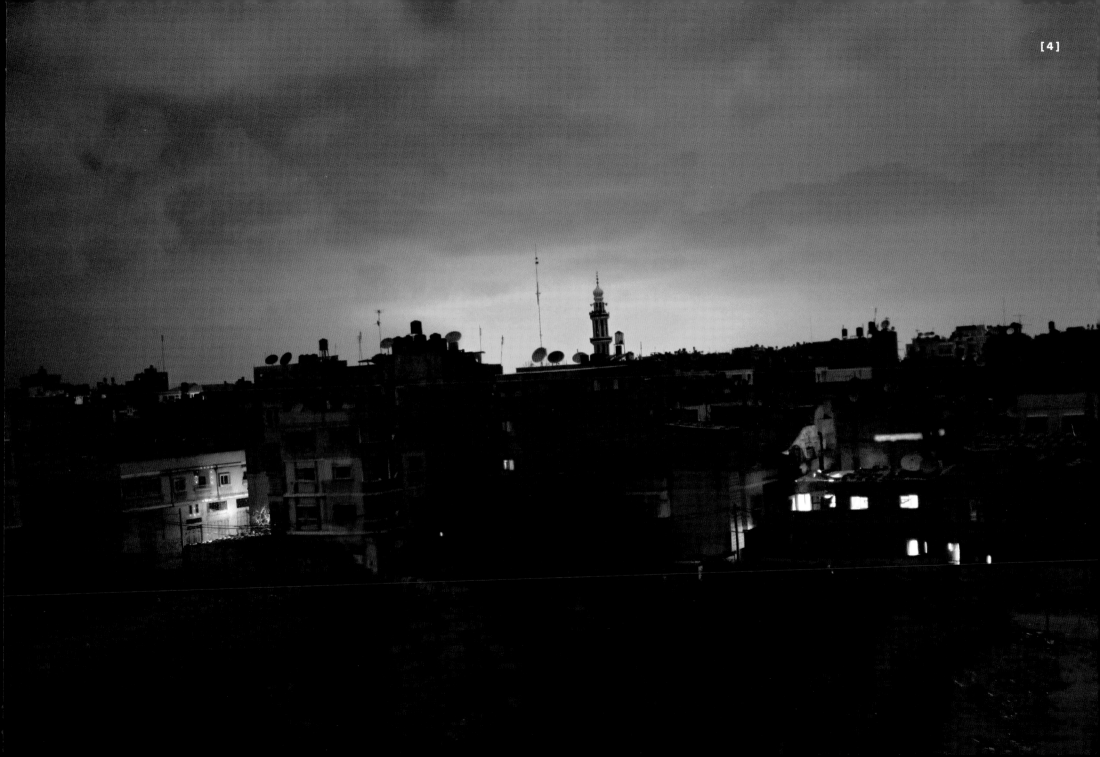

[5] **February 12, 2012, 11:58 a.m.** Ahmed Salah al-Samouni, seven years old, gives a lukewarm smile at his school in the al-Zaytoun neighborhood. Ahmed's sister, grandmother, and grandfather were killed before his eyes during Operation Cast Lead, Israel's twenty-two-day assault on Gaza in 2008 and 2009. Forty-eight members of his family were killed that day, and his father, mother, and two brothers were injured. In the aftermath, Ahmed lay in a pool of his family members' blood; his mother didn't know Ahmed had survived until he shouted out to her.

Following pages:

[6] **November 24, 2012, 12:19 p.m.** A Palestinian man works in one of the Rafah tunnels, which run from Gaza to Egypt and serve as underground routes for transporting goods, weapons, and people. Gazans increased construction of the tunnels in response to severe restrictions on both Palestinian movement and the import of consumer goods, medicines, and construction materials. These restrictions paralyze all aspects of life and development in Gaza. The tunnels—often guarded by Hamas police—are dangerous places to work. The Egyptian army has pumped poisonous gases and sewage water into the tunnels, and Israel has bombed the tunnels. To visit, I had to receive permission from the Hamas-run interior ministry.

[7] **November 24, 2012, 1:19 p.m.** A bottle of water for Palestinian tunnel workers hangs on the wall of a tunnel linking the Gaza Strip and Egypt. During my descent into this tunnel, which ranges from fifteen to twenty meters deep, I immediately felt pressure and shortness of breath. Two hundred and thirty-two Palestinian tunnel workers died and 597 were injured between 2006 and 2013.

[8] **May 31, 2013, 10:12 a.m.** Kids play soccer in front of their houses in Gaza City's al-Shati refugee camp, which translates to "beach camp."

[9] **June 3, 2013, 2:26 p.m.** A boy sells sweet corn in front of his house in Gaza City's al-Shati refugee camp.

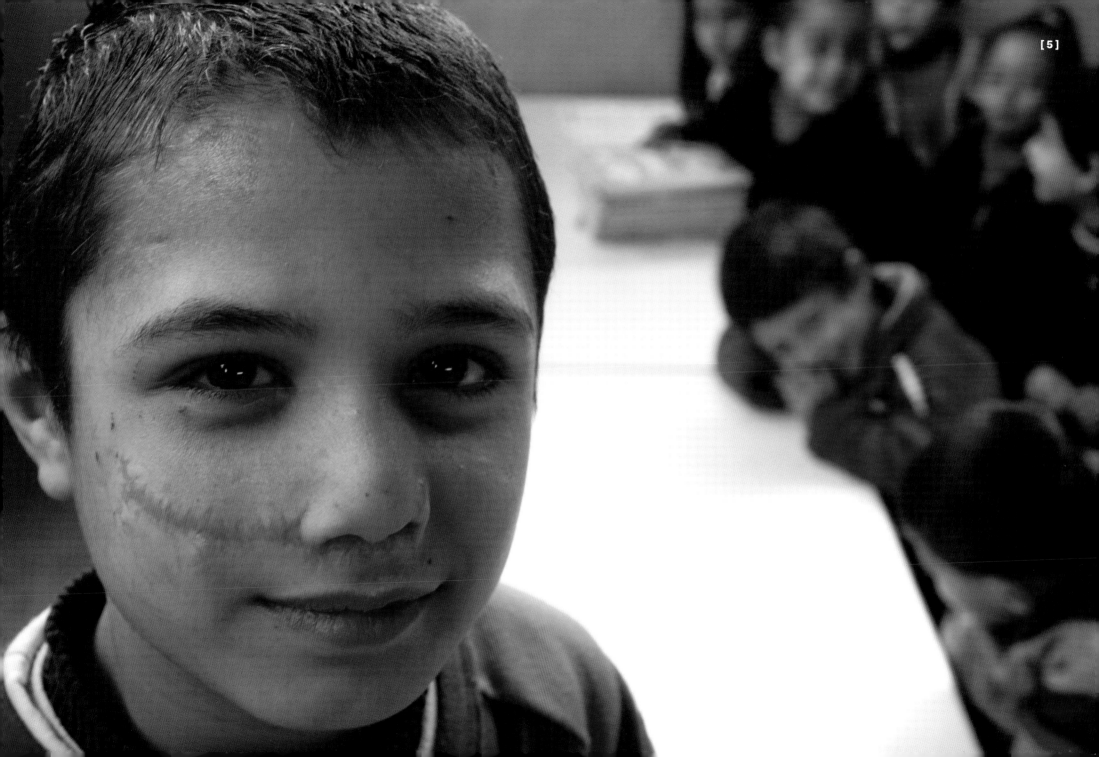

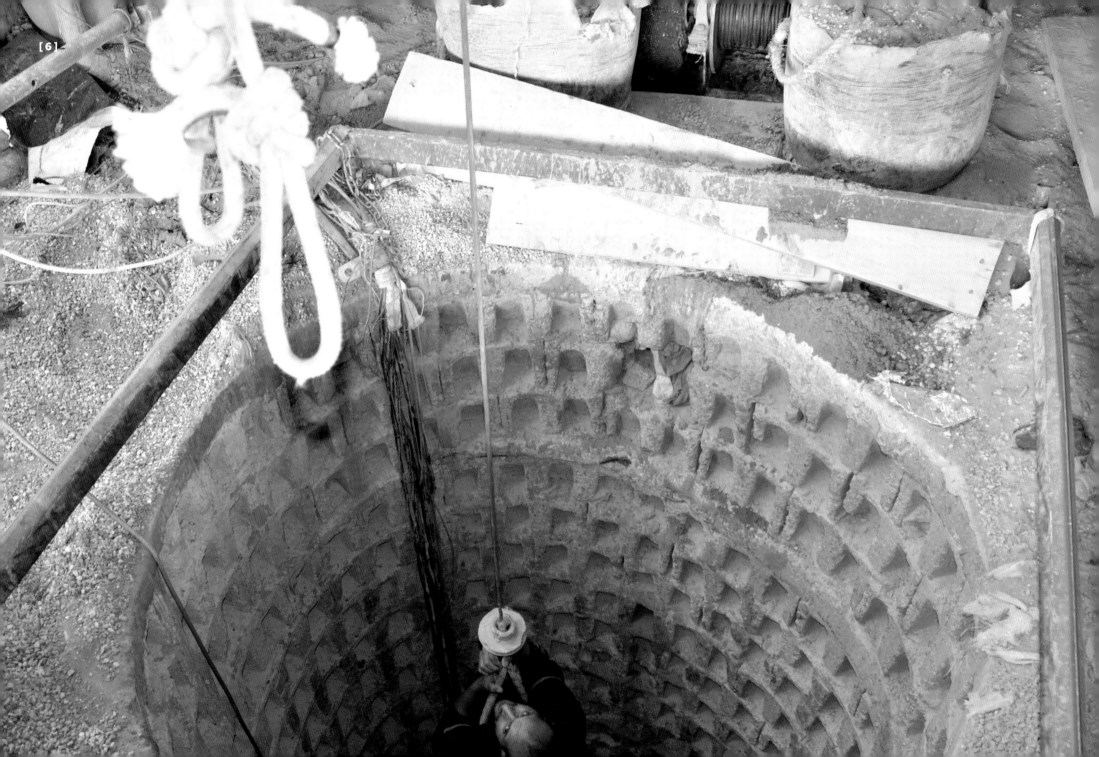

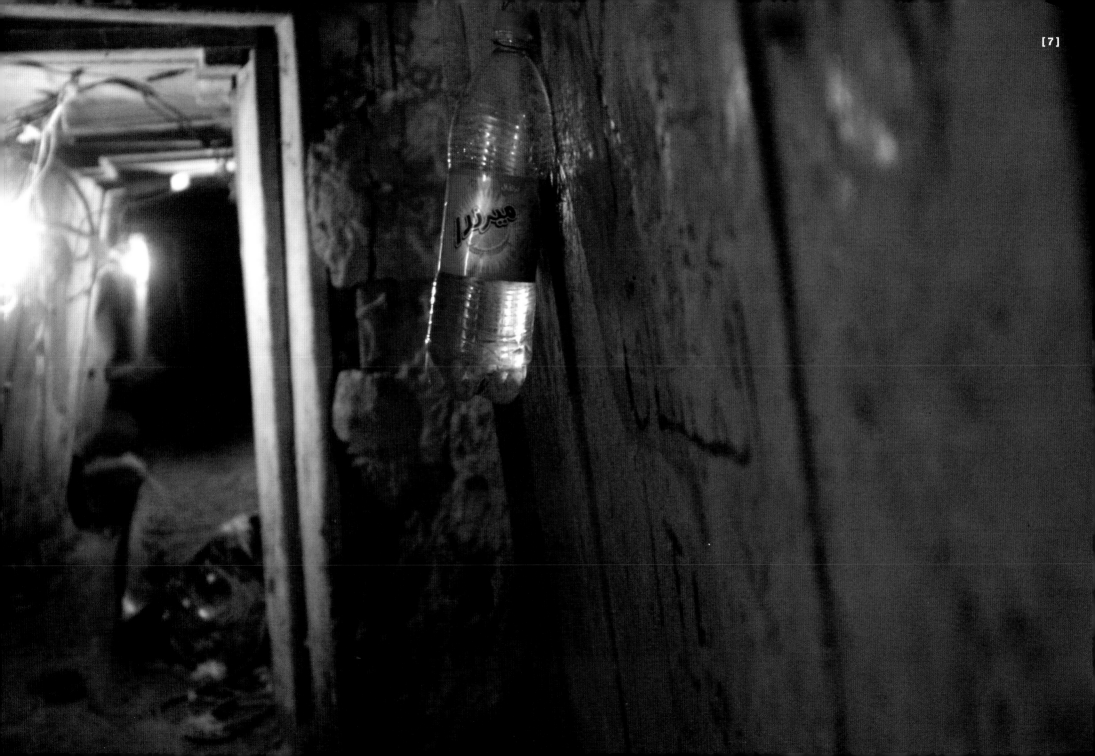

[7]

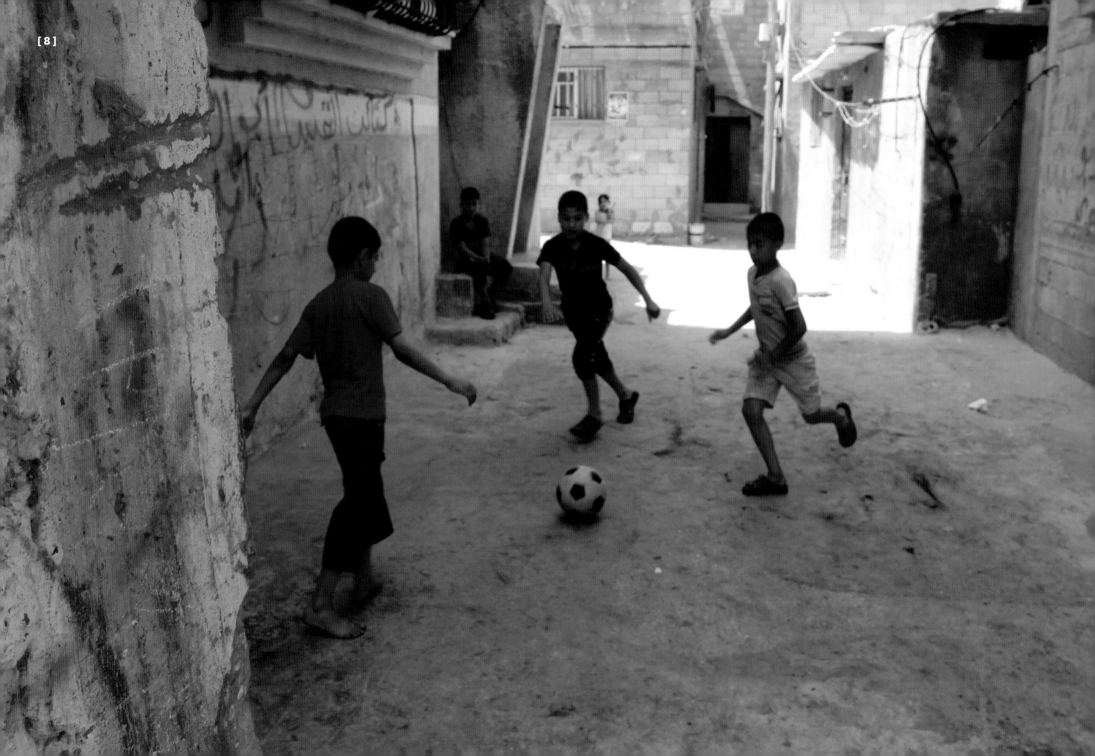

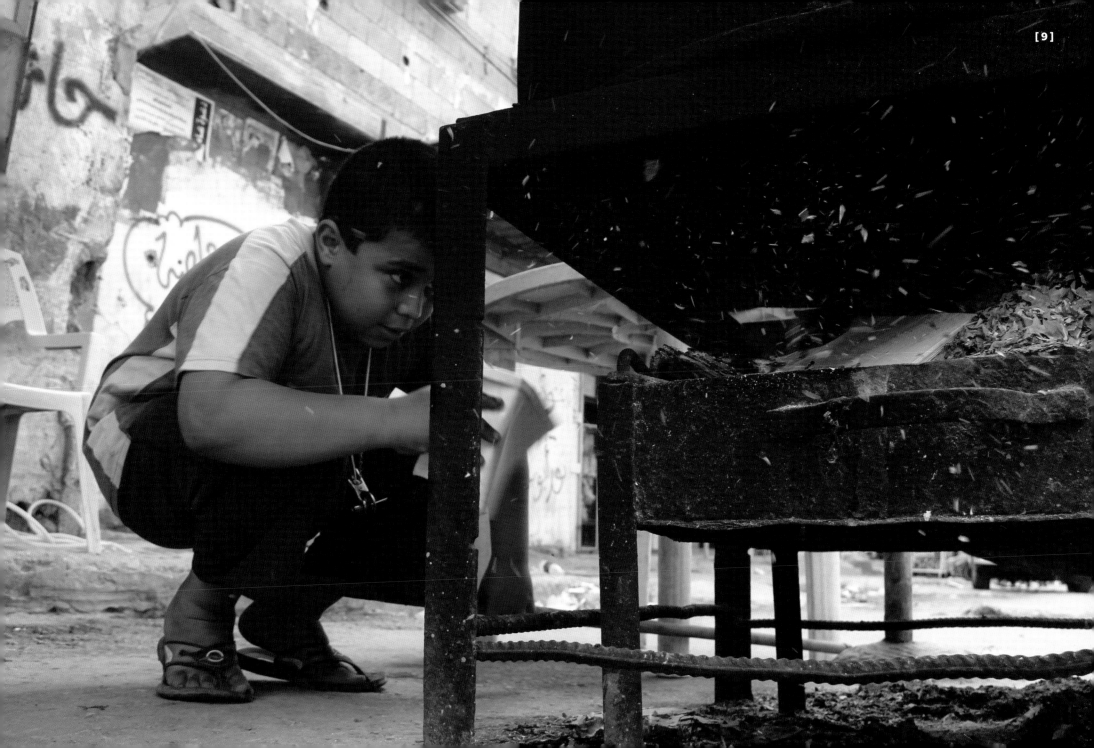

[10] <u>June 3, 2013, 2:22 p.m.</u> A mechanic eats lunch with his children and an employee at his workshop in the al-Shati refugee camp. The camp is located on the Mediterranean coast in the Gaza City area, and was established for the tens of thousands of Palestinians forced to flee their homes during the 1948 Arab-Israeli War. The camp began as a collection of tents and developed into concrete houses, out of which residents opened small workshops. Al-Shati is now home to more than 87,000 refugees. They all reside within only 0.52 square kilometers. It's the third-largest refugee camp in the Palestinian territories.

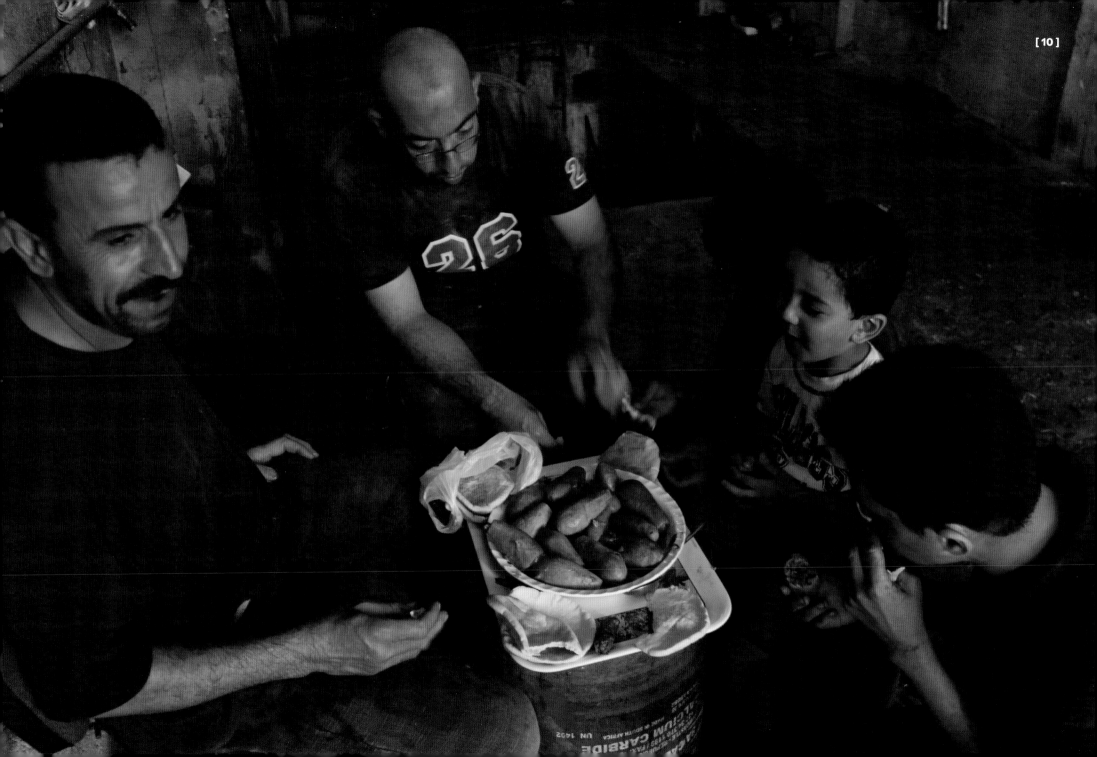

[11] **June 22, 2013, 11:51 p.m.** A crowd of youth in Gaza City takes to the streets to celebrate Mohammed Assaf winning the *Arab Idol* contest. Thousands gathered on Omar al-Mokhtar Street for hours after the announcement. Minutes after I arrived, security police stopped me, seized my camera, and handed me over to uniformed officers for interrogation. As of at least 2018, Hamas had not allowed Mohammed to hold a concert in Gaza, his home.

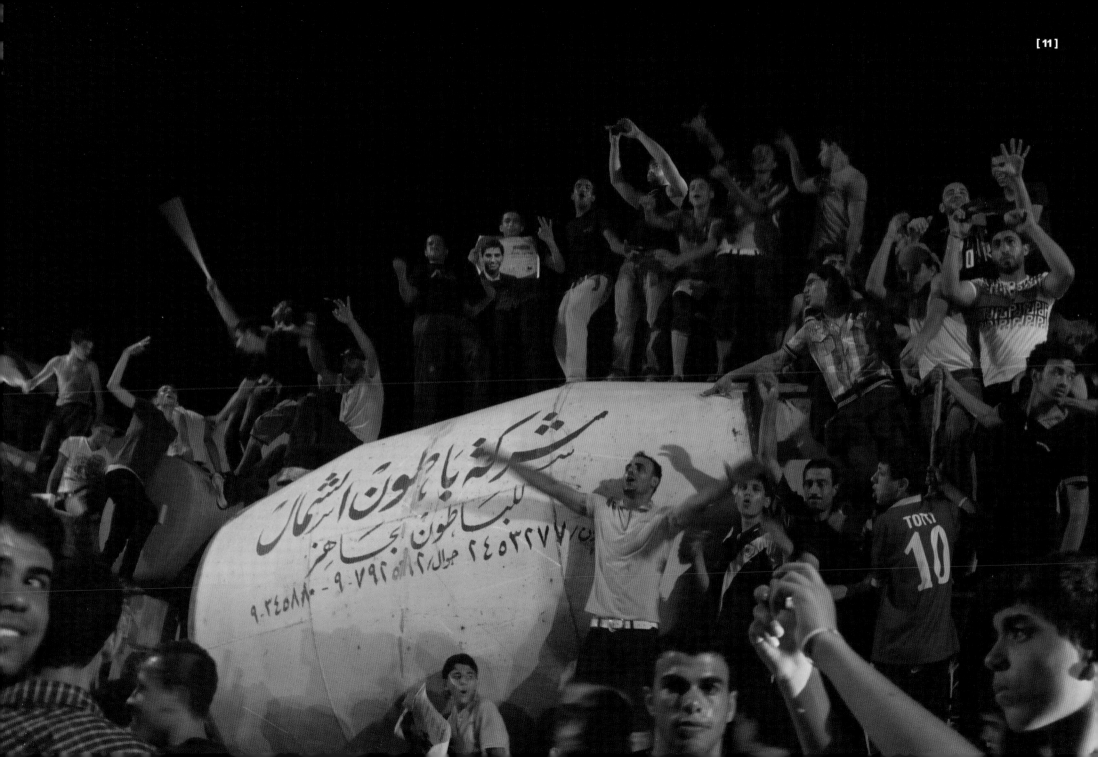

[12] **October 12, 2013, 6:46 p.m.** A farmer feeds his cows on the first day of Eid al-Adha and prepares to receive customers. On this holiday, Muslims offer a sacrifice of an animal and then divide the meat into three portions: one is given to relatives, friends, and neighbors; another to the poor; and the final one is kept at home for the family.

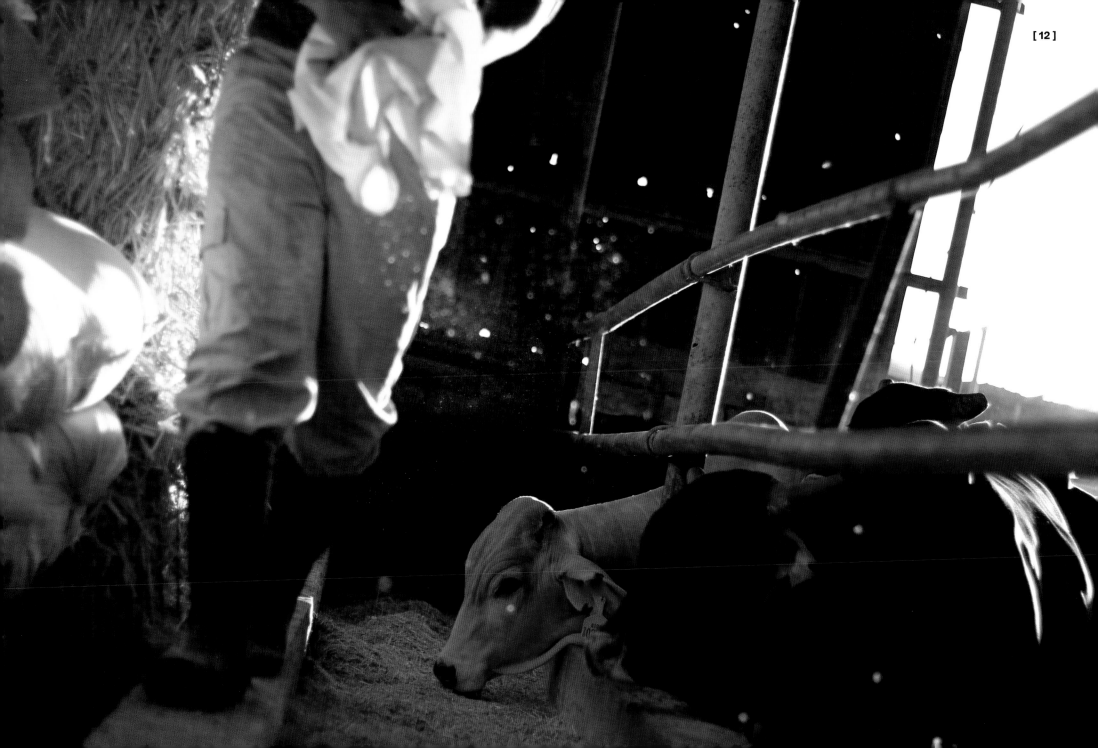

[13] **October 30, 2013, 3:29 a.m.** Friends, family, and members of militant factions celebrate a Palestinian prisoner's release from an Israeli prison at the Erez Crossing, on the Gaza-Israel border. For many years, I had feared witnessing a scene just like this one upon my father's release from prison. And, indeed, in December of 2018, I watched a live stream of his homecoming. Dozens caravaned as my father was driven from the Erez Crossing to our family's building in Gaza City. Leading the caravan were two pick-up trucks filled with Izz ad-Din al-Qassam Brigades masked militants. My father stood in the bed of one of the trucks carrying an M16 rifle. I cried as I watched from my home in Berkeley, fearful about my family's future.

Following pages:

[14] **October 31, 2013, 1:47 p.m.** Propane canisters smuggled from Egypt through the Rafah tunnels wait for distribution within Gaza. Movement is not easy in this area, especially if you're carrying a camera. On the day I took this photograph, I was stopped and interrogated multiple times by undercover Hamas police. Years later, I was arrested and my equipment was taken while I was working on a film here. I was brought to an Izz ad-Din al-Qassam Brigades site, where my phone was confiscated for fifteen days, during which time al-Qassam brigades militants accessed my email and social media accounts. During and after these fifteen days, I was interrogated about my work at many military and governmental sites. Days before leaving Gaza for good, I was ultimately told that Hamas would prohibit me from completing this film or doing any other documentary work on the border.

[15] **October 31, 2013, 1:03 p.m.** A building—partly destroyed during clashes between Palestine and Egypt—sits abandoned near the Rafah tunnels.

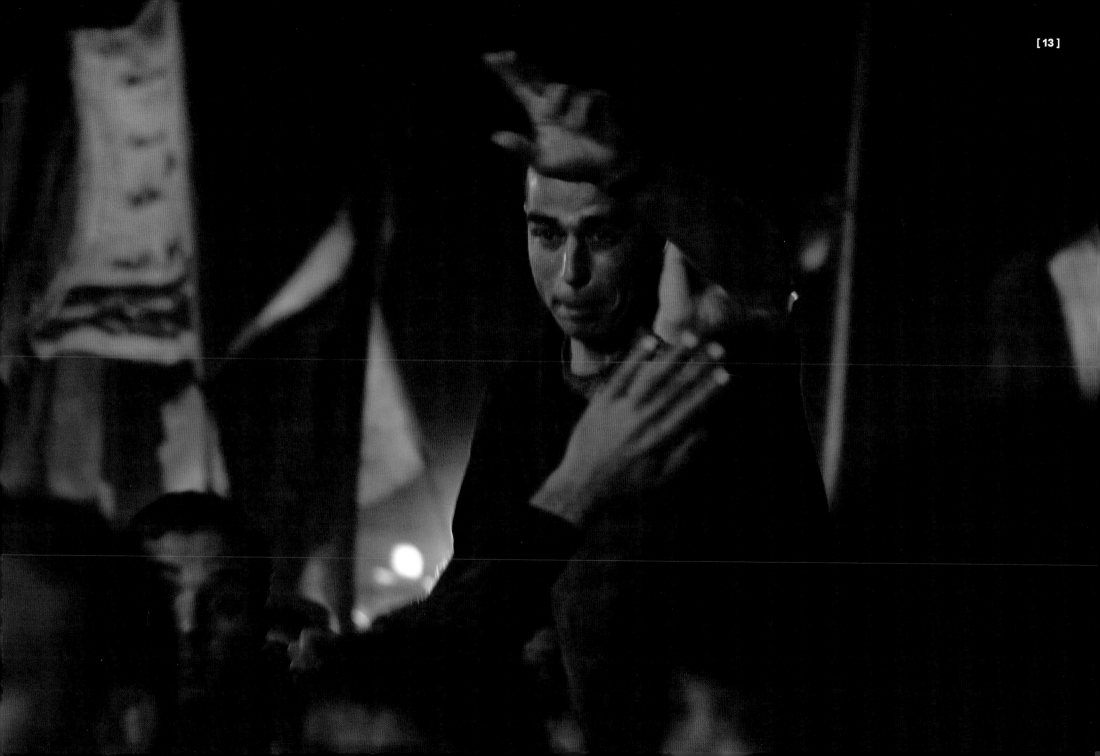

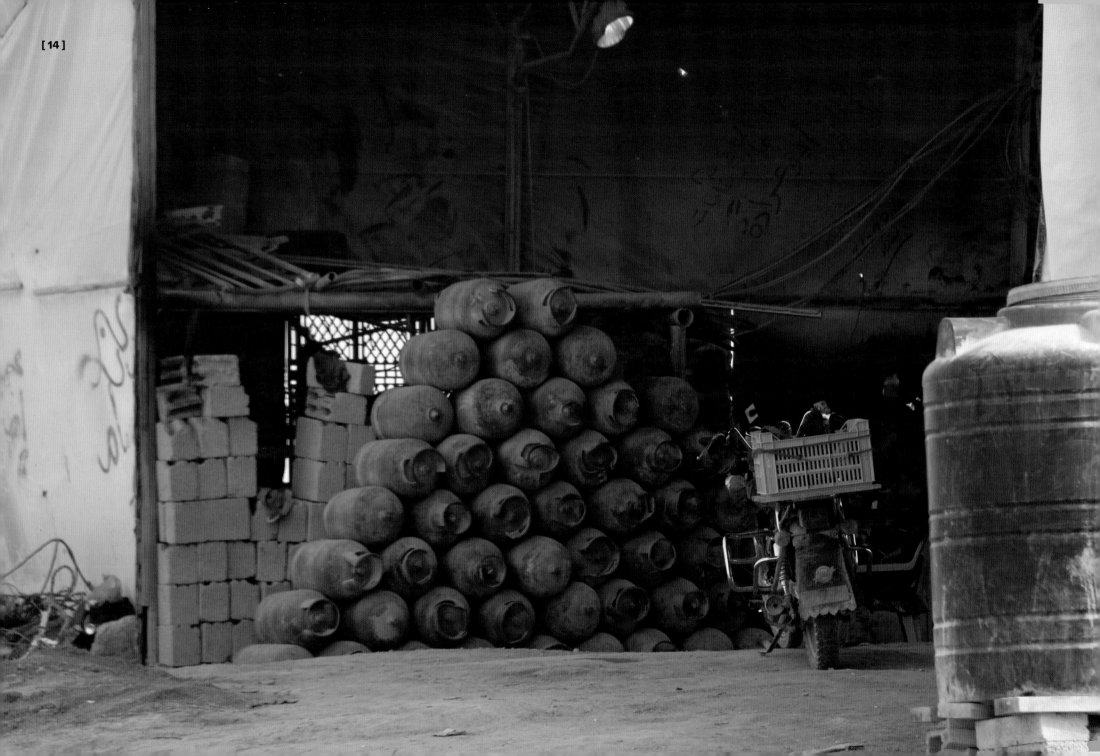

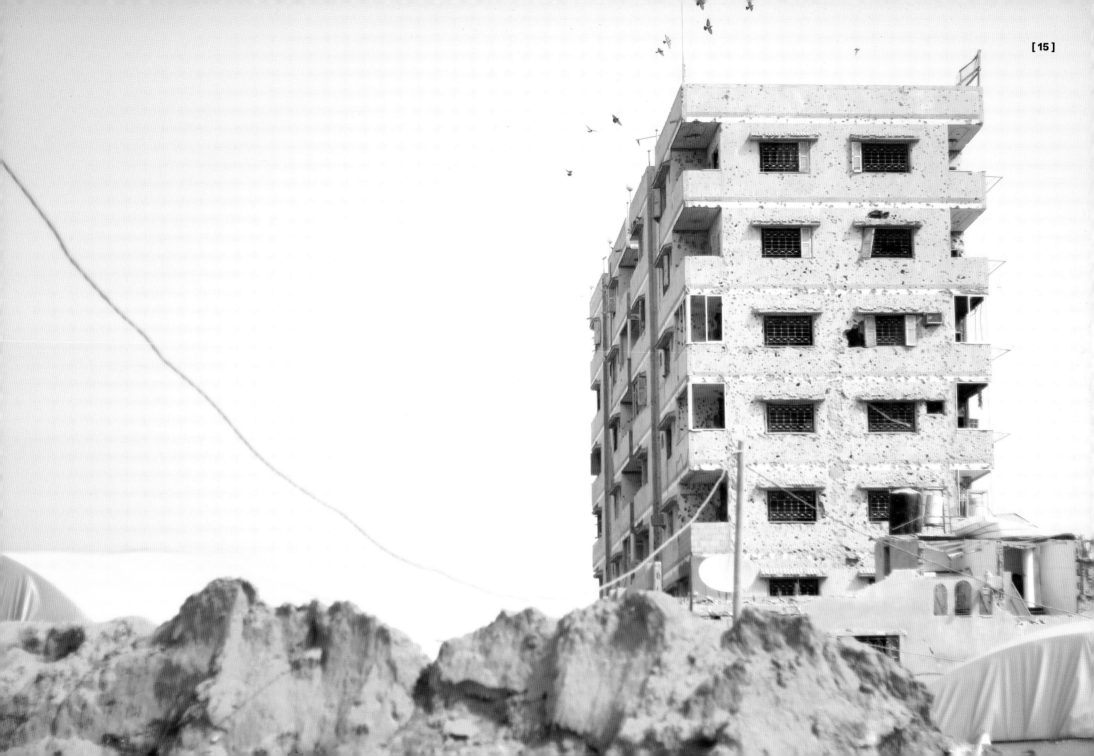

[16] <u>October 31, 2013, 1:42 p.m.</u> An Egyptian soldier stands on a watchtower overlooking the Rafah tunnels, which cross between Egypt and Gaza. Tents cover the tunnels' entrances. The Egyptian army turned a blind eye to the tunnels until relations with Hamas deteriorated, leading to Egypt's 2013 decision to close the tunnels.

Following pages:

[17] <u>November 21, 2013, 2:09 p.m.</u> Residents of Gaza wait in line to fill up their propane tanks. A driver who had been waiting for hours said to me, "Whenever there's an Israeli holiday, they close the crossing and cause shortages, and the prices go up. Our life stops and we don't make enough money to feed our families."

[18] <u>November 21, 2013, 2:04 p.m.</u> During one of the frequent gas crises in the Gaza Strip, a man takes a nap while waiting for his turn to fill his propane canisters. Israel regularly extorts Gaza's government by closing the Israeli Kerem Shalom Crossing, the main import route for gas and fuel. During these crises, it often takes the local gas distributors more than two months to return a canister, usually in a van with dozens of the highly pressurized canisters stacked on top of one another.

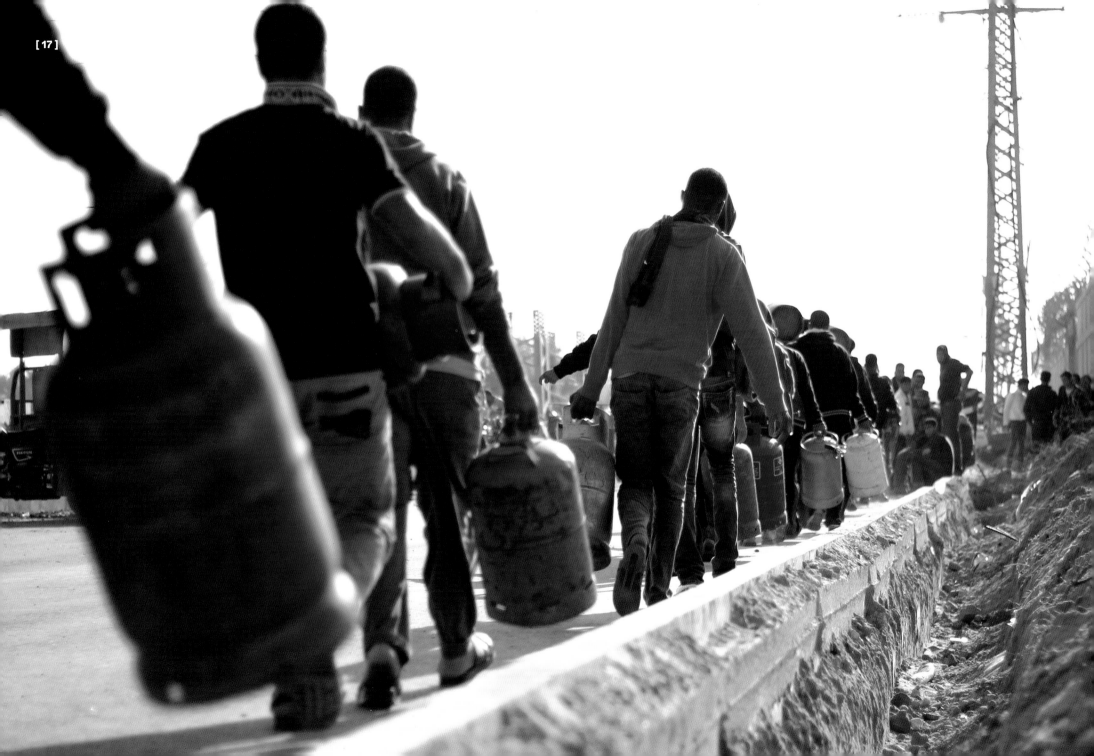

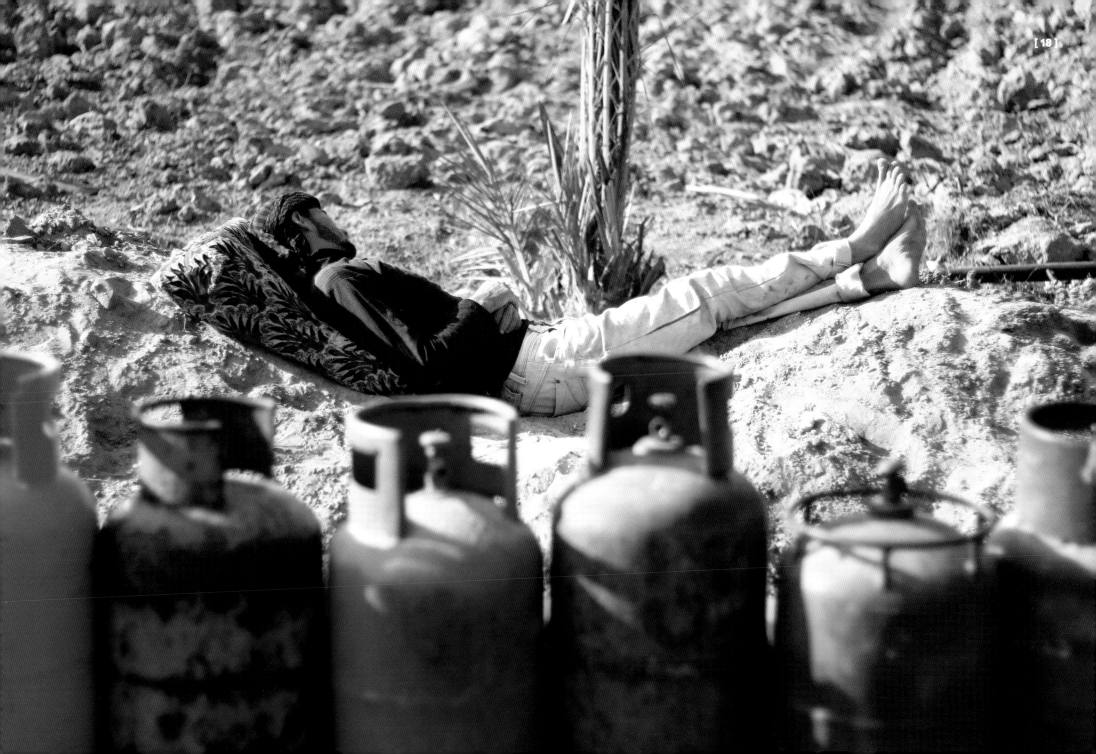

[19] **November 14, 2013, 1:59 p.m.** Palestinian kids face challenges getting to school due to flooded rainwater and bad infrastructure in Gaza City.

Following pages:

[20] **December 21, 2013, 11:43 a.m.** Moments before Odeh Hamad's burial, his brother grieves in the Eastern Cemetery in the northern Gaza Strip. Odeh was fatally shot by an Israeli soldier almost a kilometer from Gaza's Israeli-sealed border. Odeh and another brother, Raddad, had been collecting discarded plastic products, a common activity for unemployed Gazans. Raddad was shot in the hand the same day.

[21] **February 25, 2014, 1:13 p.m.** Palestinian protesters rally with mirrors on Gaza's eastern border with Israel. The protest marked the anniversary of the Ibrahimi mosque massacre. The mirrors were held to force Israeli soldiers to witness themselves shooting Palestinians. They were also used to reflect sunlight to confuse the soldiers' vision. Ashraf al-Qidra, the spokesperson for Gaza's Hamas-run health ministry, announced that Israeli soldiers shot three civilians that day, including a journalist, and injured many others with tear gas.

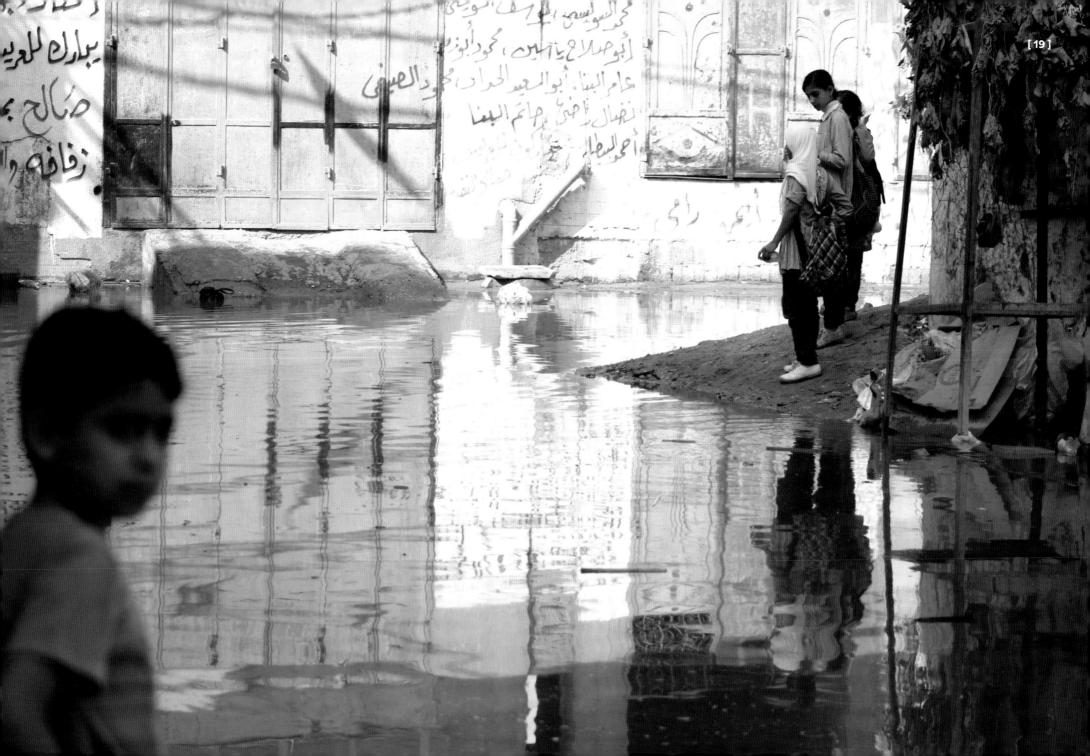

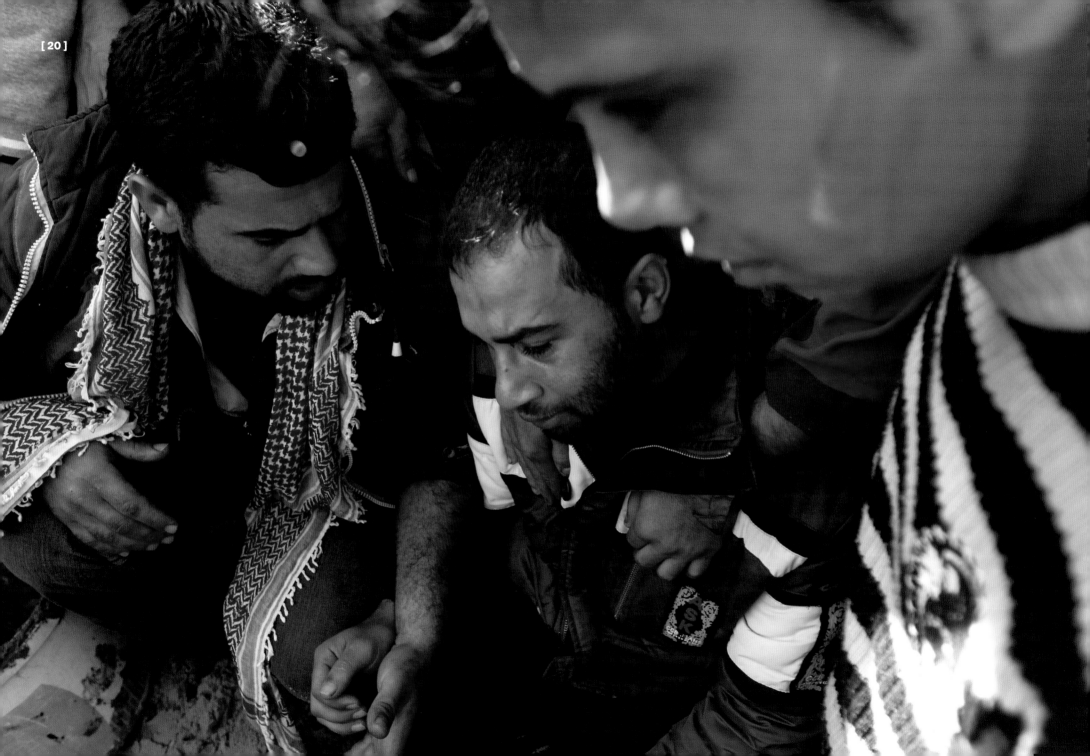

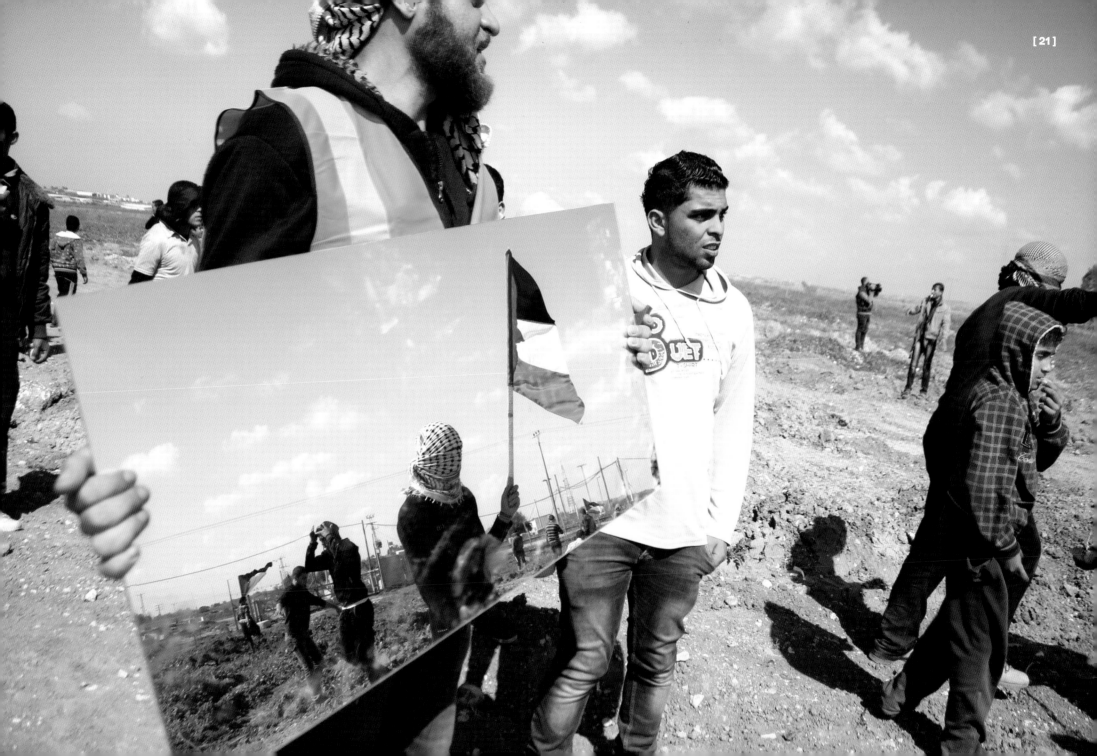

[22] **June 7, 2014, 3:40 p.m.** My thirteen-year-old sister, Leen al-Saftawi, stands on the rooftop of our house. When Leen was four years old, she accompanied me to visit our father in an Israeli prison. It was her first time meeting him. Her little hands gripped his fingers through the fence. Two years after this photo was taken, my uncles discovered that Leen had made a Facebook page and posted a photo of herself, so they broke into my family's house, took Leen's phone, and put her on house arrest. They moved Leen without her consent to my father's family's building, where for nearly two months she was humiliated and forbidden to leave, except to buy things from the shop down the block.

Following pages:

[23] **July 10, 2014, 9:39 a.m.** A shelled media vehicle sits on the street after an attack by an Israeli warplane. The bombing killed the driver, Hamed Shehab, who worked for the Gaza-based outlet Media 24. Eight others were injured. My brother and a friend were passing by on the night of the attack and were the first on the scene. They found Hamed's body torn apart by the missile. Some neighbors brought a mattress, and together they collected the body parts.

[24] **July 11, 2014, 2:49 p.m.** An ambulance carries an injured person to the al-Shifa Hospital in Gaza City during the Israeli attack on Gaza in July and August of 2014. The hospital reception area was in chaos the whole day. Hamas police shouted orders not to photograph injured women and certain injured men. The attack was known as Operation Protective Edge, and it lasted for fifty-one days. According to the UN, it killed 2,251 Palestinians, including 551 Palestinian children, sixty-seven Israeli soldiers, and six Israeli civilians.

[25] **July 12, 2014, 1:59 p.m.** Men and children gather at the site of an Israeli missile attack. The attack killed eight people—five of them members of the Izz ad-Din al-Qassam Brigades—and injured ten others. The men killed were seated just beyond this car, in front of their house in the Sheikh Radwan neighborhood, north of Gaza City. It was a direct hit; their bodies were torn to pieces. I arrived minutes after the attack, blood still fresh on the ground. The casualties were Rateb al-Saifi, twenty-two; Azmi Obaid, fifty-one; Nidal al-Malash, twenty-two; Suleiman Obaid, fifty-six; Ghassan al-Masri, twenty-five; Mustafa Inaya, fifty-eight; Mostafa Amer, twenty-nine; and Mohamed Salem, thirty.

[26] **July 12, 2014, 2:04 p.m.** A father cries fifteen minutes after his son and seven others were killed in the Israeli air strike mentioned in the caption above. Their blood pooled on the pavement meters from where he sat.

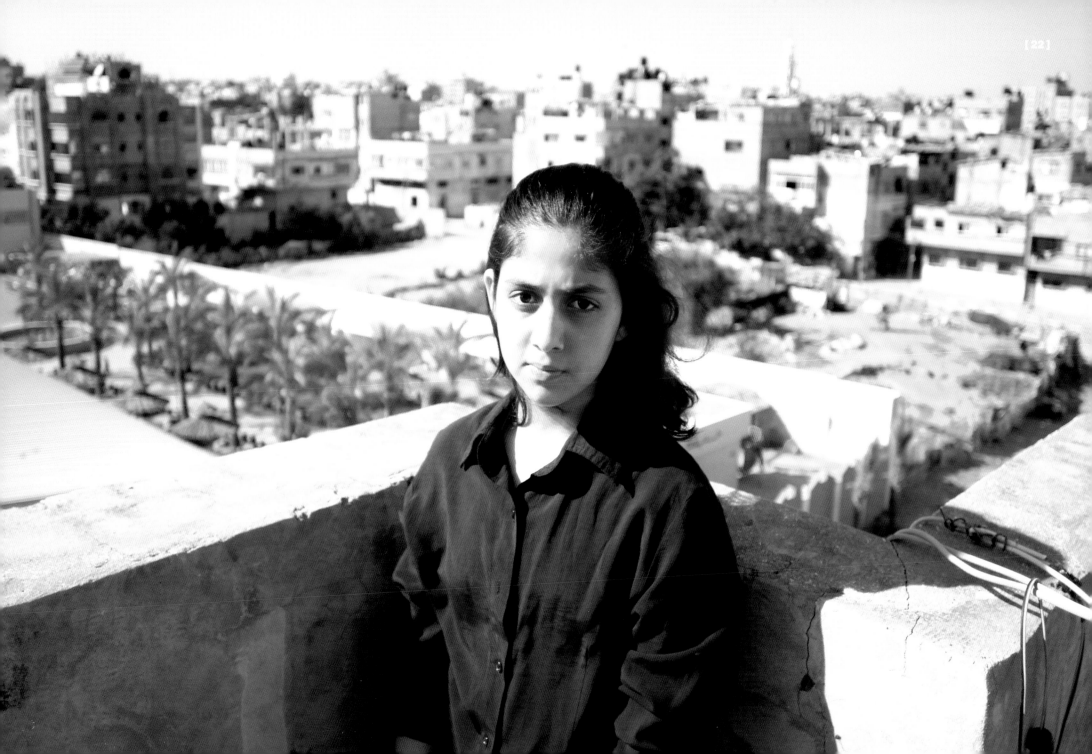

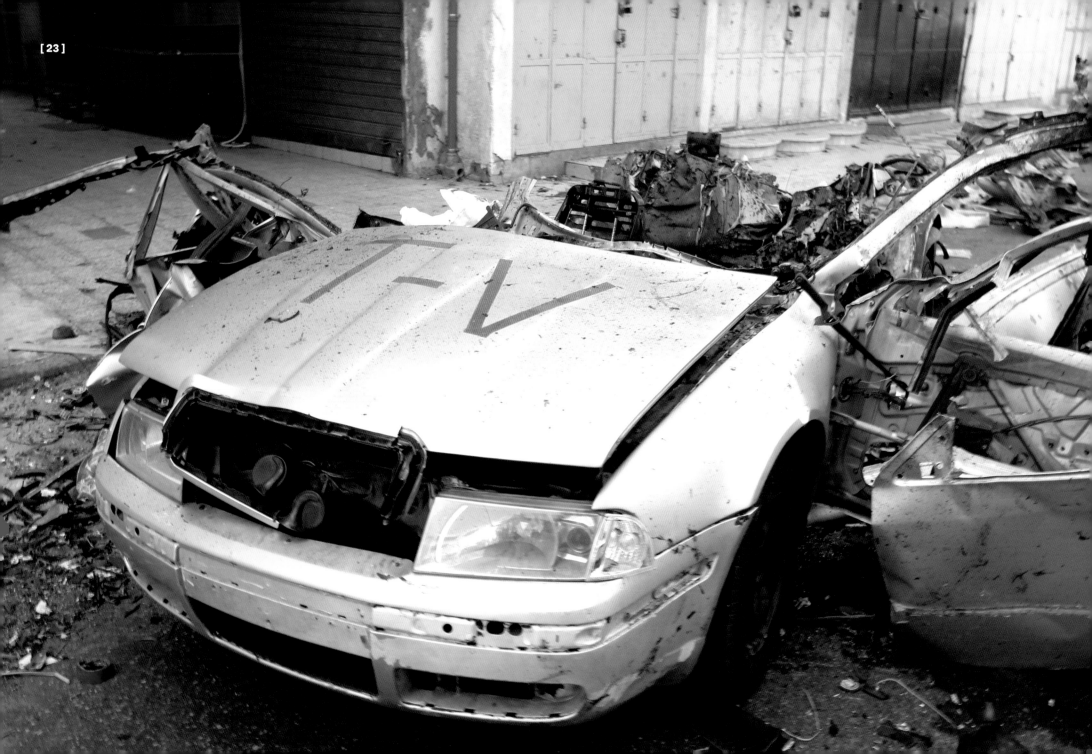

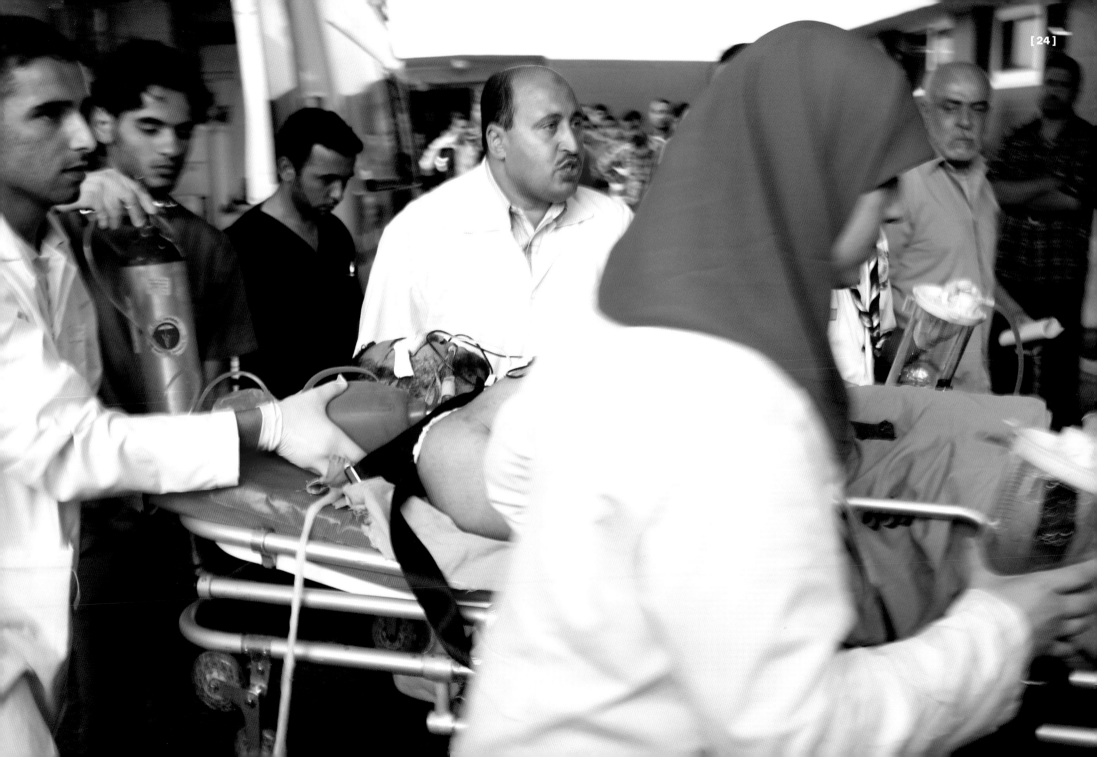

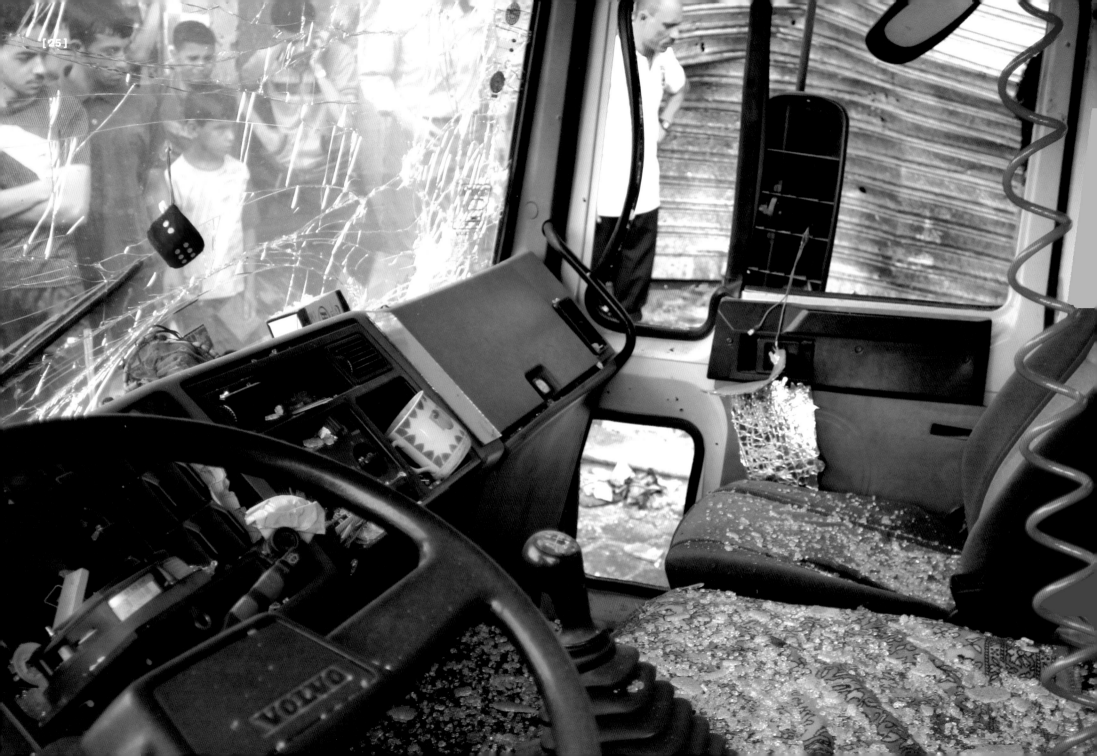

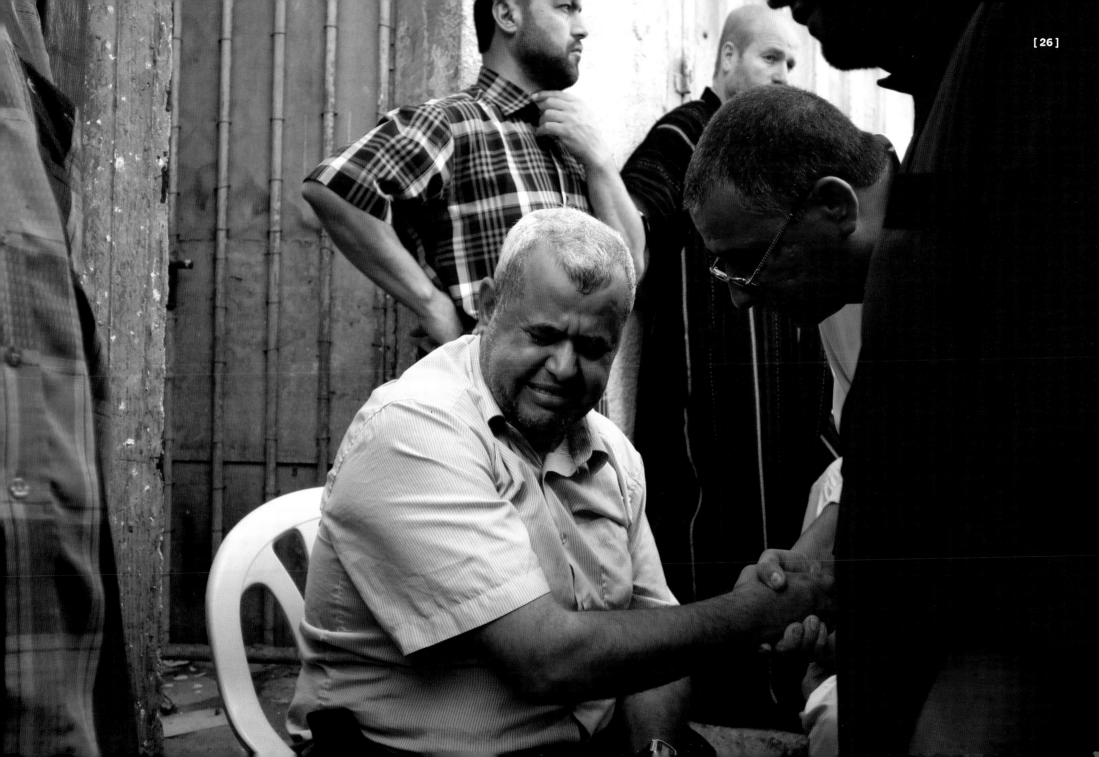

[27] **July, 11, 2014, 8:56 p.m.** A resident of Gaza City carries an injured person to the al-Shifa Hospital. Civilians played a key role in transporting the injured during Operation Protective Edge.

Following pages:

[28] **July 12, 2014, 8:12 p.m.** Palestinian rockets sail toward Israel. Various Palestinian militant groups headed by Hamas operate out of the Gaza Strip and use its residential neighborhoods to launch attacks on Israel. Hamas is designated as a terrorist organization by the United States, the European Union, Canada, the United Kingdom, New Zealand, Australia, and Japan, among other countries.

[29] **July 16, 2014, 12:33 p.m.** Residents of the al-Tofah neighborhood wait for the imminent bombardment of a targeted house after receiving a warning phone call from the Israeli army.

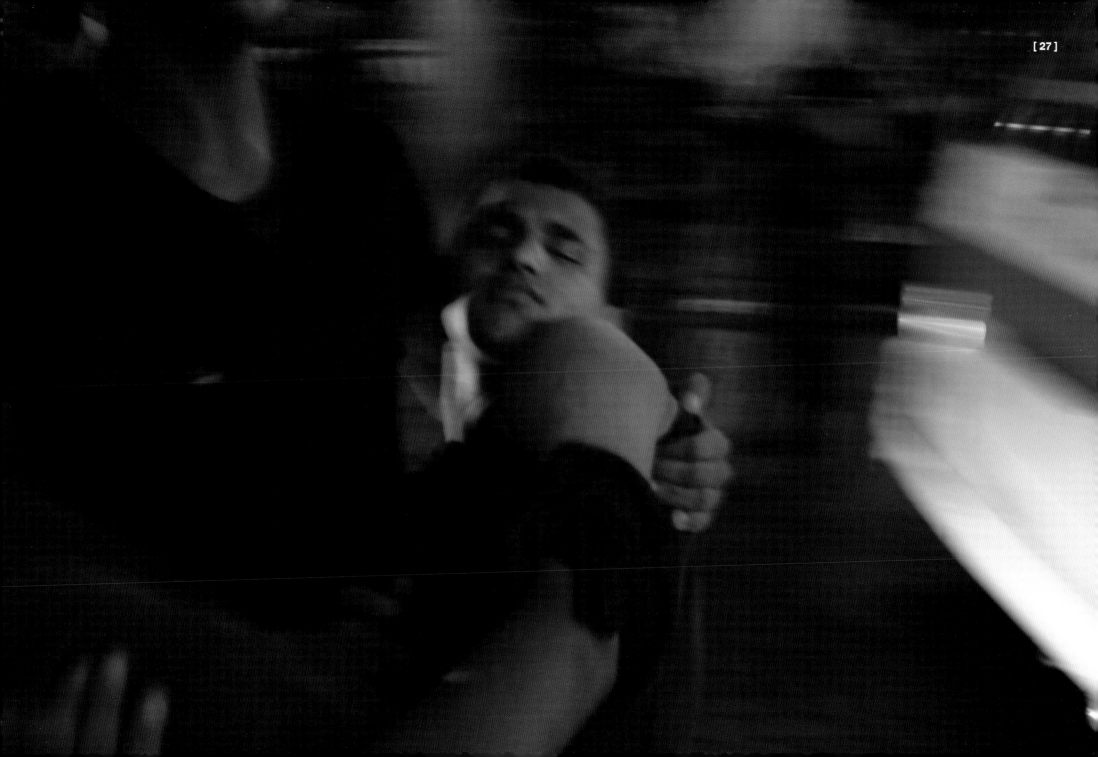

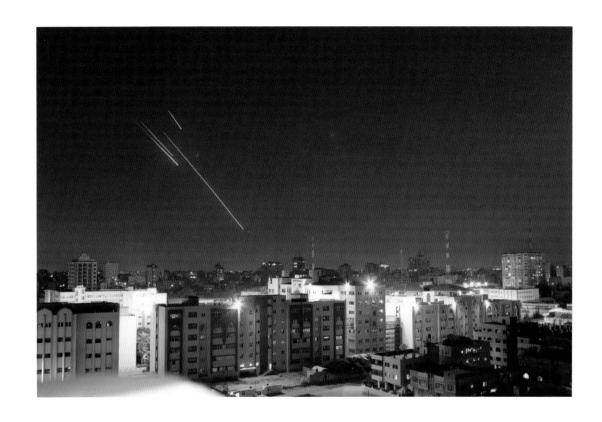

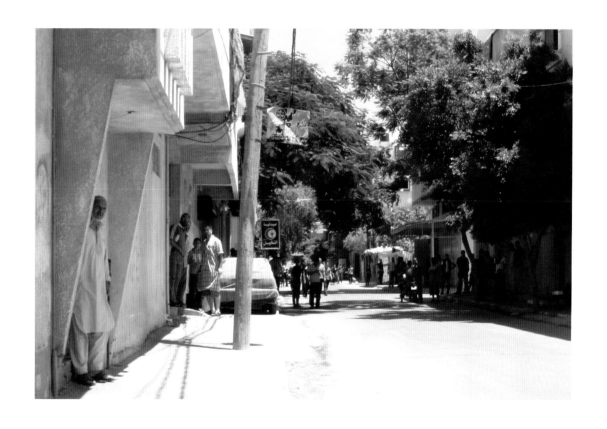

[30] July 16, 2014, 1:49 p.m. Civil defense workers and volunteers extinguish fires after Israeli warplanes shelled the Hashem family home. The family's women and children gathered outside while the men tried to recover valuables. Israel targets the homes of families who it claims are connected to armed factions within Gaza.

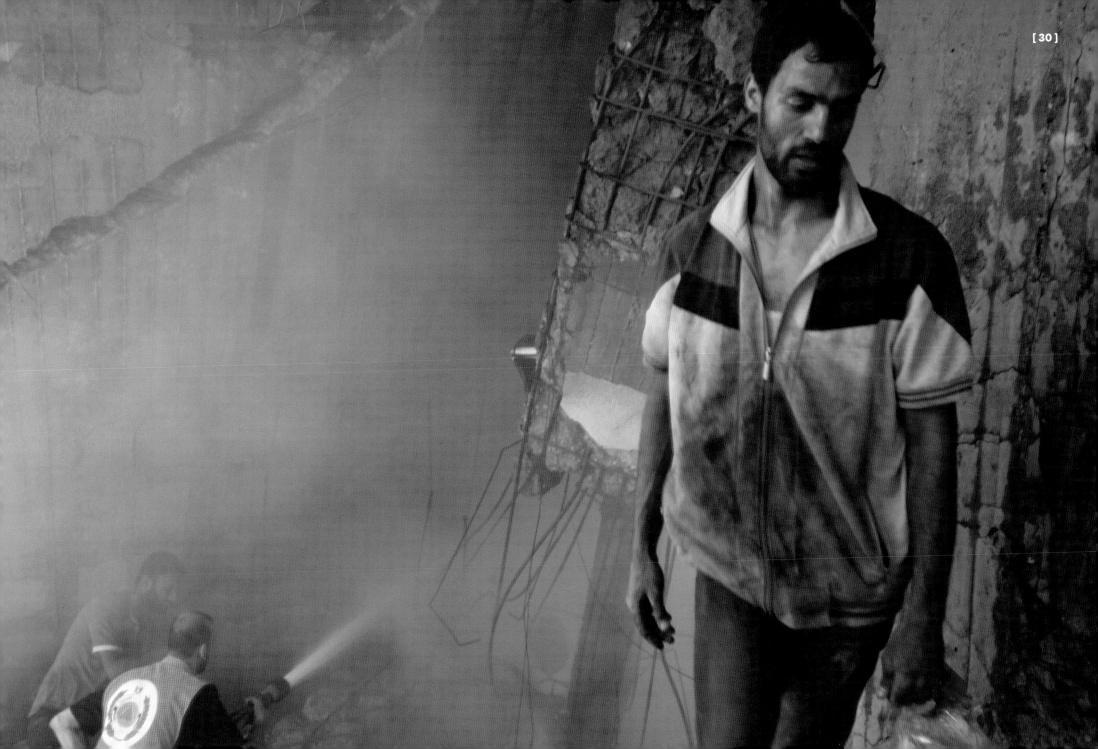

[31] <u>July 18, 2014, 1:43 a.m.</u> Light flares fall on the Shuja'iyya neighborhood, in eastern Gaza City, during an Israeli warplane bombing.

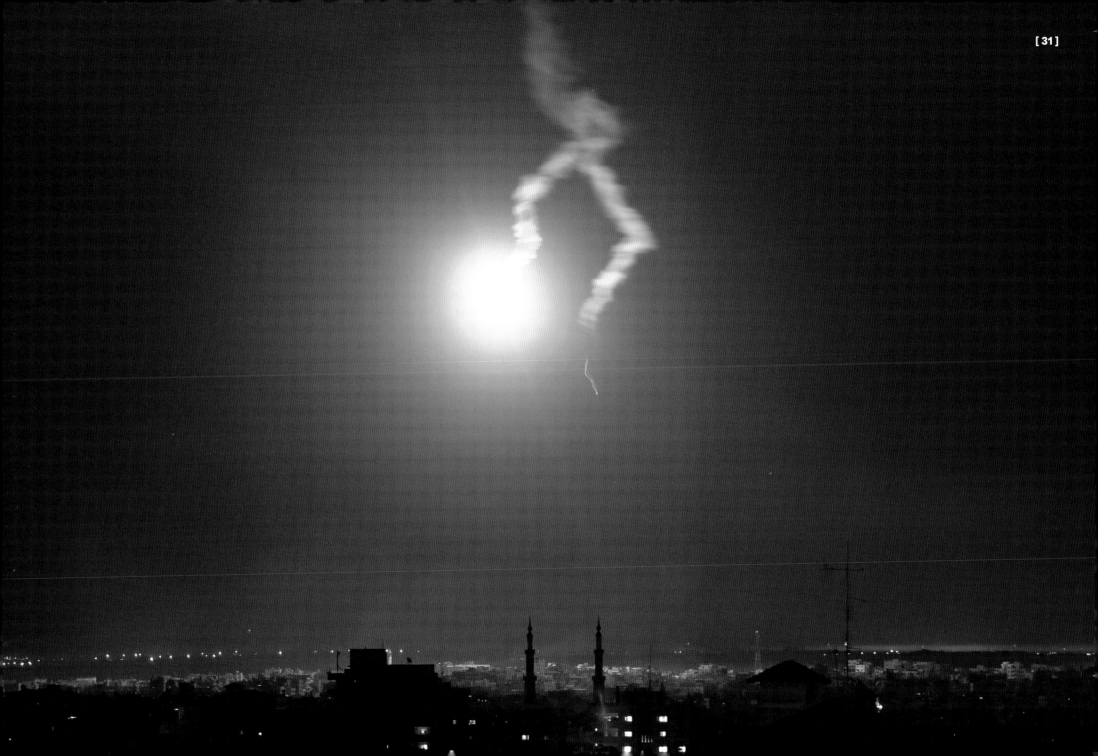

[32] **July 23, 2014, 12:04 p.m.** Smoke fills the sky as intensive air strikes rain down on Shuja'iyya. I took this picture from the window of my eleventh-story apartment in Gaza City. My wife, Lara, and I started a live stream during the fifty-one days of Operation Protective Edge, in an attempt to show what we hadn't been able to during previous conflicts in our city.

Following pages:

[33] **July 26, 2014, 7:55 a.m.** Gazans survey Shuja'iyya during the first hour of a ceasefire between Hamas and the Israeli army. Israeli bombardments had targeted large swaths of the neighborhood, leaving tens of thousands homeless.

[34] **July 26, 2014, 8:59 a.m.** Residents of Shuja'iyya carry what they can from their destroyed homes. Though the July 26 truce lasted only twelve hours, people continued to evacuate the injured and the dead for two days.

Sixty-seven bodies were found in this neighborhood alone in that time—including those of seventeen children, fourteen women, and four elderly people—and hundreds were wounded.

[35] **July 26, 2014, 9:06 a.m.** Shuja'iyya residents venture to the farthest point they can access in their neighborhood. Israeli tanks were stationed a few blocks away. From this spot, one could hear the tanks' engines as well as the Israeli drones overhead, surveying the area.

[36] **July 26, 2014, 9:09 a.m.** Violence on the day of the July 26 ceasefire was not limited to Shuja'iyya, pictured here. Moments before the truce began, an Israeli strike in Khan Younis, a city on the other side of the strip, killed twenty-one members of the al-Najjar family. Many of the family members killed were seeking refuge in Khan Younis after fleeing violence in another village.

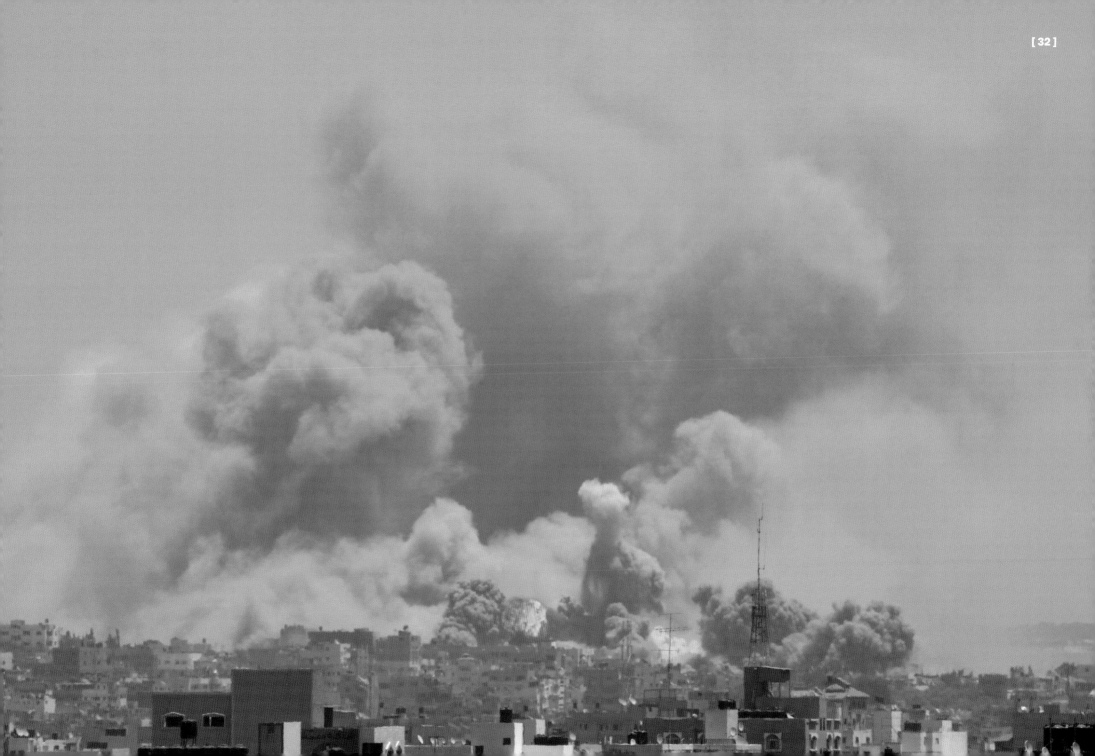

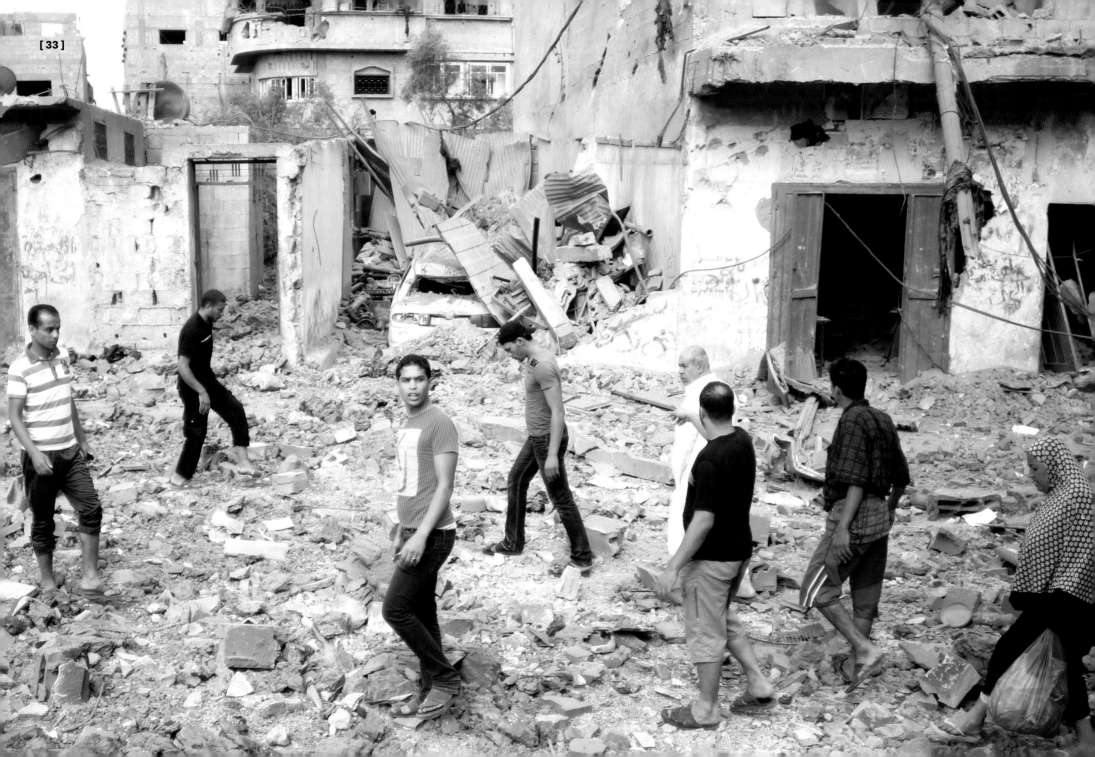

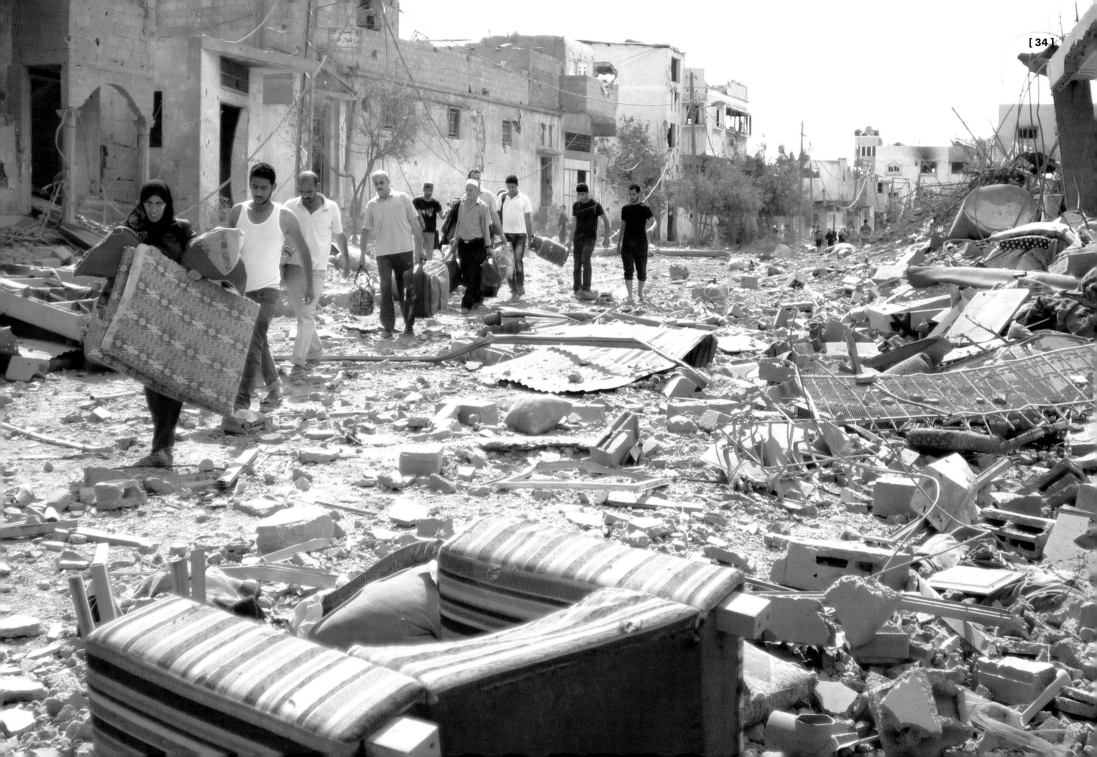

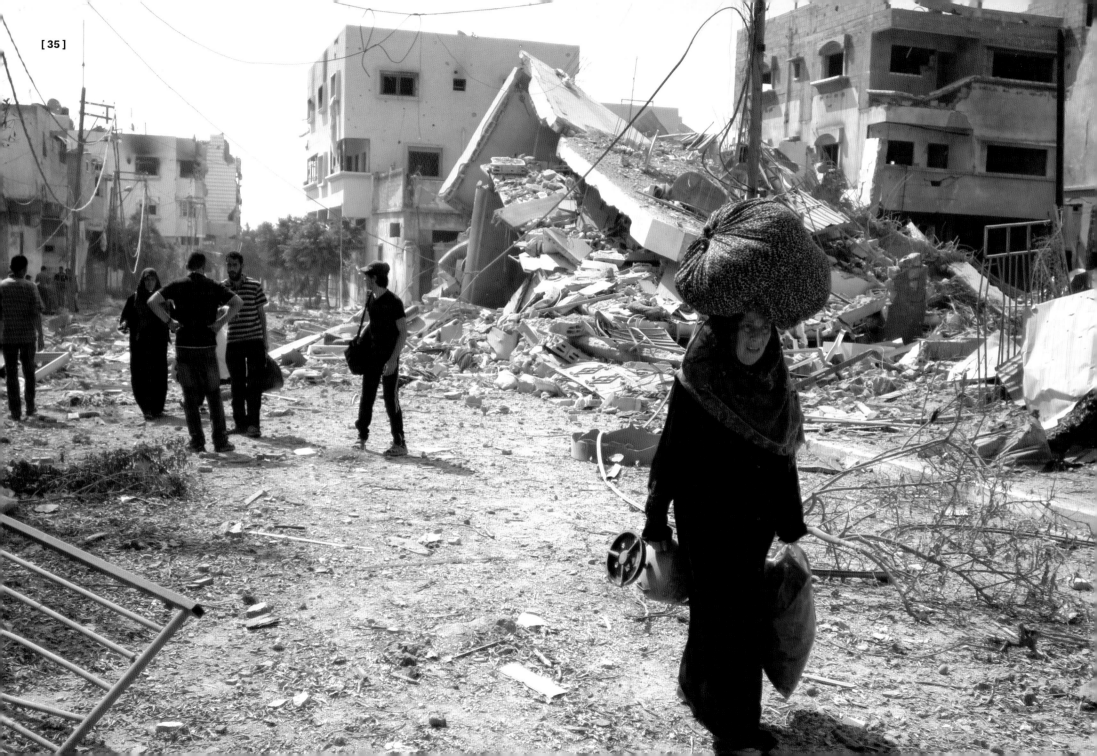

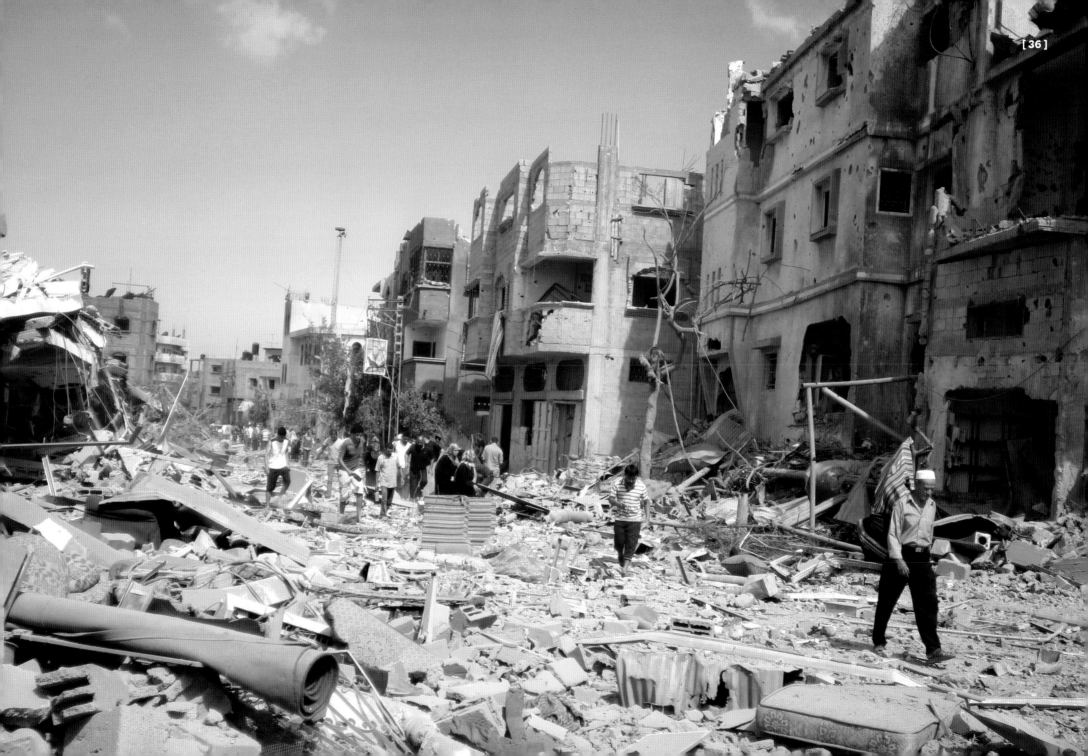

[37] **July 26, 2014, 7:52 a.m.** Residents of Shuja'iyya return to their neighborhood during the July 26 ceasefire between Hamas and the Israeli army.

Following pages:

[38] **July 26, 2014, 9:15 a.m.** A man surveys the remains of his house in Shuja'iyya during the July 26 ceasefire.

[39] **July 26, 2014, 9:21 a.m.** A mosque in Shuja'iyya is left partly destroyed after an Israeli attack. Hamas uses mosques as headquarters to mobilize people and gain ground control.

[40] **July 26, 2014, 9:34 a.m.** In a moment of uncertainty, residents of Shuja'iyya carry what can be salvaged from their evacuated neighborhood during the July 26 ceasefire. The previous day, Israel rejected a weeklong truce proposed by US secretary of state John Kerry. Instead, a twelve-hour truce was approved, starting at 8 a.m. the day this photo was taken.

[41] **July 27, 2014, 1:02 p.m.** An Israeli air strike hits the al-Muntada police compound, in western Gaza City. I took this photo from my apartment. My wife and I witnessed dozens of air strikes each day during Operation Protective Edge.

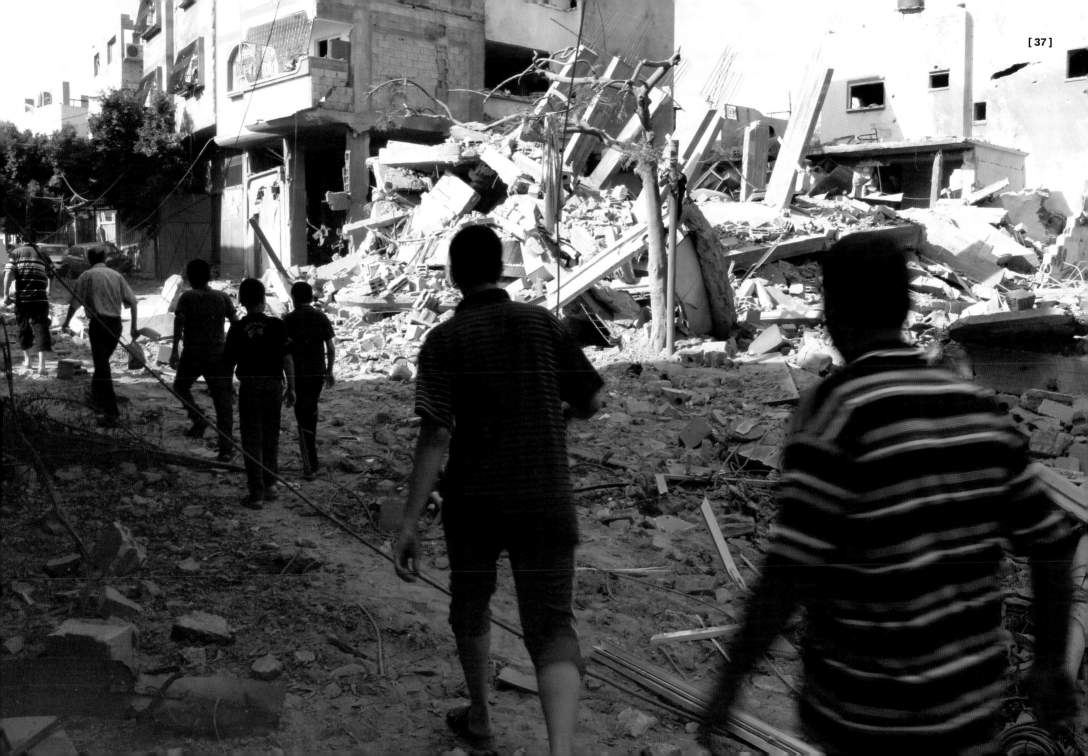

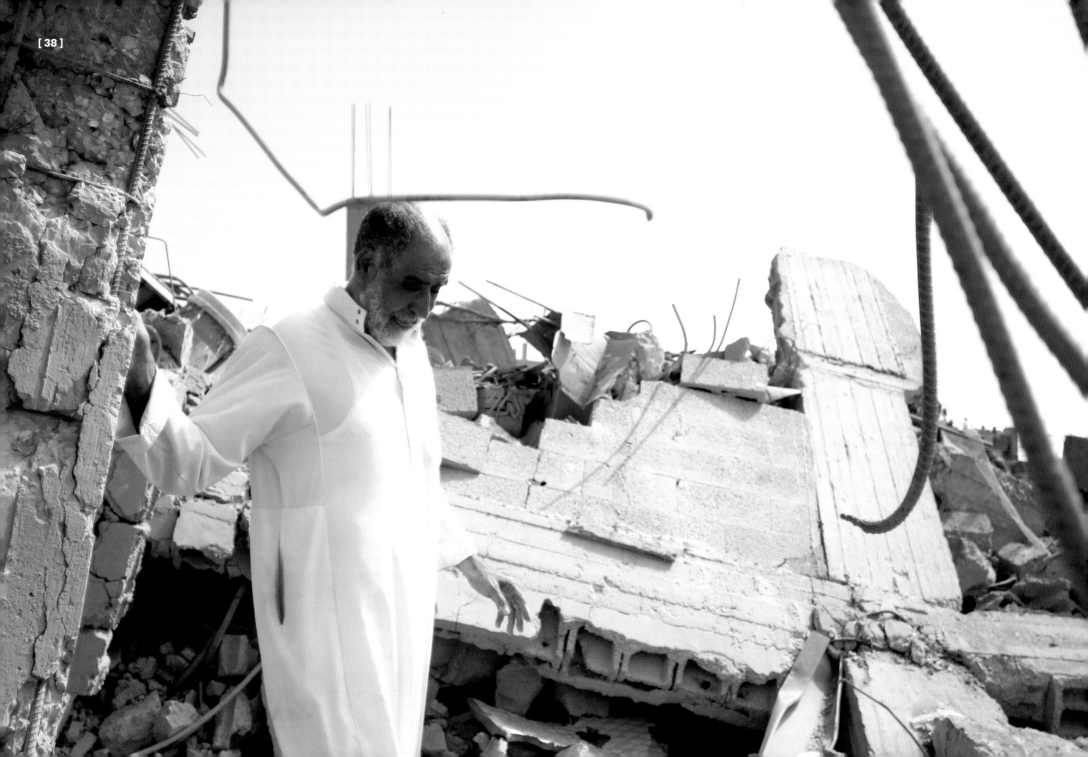

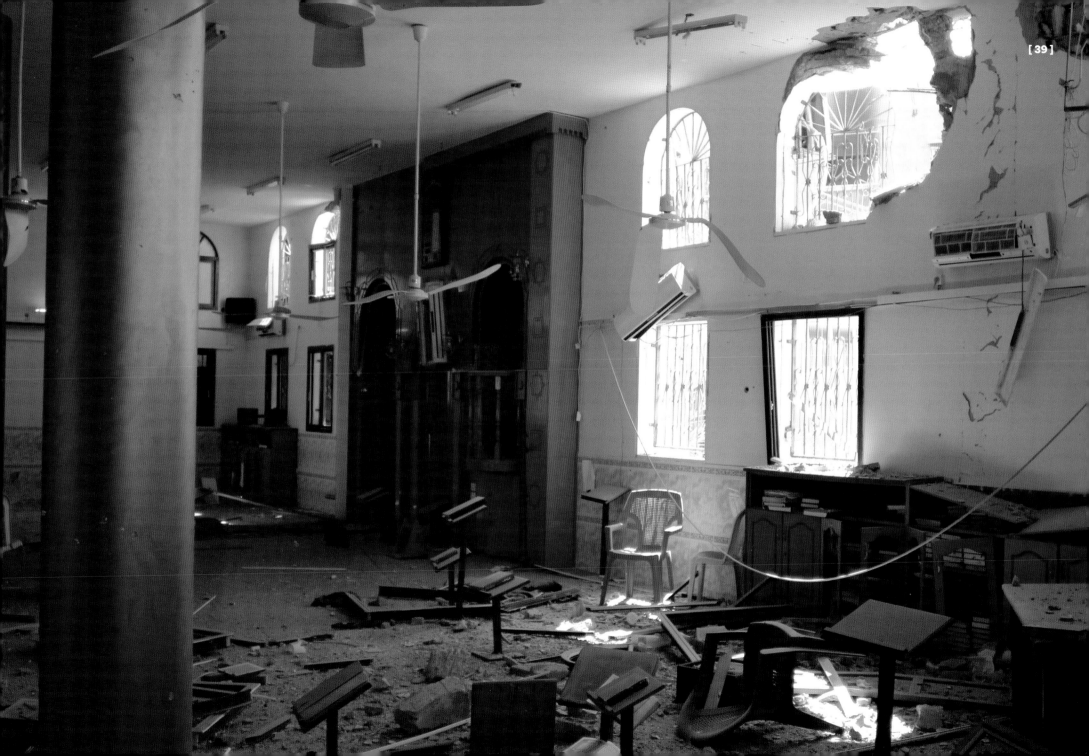

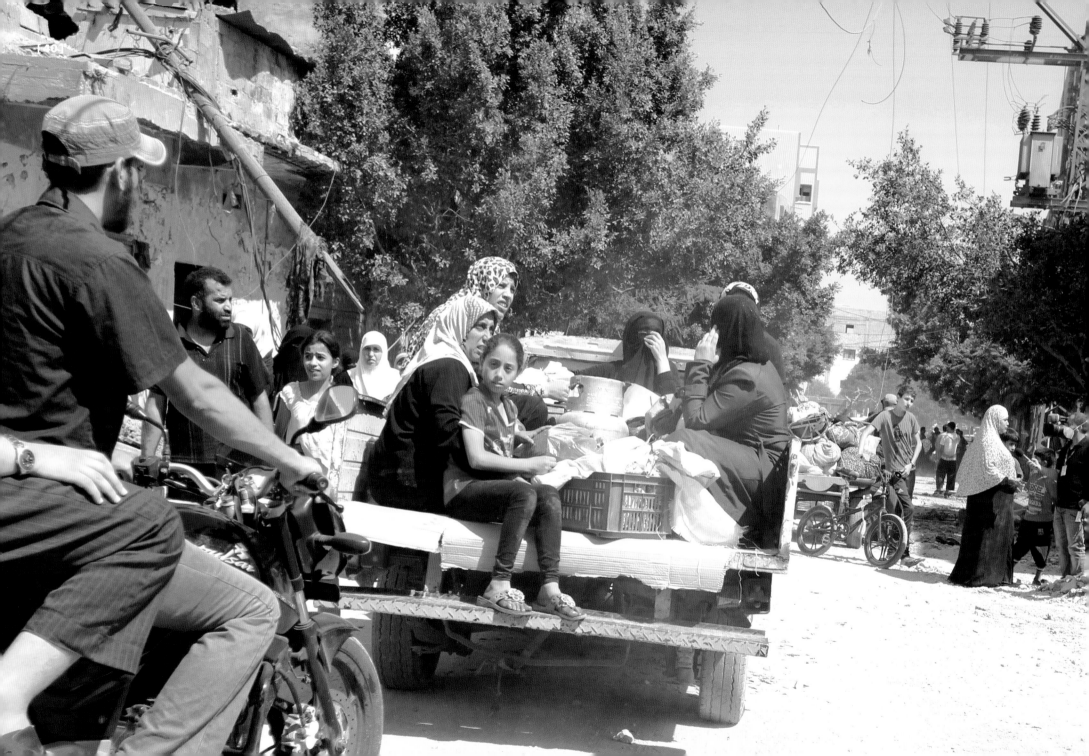

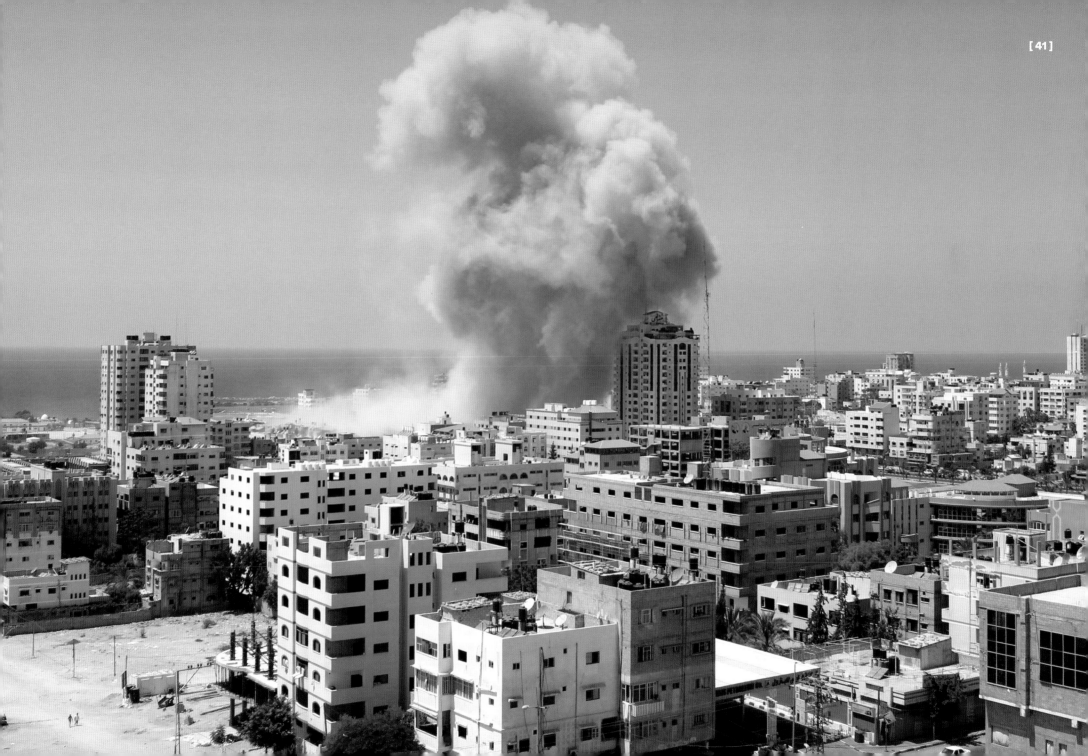

[42] **July 29, 2014, 2:11 a.m.** Israeli flares light up the sky behind my wife, Lara, as she stands on the balcony of our apartment during Operation Protective Edge.

Following pages:

[43] **August 1, 2014, 9:13 a.m.** An unexploded Israeli shell remains lodged in the street as residents of Shuja'iyya return home during a ceasefire. The truce collapsed an hour or two after it began, when a firefight broke out between a group of Israeli soldiers and Hamas fighters. One Palestinian fighter and two Israeli soldiers were killed, and a third Israeli soldier, Hadar Goldin, was abducted into Gaza's tunnels. The ensuing four days of heavy artillery shelling and bombing, beginning in Rafah and extending throughout the rest of the strip, killed and injured hundreds of Gazans, and destroyed or damaged hundreds of buildings.

[44] **August 1, 2014, 10:07 a.m.** Residents of Shuja'iyya rush to retrieve their belongings shortly before the truce collapses. Soon after this photo was taken, people ran for safety as Israeli soldiers opened fire, preventing many who lived on the eastern outskirts of the neighborhood from reaching their homes.

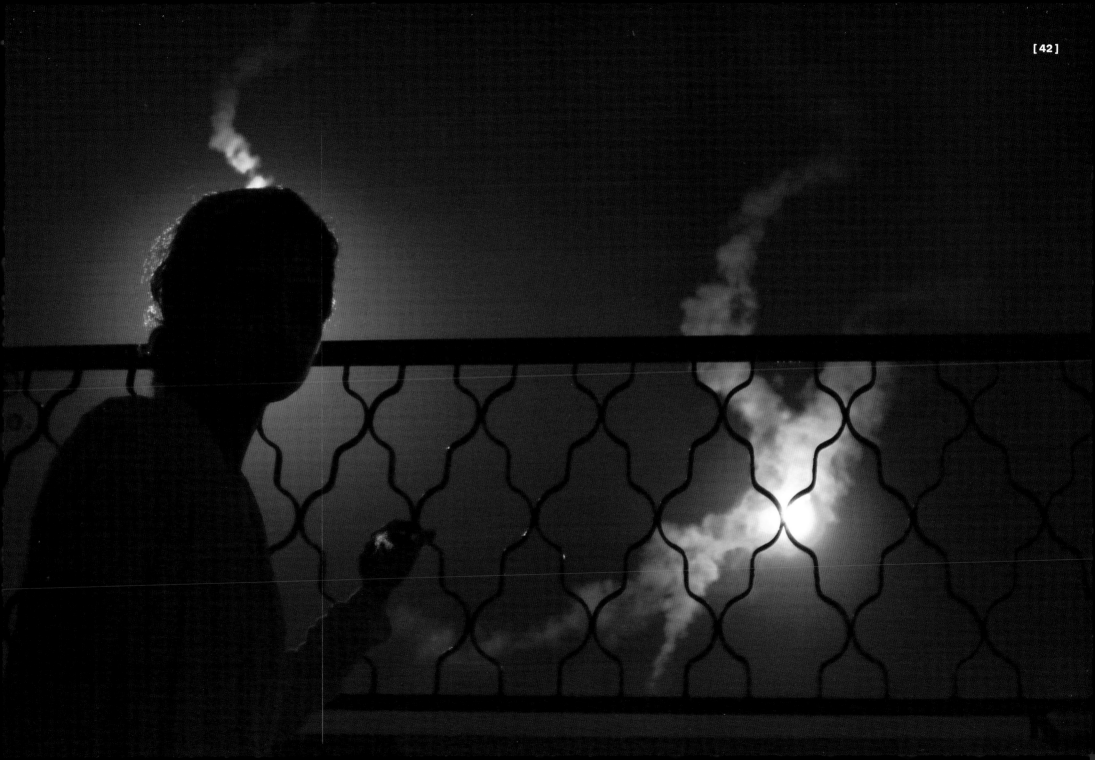

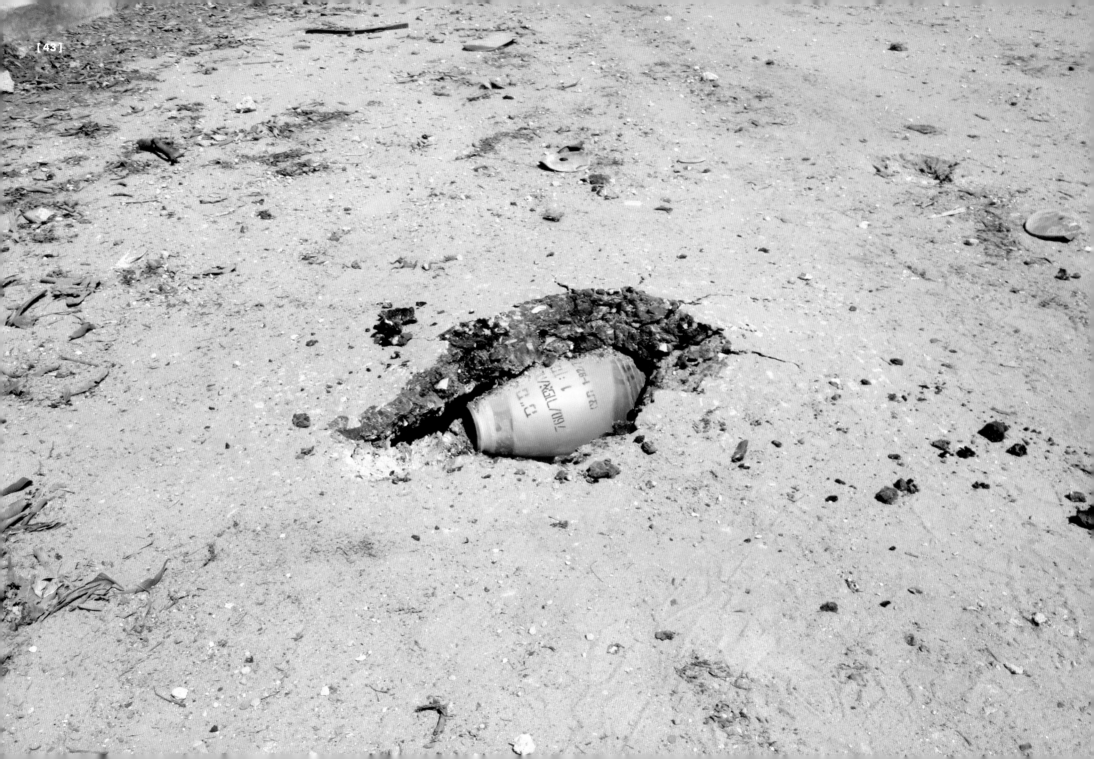

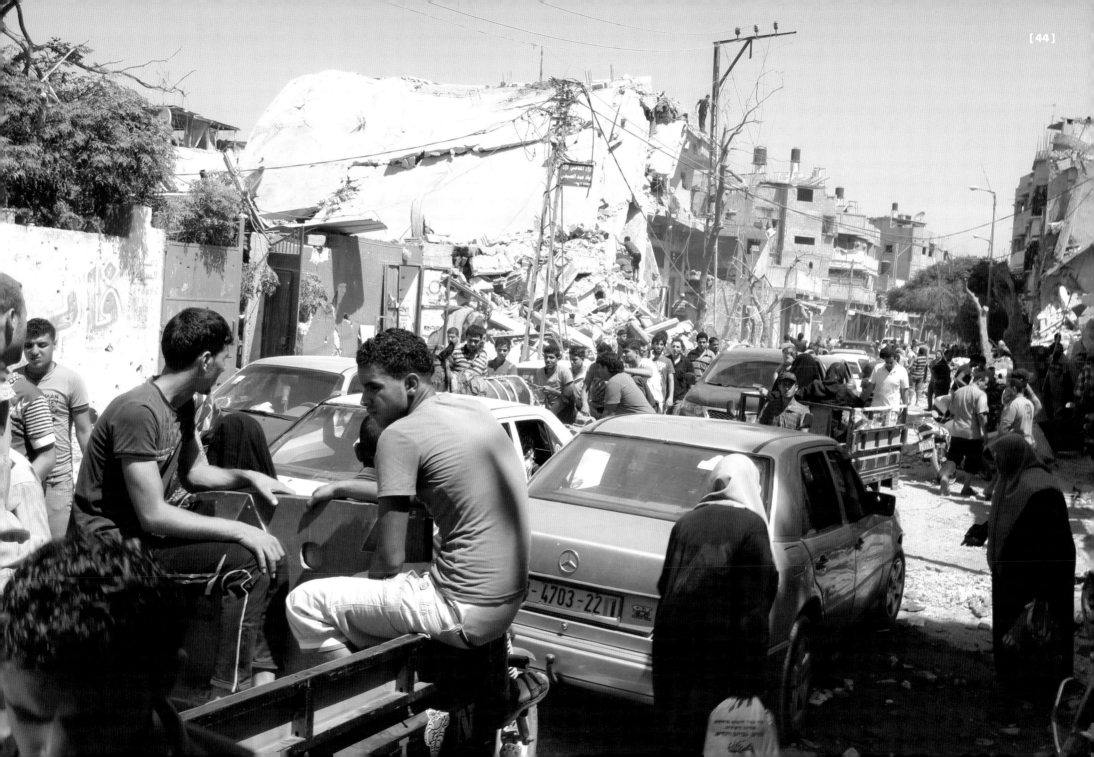

[45] **August 2, 2014, 5:27 p.m.** A displaced man shows me the shelter he made for his wife and their two children. His brother and his brother's family were living next to this man's family in a similar tent after fleeing the bombing in Shuja'iyya.

Following pages:

[46] **August 2, 2014, 5:45 p.m.** Fifty-two-year-old Sabah Qtati and her son sit in a hallway of the al-Shifa Hospital, where they took refuge after evacuating their home in Shuja'iyya. Thousands of displaced Gazans have taken to squares, parks, and hospitals.

[47] **August 5, 2014, 4:33 p.m.** A young man pauses for a picture in front of his nearly destroyed home in Shuja'iyya. The ruins of the al-Wafa Hospital are across the street.

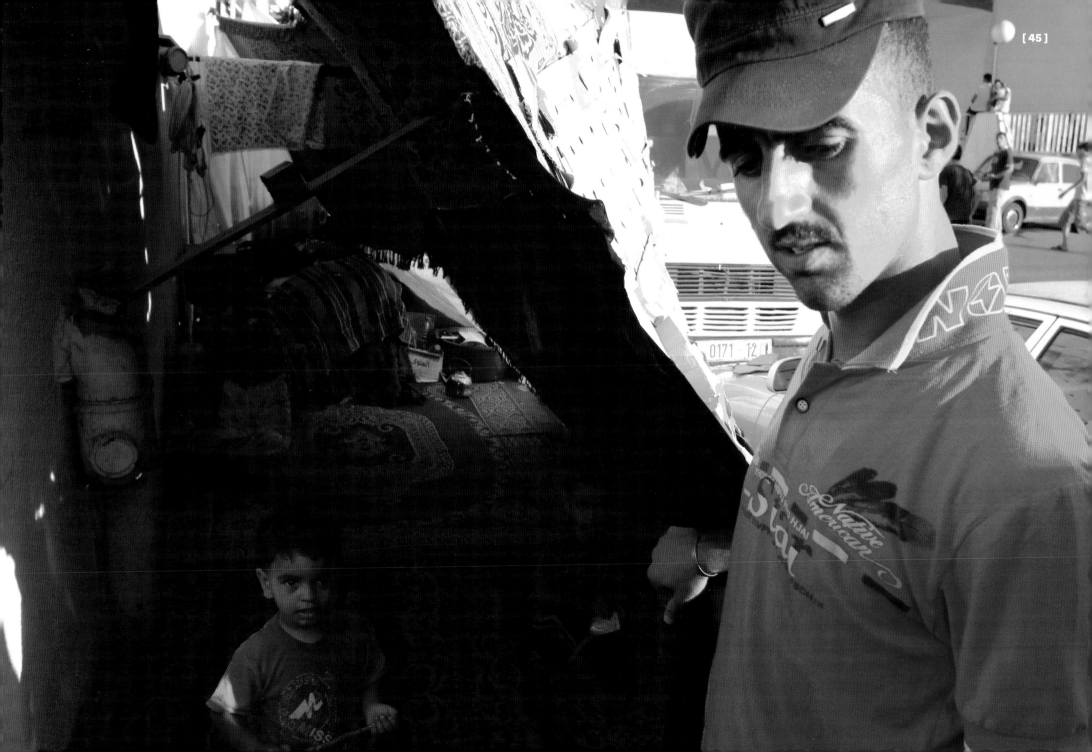

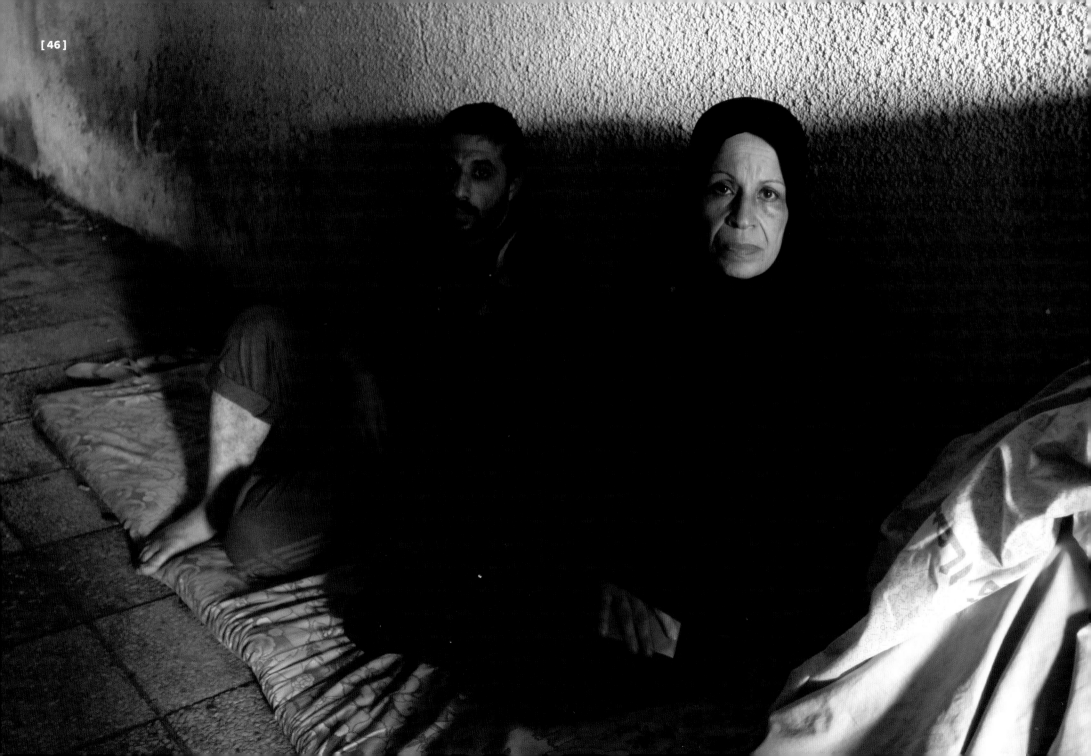

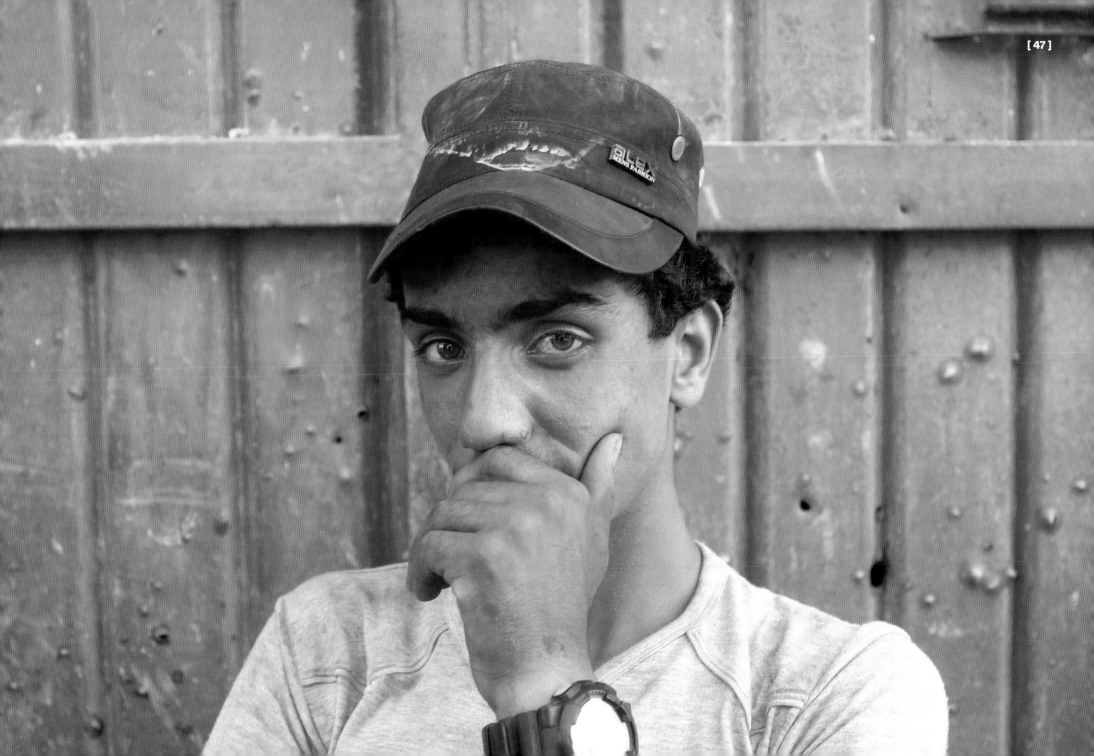

[48] **August 4, 2014, 4:02 p.m.** Salah Salameen rests in the schoolyard of a UN agency school, where he was injured by shrapnel in an Israeli air strike. More than twenty-five people were injured and fourteen were killed in the attack. The casualties included a UN employee and eight children who had sought shelter at the school, which hosted over 2,900 refugees.

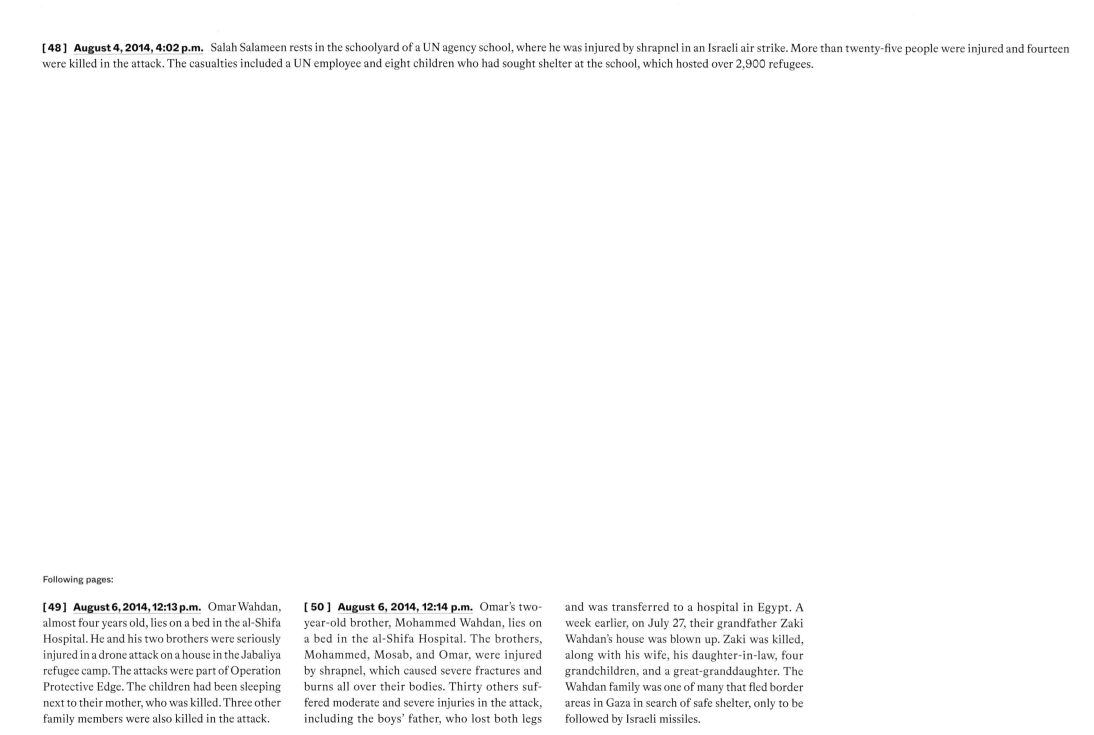

Following pages:

[49] **August 6, 2014, 12:13 p.m.** Omar Wahdan, almost four years old, lies on a bed in the al-Shifa Hospital. He and his two brothers were seriously injured in a drone attack on a house in the Jabaliya refugee camp. The attacks were part of Operation Protective Edge. The children had been sleeping next to their mother, who was killed. Three other family members were also killed in the attack.

[50] **August 6, 2014, 12:14 p.m.** Omar's two-year-old brother, Mohammed Wahdan, lies on a bed in the al-Shifa Hospital. The brothers, Mohammed, Mosab, and Omar, were injured by shrapnel, which caused severe fractures and burns all over their bodies. Thirty others suffered moderate and severe injuries in the attack, including the boys' father, who lost both legs and was transferred to a hospital in Egypt. A week earlier, on July 27, their grandfather Zaki Wahdan's house was blown up. Zaki was killed, along with his wife, his daughter-in-law, four grandchildren, and a great-granddaughter. The Wahdan family was one of many that fled border areas in Gaza in search of safe shelter, only to be followed by Israeli missiles.

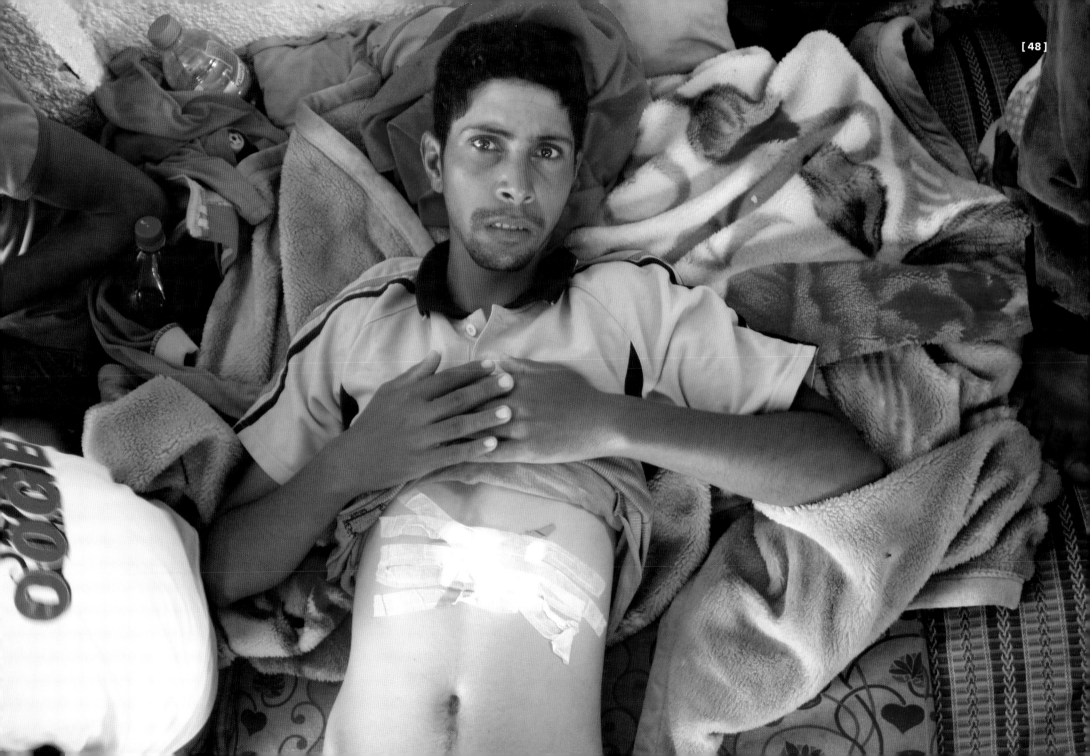

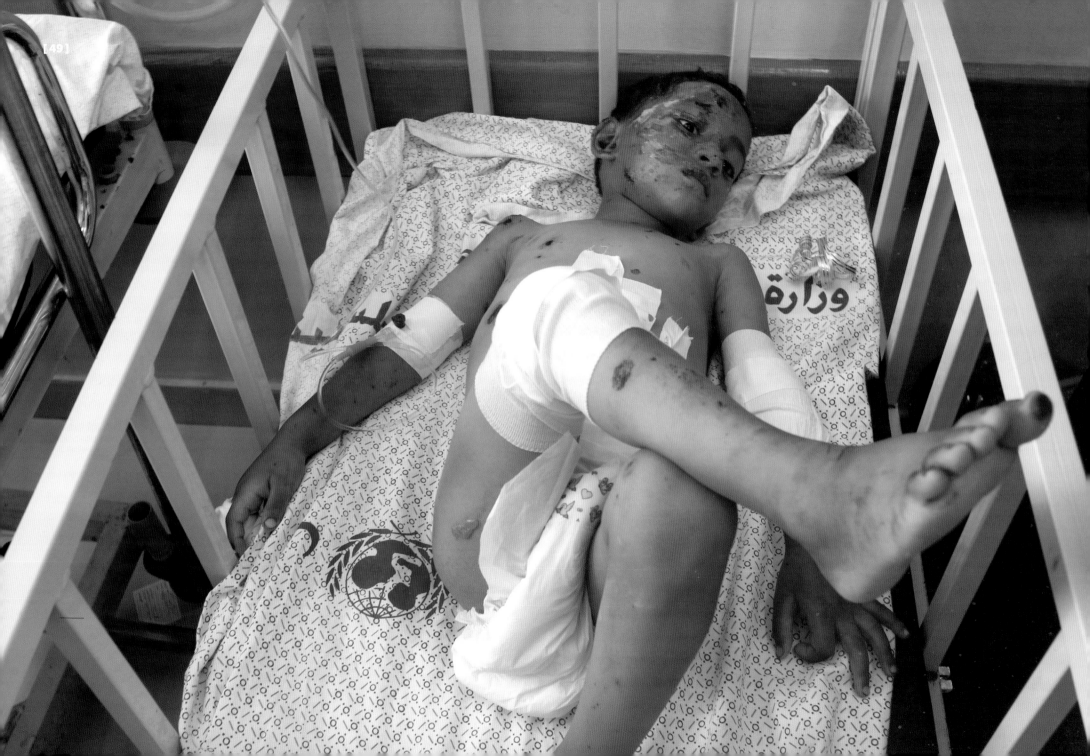

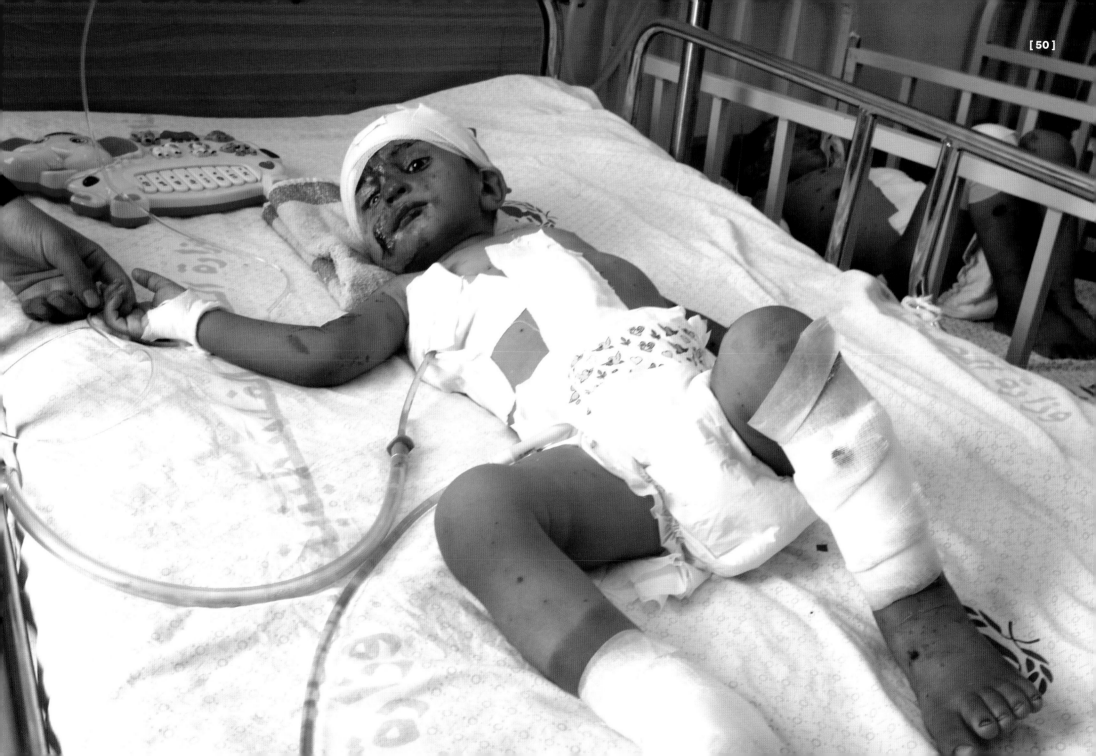

[51] **August 22, 2014, 9:56 a.m.** The minaret of the al-Soussi mosque remains lodged in a house in the Beach refugee camp after being targeted by Israeli warplanes. Israel struck the mosque with three drone missiles as an evacuation warning to the mosque's neighbors. Ramez Radwan, the owner of the building the minaret fell on, said there were only seven minutes between the warning and the bombing.

Following pages:

[52] **August 24, 2014, 10:25 a.m.** Residents of the destroyed al-Zafer apartment building collect what remains of their belongings the morning after an Israeli air strike. Twenty-two residents of the tower and neighboring buildings were wounded in the bombardment. The thirteen-story structure in Gaza City had forty-four apartments and was located across the street from the building where my wife and I lived. We were both away from home when a resident of our building received a warning call to evacuate. We couldn't sleep in the apartment for the next three nights out of fear that our building would be targeted next.

[53] **September 5, 2014, 12:42 p.m.** The destroyed al-Nada apartments sit empty after residents fled Israeli attacks. The buildings made up a complex that faced the Erez Crossing, in the far north of the Gaza Strip. They were home to about 400 Palestinian families. This area is close to the Israeli border and was one of the first to be targeted when the Israeli army launched Operation Protective Edge.

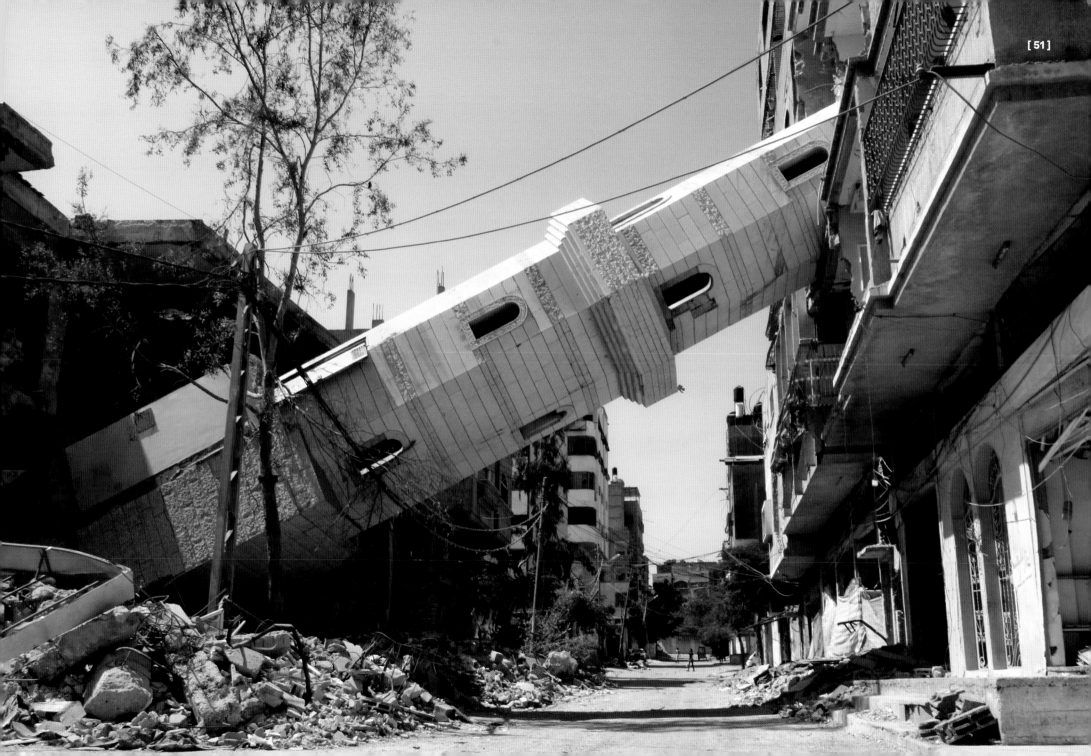

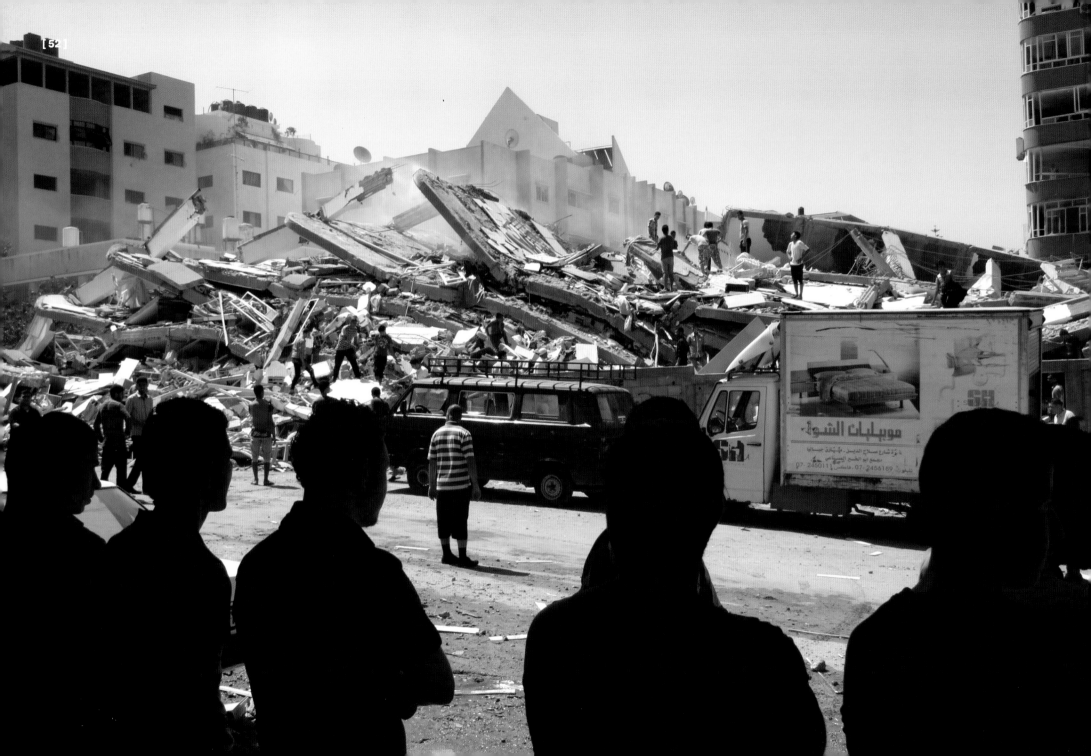

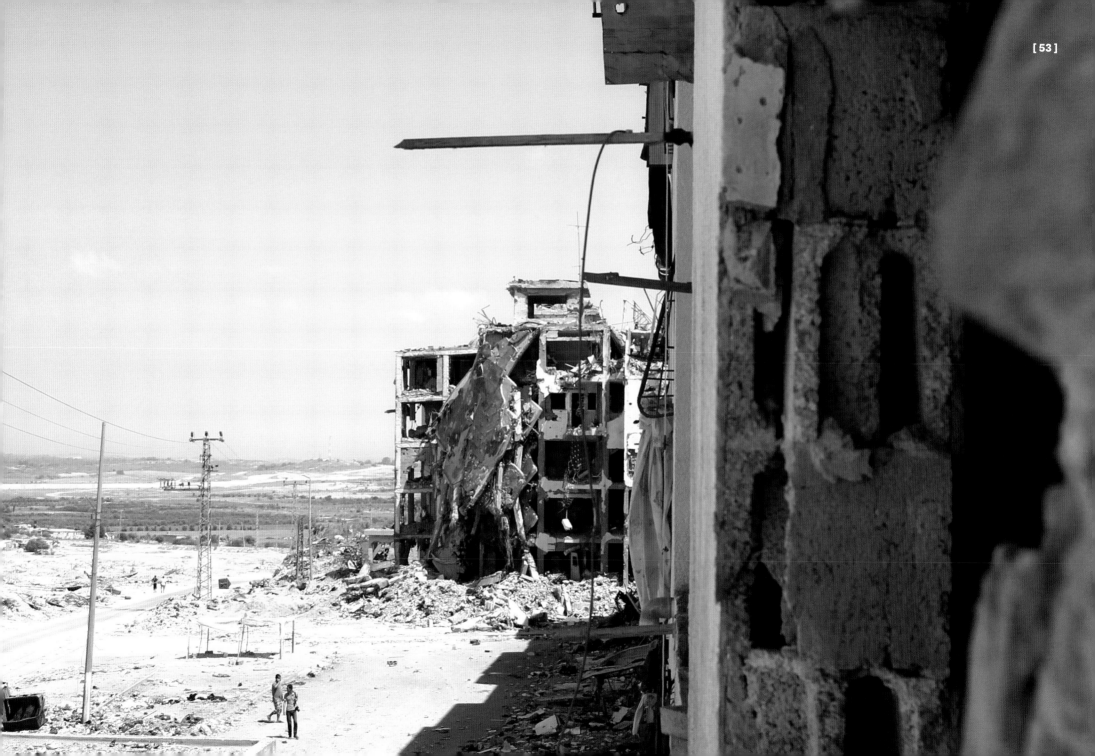

[54] **September 30, 2014, 3:13 p.m.** Forty-four-year-old farmer Shehda al-Najjar shows a picture of his face from when he was shot in the jaw and arm with exploding bullets by an Israeli soldier. When the Israeli army invaded Khuza'a, a village in the southeastern Gaza Strip, they told Shehda to take his clothes off. The Israeli soldiers ordered Shehda's family members to come out of their house one by one. Shehda hadn't been able to evacuate Khuza'a before the Israeli invasion because he was under house arrest by Hamas militants, who suspected him of being anti-Hamas. He said, "If I hadn't been shot by Israeli soldiers, [Izz ad-Din al-Qassam militants] would have called me a spy and shot me in the middle of downtown."

Following pages:

[55] **September 30, 2014, 4:45 p.m.** Children sit in front of their destroyed house in Khuza'a. The Israeli army heavily bombed Khuza'a before invading the area.

[56] **October 14, 2014, 2:55 p.m.** A neighborhood in Khuza'a reels in the aftermath of Operation Protective Edge. Dr. Kamal Abu Rujaila once operated a clinic out of his house on the next block. Many people in and around the clinic were killed when it was hit by repeated Israeli air strikes in July 2014. Among the dead were women and children, as well as the doctor's brother. Dozens of injured Khuza'a residents had received urgent treatment at the clinic while their village was deemed a closed military zone by the Israeli army earlier that summer.

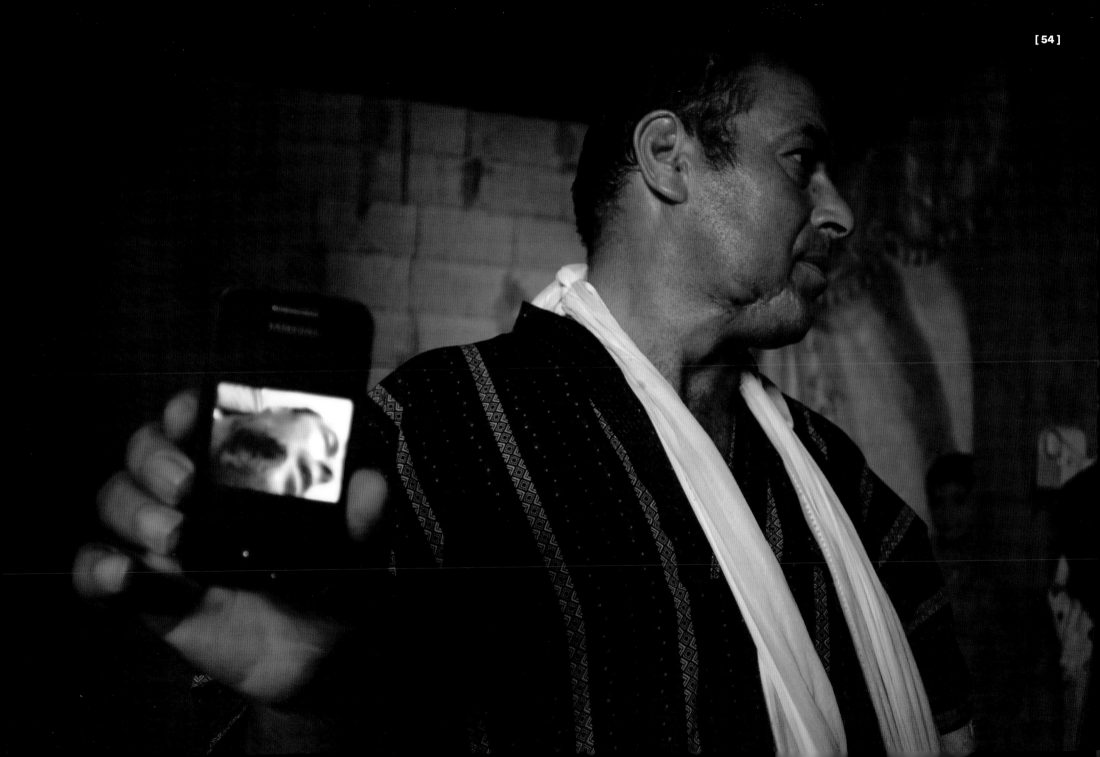

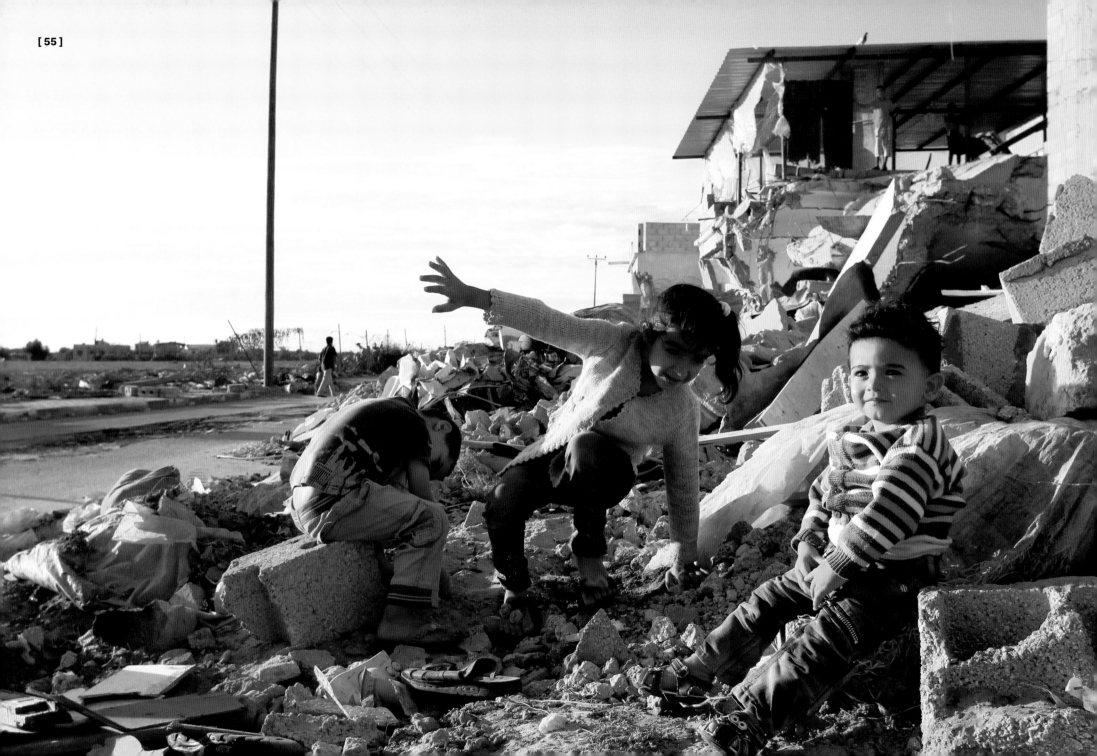

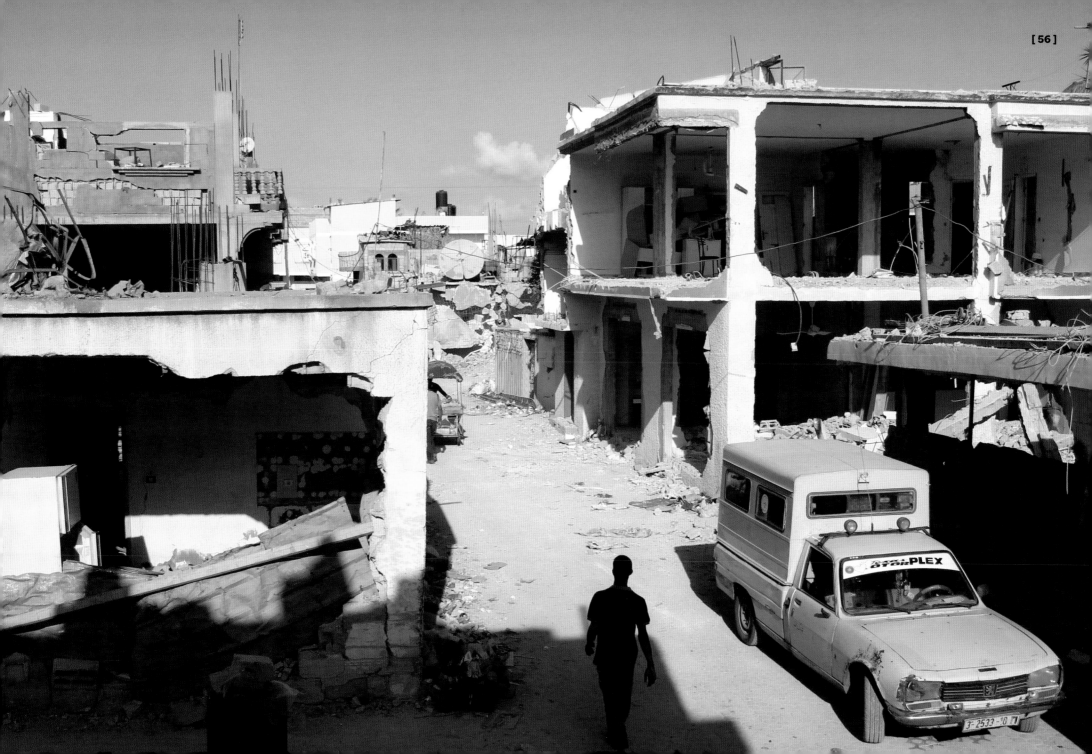

[57] **October 14, 2014, 3:17 p.m.** A child bikes past a door in Khuza'a that once led to a home full of life. The home was destroyed in Operation Protective Edge. The magnitude of destruction in the village of Khuza'a is shocking. More than 550 houses were destroyed, and 900 more were left uninhabitable. Six mosques were destroyed and three were severely damaged.

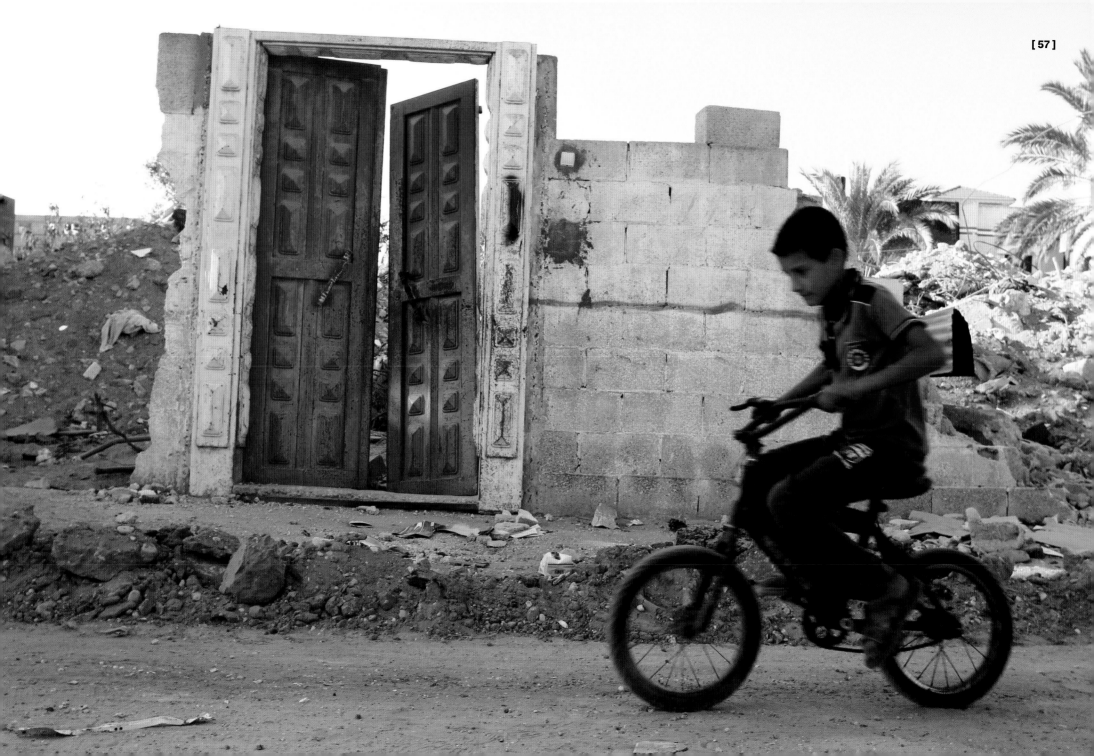

[58] **November 6, 2014, 3:09 p.m.** A bombed-out classroom sits empty in the Jamal Abdul Nasser School in Shuja'iyya. Large parts of the school were turned to rubble during Operation Protective Edge.

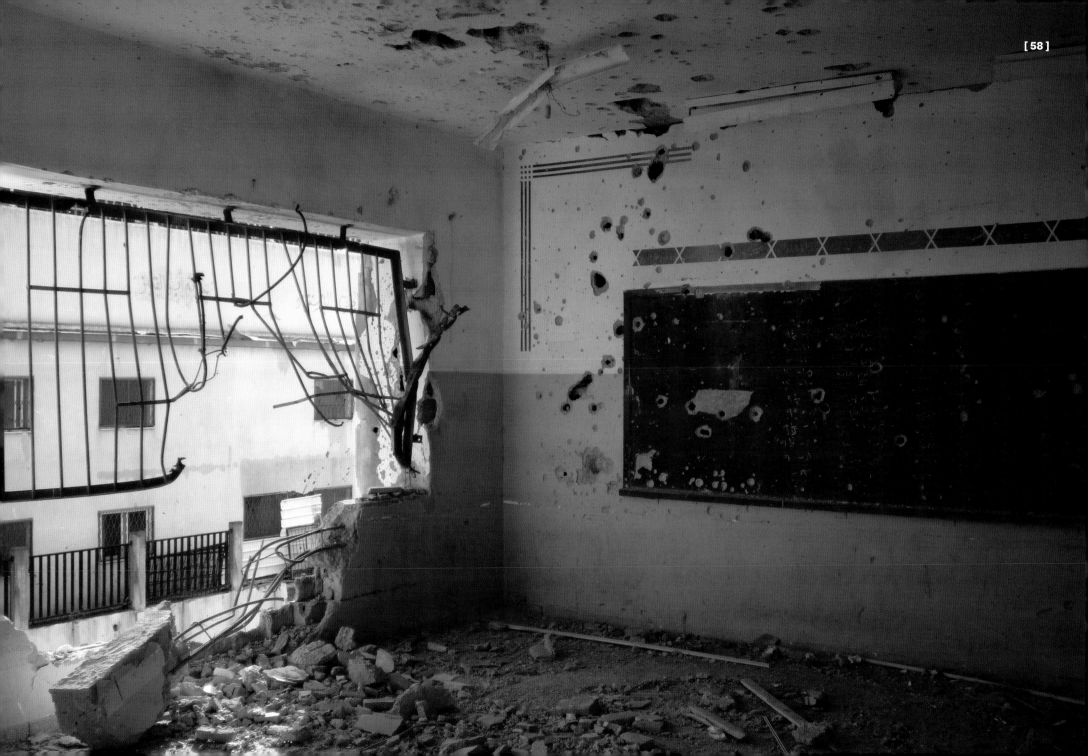

[59] **November 16, 2014, 4:44 p.m.** A boy heads back to his home in Shuja'iyya after playing soccer with friends at a sports club nearby.

Following pages:

[60] **November 16, 2014, 4:16 p.m.** Palestinian boys play soccer in a damaged sports club in Shuja'iyya. The building was targeted during Operation Protective Edge.

[61] **November 16, 2014, 4:22 p.m.** Emad Saeed Sersawi, age twenty, plays soccer as light streams in through the damaged parts of the sports club's walls.

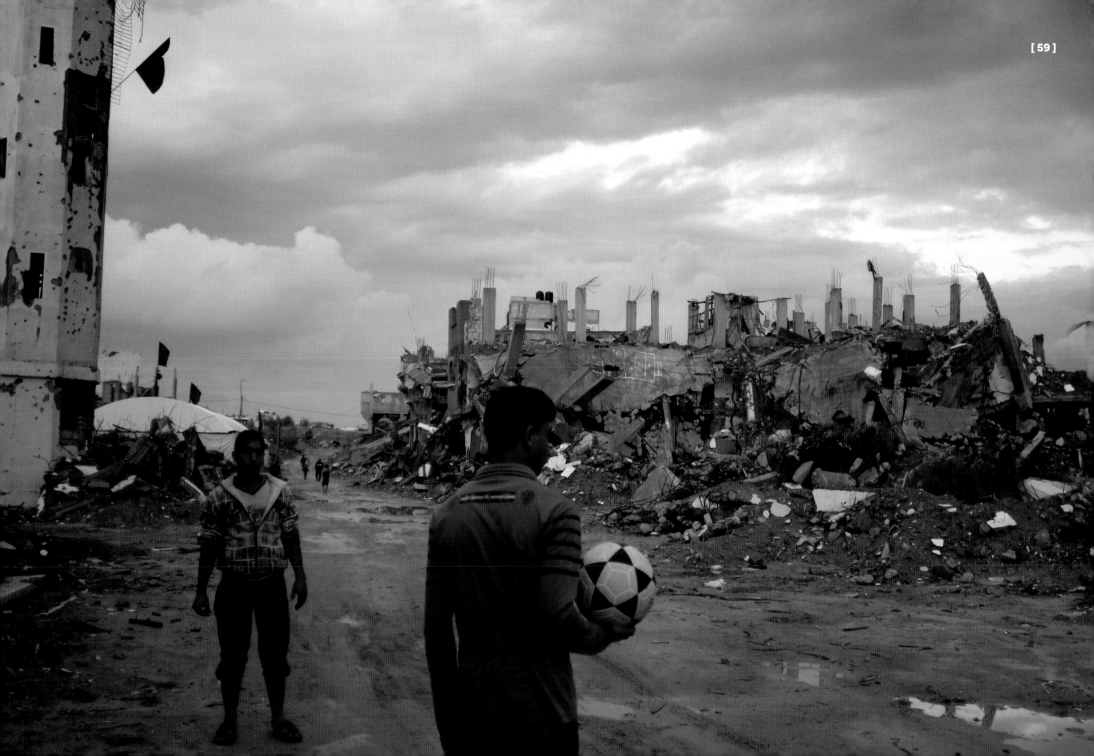

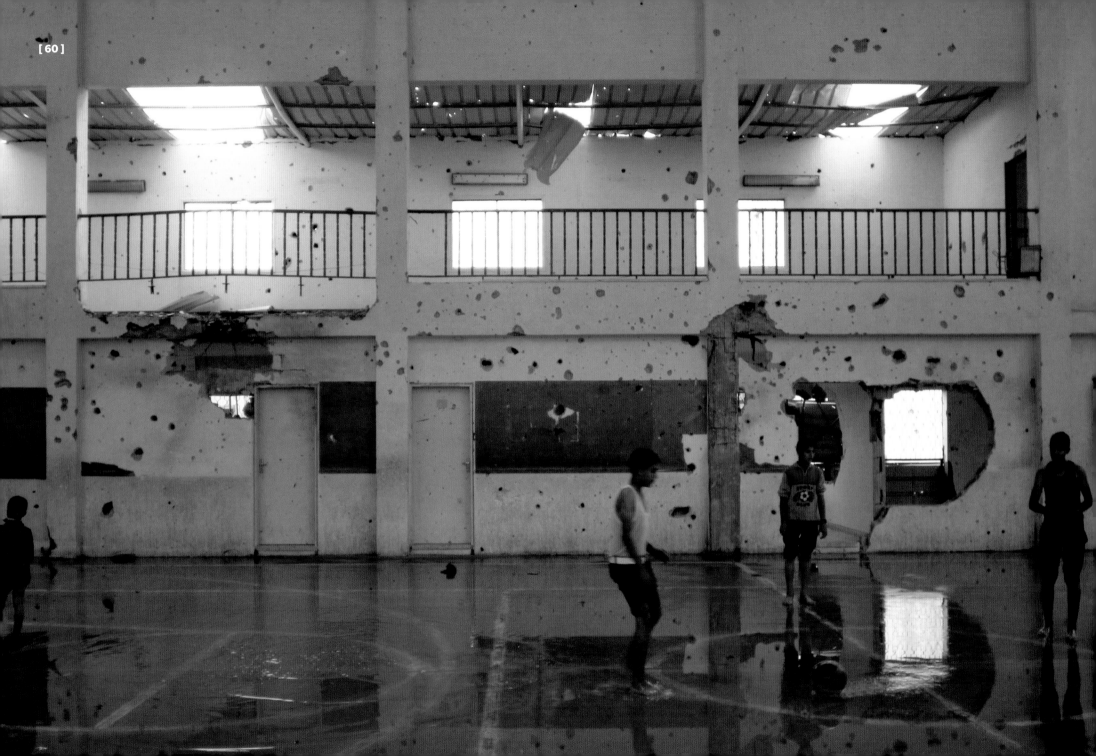

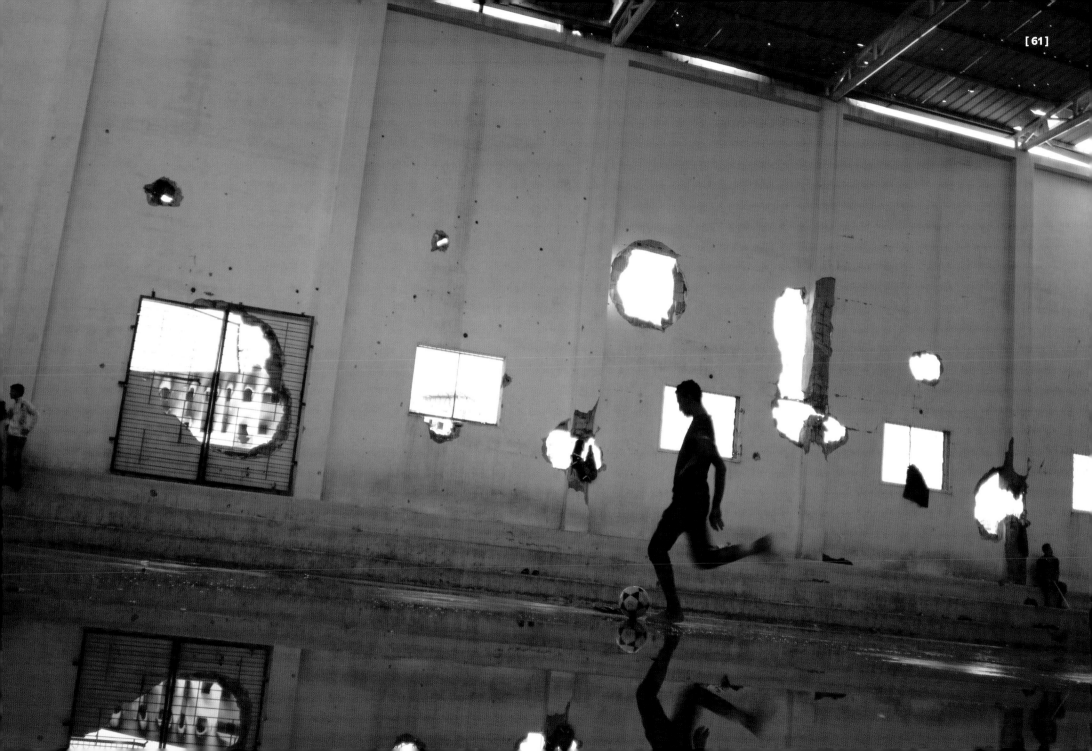

[62] **February 22, 2015, 1:48 p.m.** Yassir Mahmoud El Haj holds a picture of his family, who, except for his sister, were all killed in an Israeli bombardment of their house in Khan Younis. On July 10, 2014, at 1:30 a.m., Yassir lost his parents, Mahmoud El Haj and Basma El Haj; and six brothers and sisters: Najla, twenty-eight; Asmaa, twenty-two; Omar, twenty; Tareq, eighteen; Sa'ad, sixteen; and Fatma, fourteen. His only surviving sibling, Fidaa, twenty-seven, lives in her husband's home. Yassir had left his house to visit a neighbor thirty minutes before the bombing. He was one hundred meters away when he saw two F-16 missiles fall. Yassir couldn't see where they hit, as smoke and dust filled the air. It wasn't until he heard someone running in the street yell, "They bombed El Haj's house" that he realized his family was under the debris. Yassir couldn't find a place to rent for the next several months, as property owners feared that he had been the target of the attack. Yassir wonders about this himself.

Following pages:

[63] **March 8, 2015, 5:58 p.m.** My wife, Lara, sets the table in our apartment in Gaza as my brother Hamza checks his phone. Many of our friends used to gather at our place as an alternative to Gaza's public spaces. It's controversial in Gaza for Lara to wear these clothes in front of my brother and our friends, and it would be impossible to share such a picture if we still lived there. In Gaza, women and men aren't always allowed to mix, and must dress, talk, and act in certain ways.

[64] **March 8, 2015, 11:01 p.m.** From our apartment in Gaza City, Lara connects with the world through her phone. For almost two years, she and I desperately waited for our Israeli travel permissions in order to leave Gaza and join the outside world.

[65] **March 31, 2015, 2:01 p.m.** Alaa Habib, nine years old, raises her hand on one of the first days of school after summer break. The Subhi Abu Karsh School was heavily damaged in Operation Protective Edge the year before and still had holes in its walls. Alaa told me her house was also damaged during the attack. She said there were small holes in the wall and a big hole in their kitchen, which her father fixed.

[66] **August 31, 2015, 2:31 p.m.** Aamir Salah El Mbayed, the deputy director of the Beit Dajan School in eastern Gaza City, stands among students before the start of the evening study period.

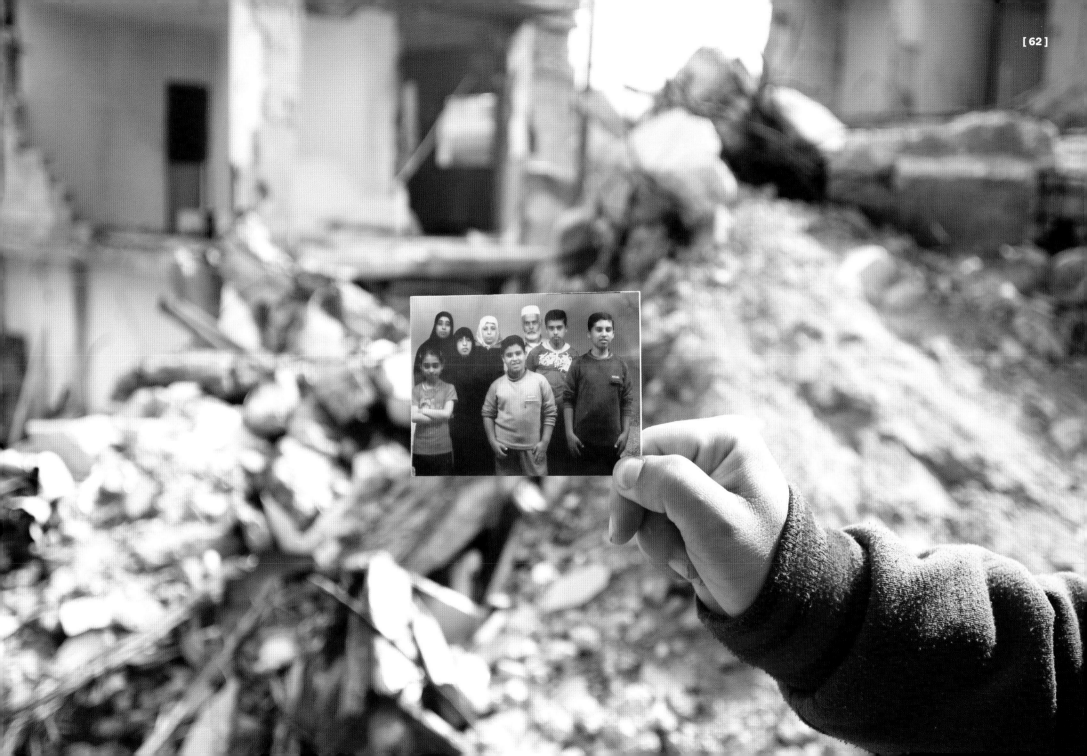

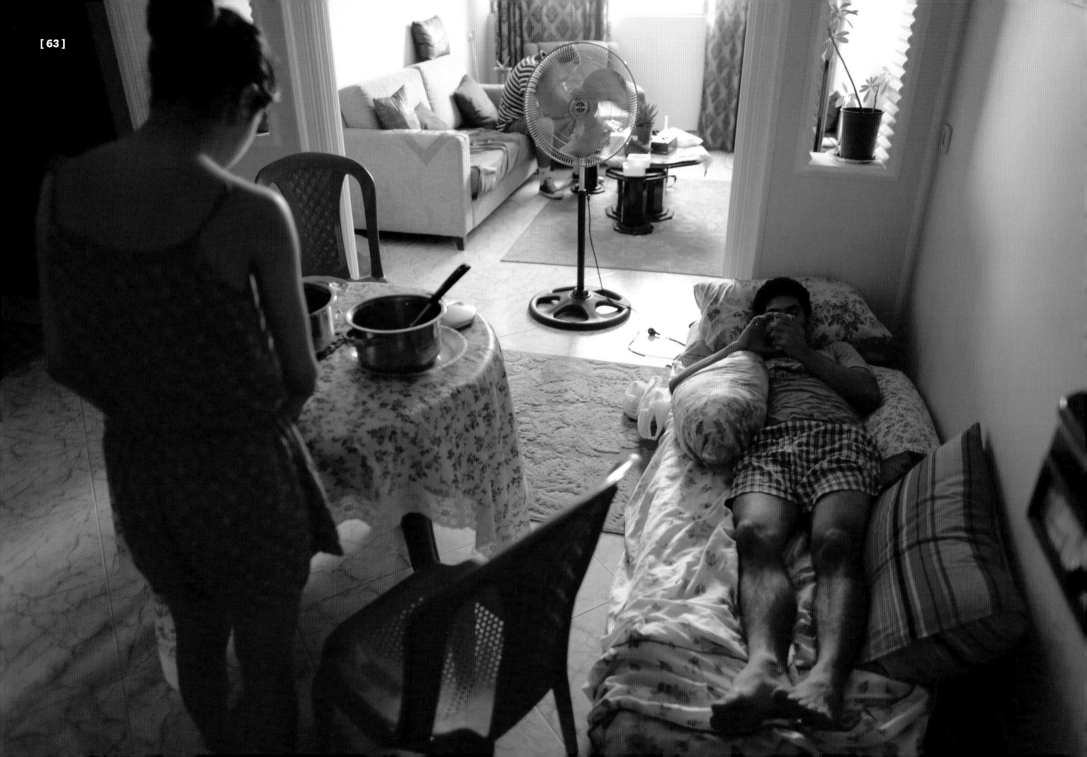

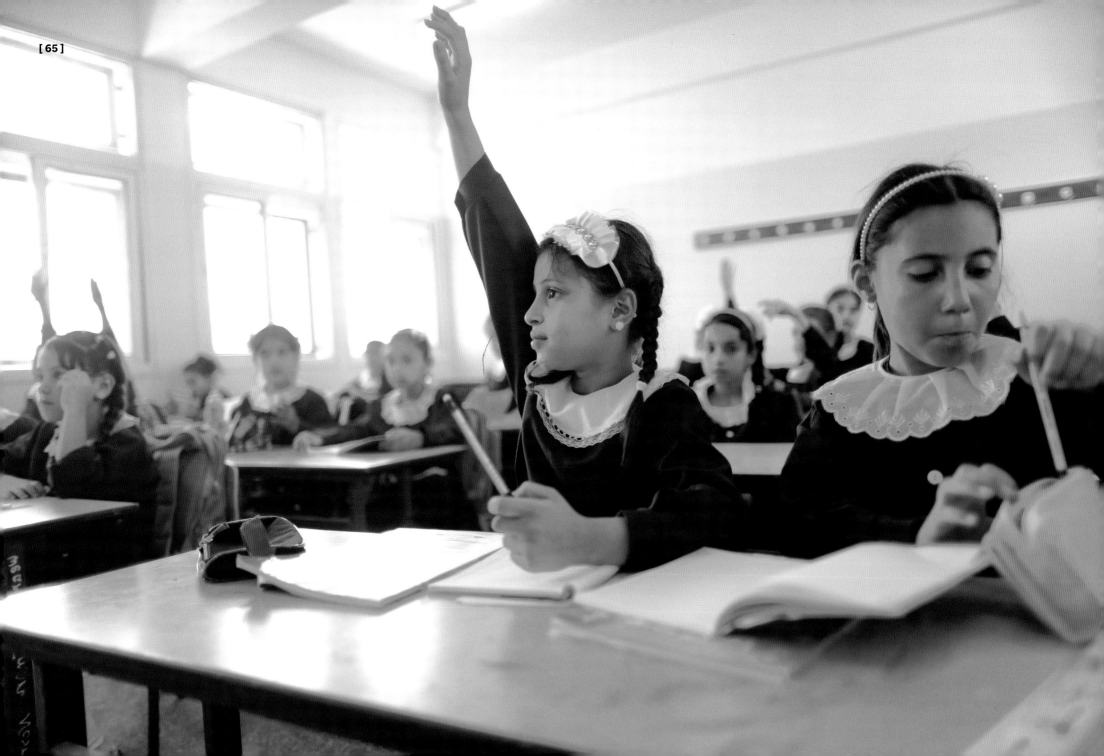

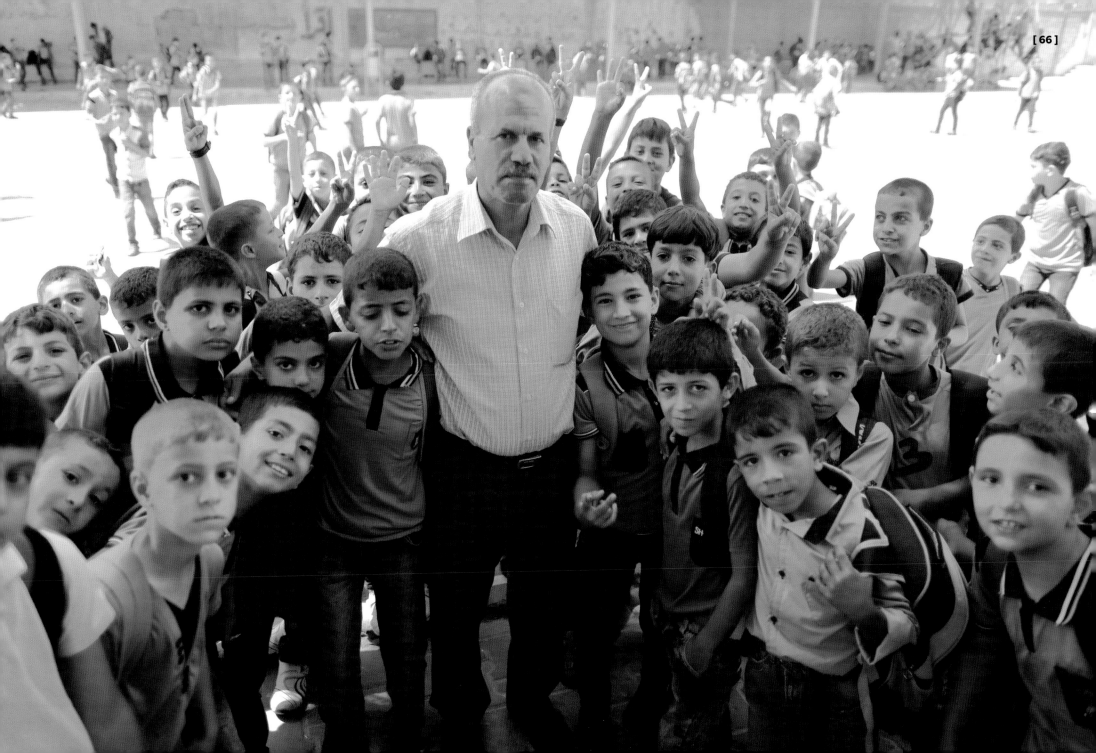

[67] **May 21, 2015, 4:13 p.m.** Palestinians carry a young man who was shot in the leg by an Israeli soldier during a protest. The protesters were on Gaza's eastern border with Israel. Between March 2018 and December 2019, more than 200 Palestinians were killed and some 19,000 injured in a series of protests on Israel's border with the Gaza Strip.

Following pages:

[68] **May 21, 2015, 5:05 p.m.** Palestinian youths carry an injured protester shot by an Israeli soldier. Gazans had been protesting the Israeli siege on Gaza when Israeli forces confronted them with tear gas and ammunition. The siege began in 2007, when Hamas gained control of Gaza. In an effort to undercut Hamas's power, Israel and Egypt imposed a land, air, and sea blockade, dramatically restricting imports to the region. Israel and Egypt also denied Gazans access to the rest of the Palestinian territory and world beyond. The World Bank reports that almost 80 percent of Gazans rely on some form of international aid.

[69] **May 21, 2015, 6:17 p.m.** Palestinian protesters hang the Palestinian flag on the fence of the al-Bureij refugee camp, on the border with Israel, and then flee as Israeli soldiers open fire.

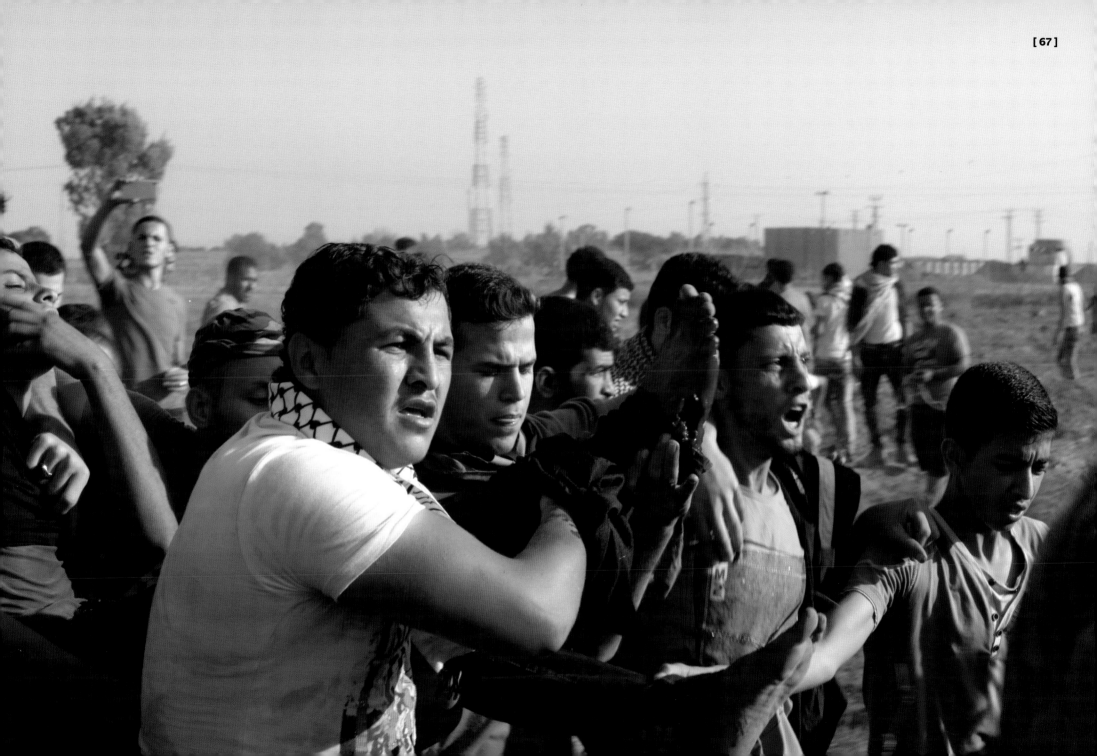

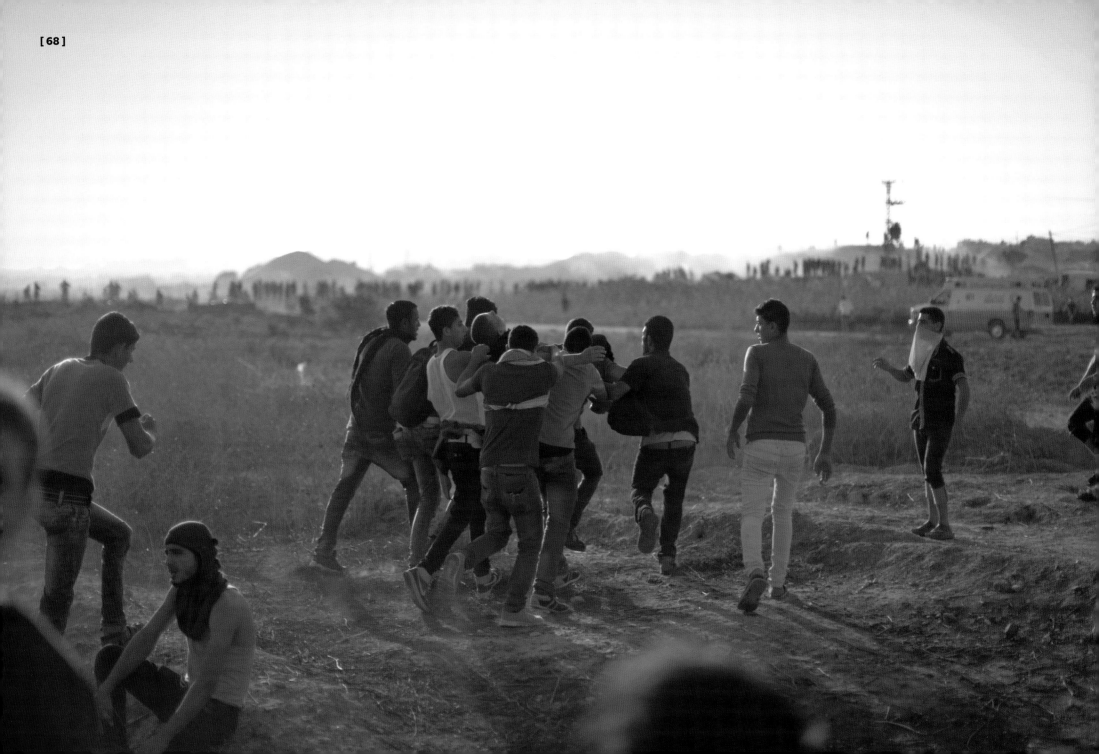

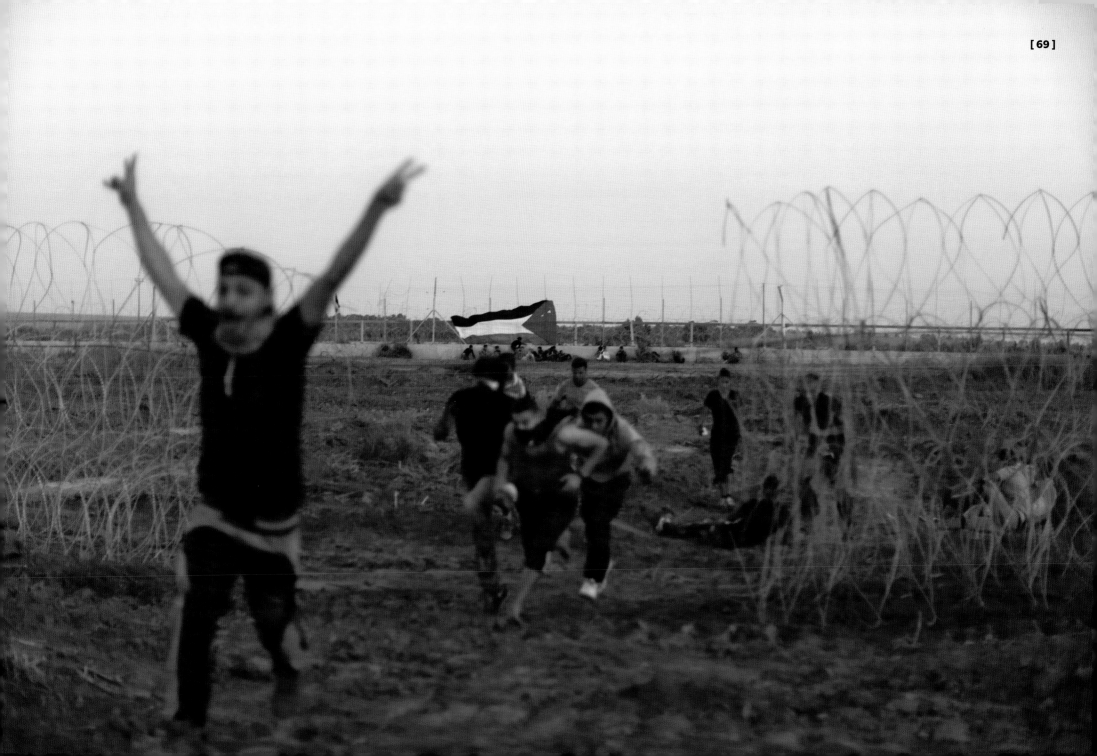

[70] **October 11, 2015, 2:47 p.m.** Residents of Gaza visit the al-Shifa Hospital, the main hospital complex in the Gaza Strip, for medical treatment. Due to the Israeli siege, the hospitals of Gaza are always short on medicine, medical equipment, and fuel to generate electricity. I saw Hamas spokesmen use the hospital's courtyard and corridors to make statements for journalists on several occasions during the 2014 Israel-Gaza conflict.

Following pages:

[71] **April 3, 2016, 7:47 p.m.** Palestinian fishermen rest on their boat while the captain, Raed Abu Owda, tells stories about his experiences in Gaza's sea. Raed was arrested by Israeli navy forces three times. During each arrest they damaged his boat, twice by shooting at the engine.

[72] **April 3, 2016, 8:05 p.m.** Palestinian fishermen sail around their fishing nets to protect them from other boats. The Gaza Strip is one of the most densely populated areas on earth. On average, there are some 6,197 people per square kilometer. This moment was one of the calmest I've experienced in Gaza.

[73] **April 3, 2016, 10:14 p.m.** Fisherman Raed Abu Owda's cousin Mohammed Abu Owda collects useful materials from a broken fishing net found in Gaza's sea. After agriculture, fishing is the largest source of income for Gazans. The fishing industry has been significantly weakened by the Israeli siege on Gaza, which has lasted for more than thirteen years. Israel has closed the crossings for exports, reduced the fishing area, and banned the import of fishing tools.

[74] **April 4, 2016, 6:14 a.m.** On the first night after Israel expanded Gazans' permitted fishing zone, Mohammed Abu Owda prepares to lift the ship's fishing nets. The designated fishing area had previously been limited to six nautical miles, as imposed by Israel in 2006. Between 2017 and 2019, there were 434 incidents in which Israeli soldiers shot at fishermen while they worked. These incidents killed two fishermen, injured twenty-two, and destroyed fifteen fishing boats. In the same period, Israeli soldiers arrested 121 fishermen, detained twenty-five fishing boats, and seized numerous fishing nets.

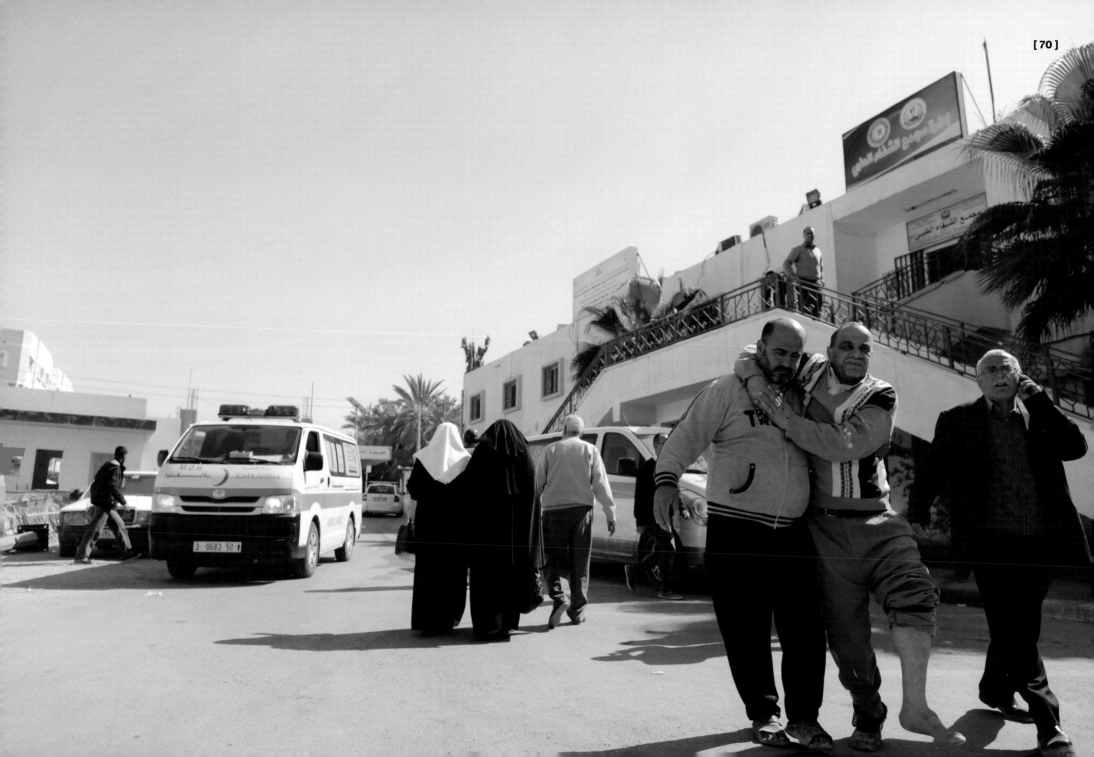

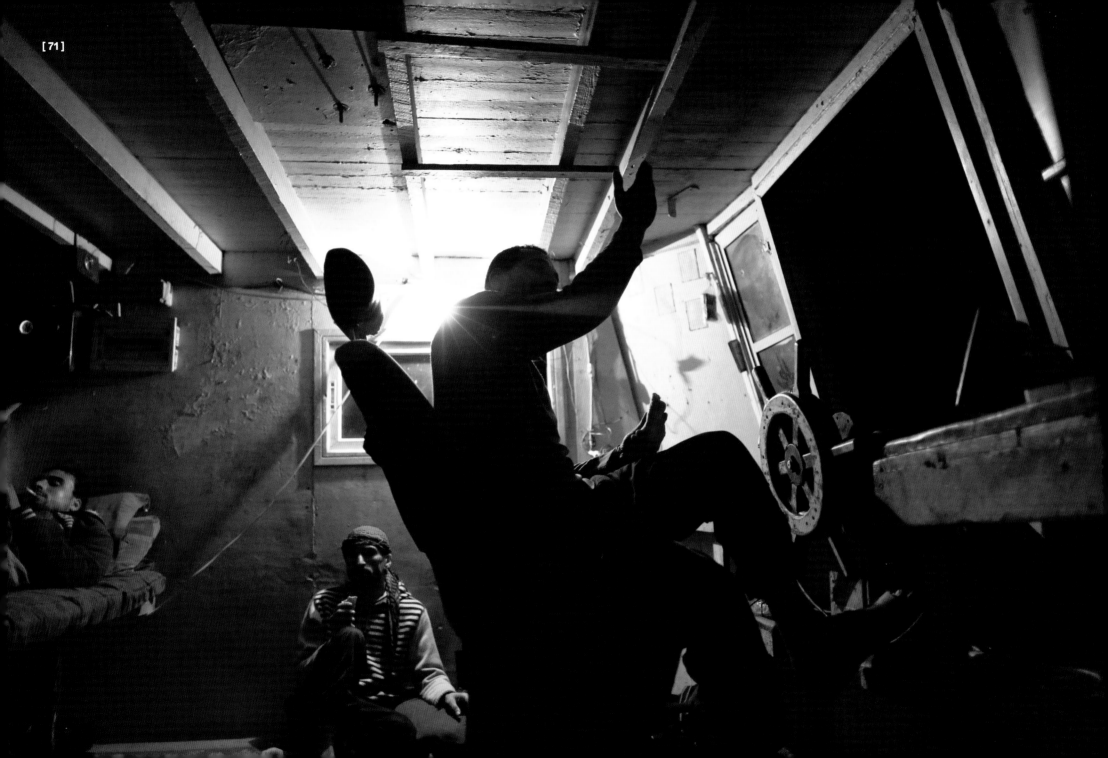

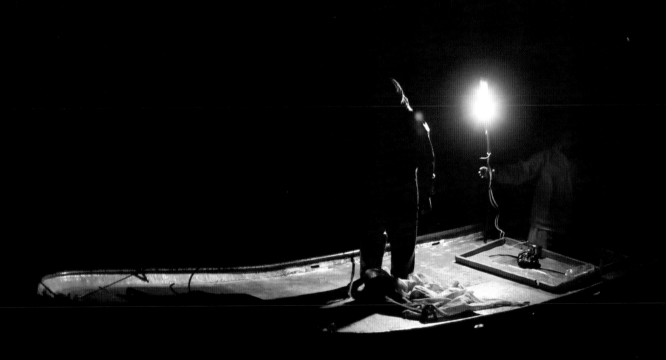

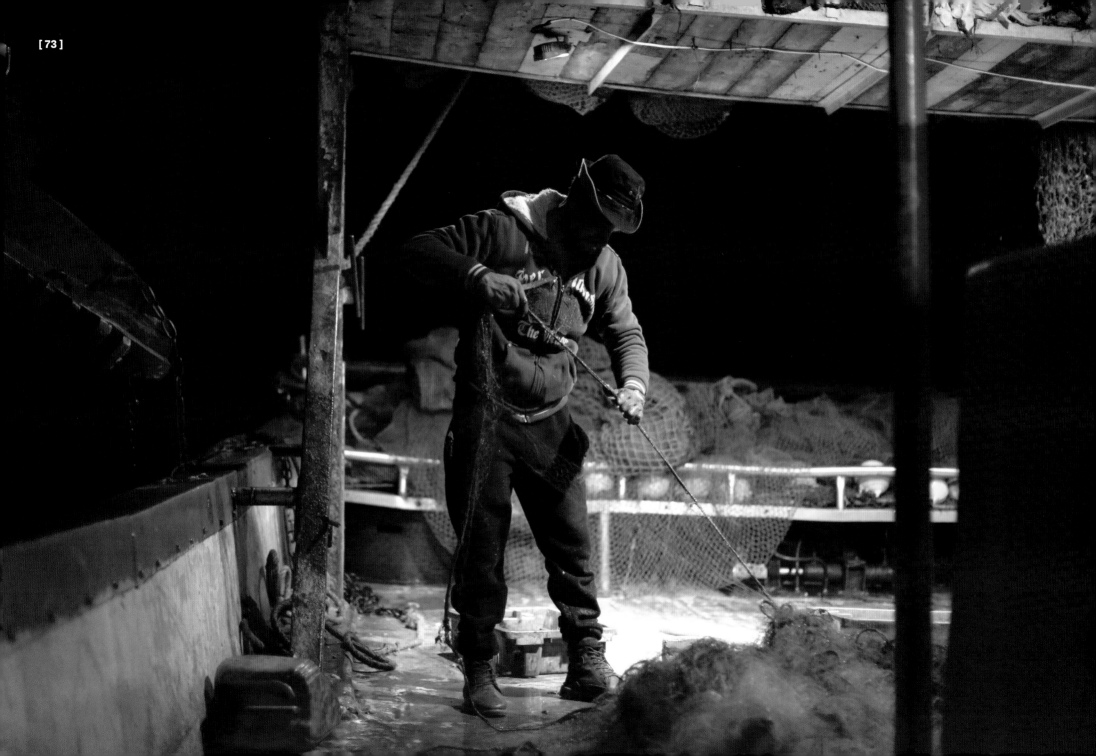

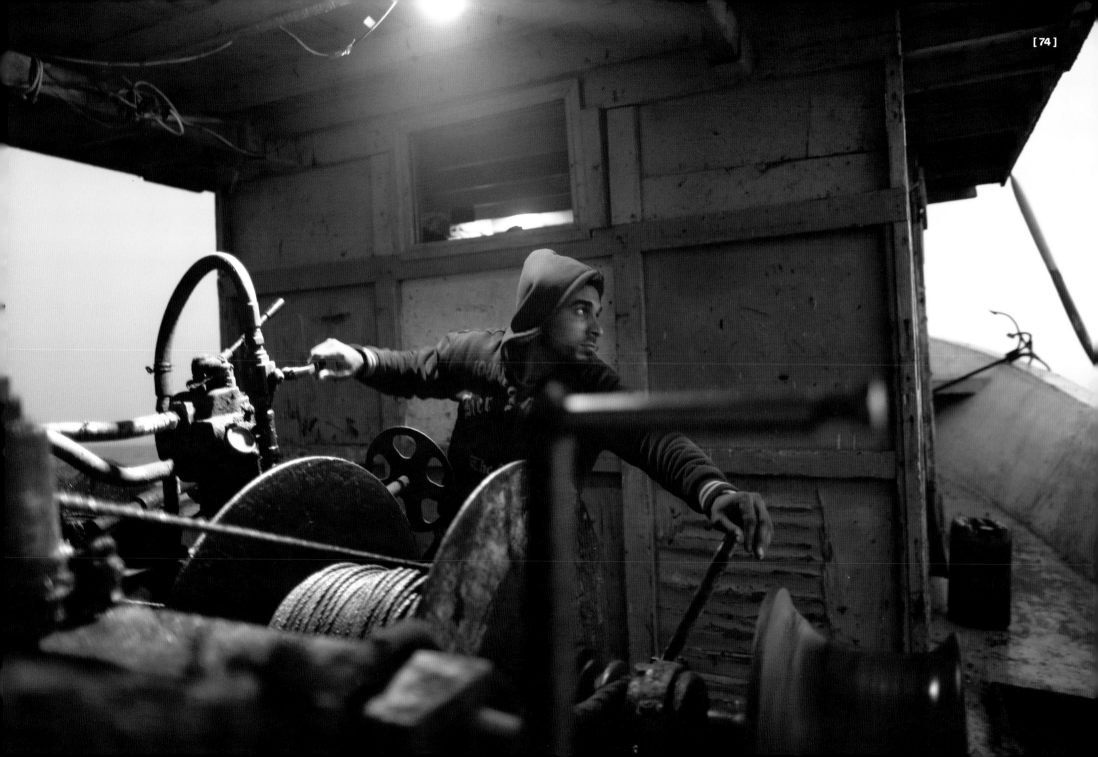

[75] **April 4, 2016, 6:16 a.m.** Mohammed Nuaija, twenty-eight, makes sure nothing is stuck in a fishing net before throwing it back into Gaza's sea. He has four children and has been a fisherman for over twelve years. He said that when he first started working, there were no wars and the atmosphere at sea was not as tense. Today, fishermen feel as if they are on a battlefield. It's illegal for a person who is not registered as a fisherman to accompany a fishing boat without permission from the Hamas government. I had two meetings over a two-week period with the media office of the Hamas-run interior ministry to get permission to accompany Mohammed and the other fishermen.

Following pages:

[76] **November 28, 2015, 12:05 p.m.** The Mediterranean Sea stretches out past western Gaza City. The beach is the only place where Gaza's nearly two million residents can feel a sense of space. Anywhere else, sandy beaches like these would be a source of business and thriving tourism. In Gaza, though, even the most spacious piece of land starts and ends with barbed wire and watchtowers mounted with machine guns.

[77] **December 13, 2015, 6:02 p.m.** Ghazi al-Amour grieves beside the grave of his mother, Zaina Attia al-Amour. Zaina was killed at age fifty-four by an Israeli tank shell that fell next to her. Zania and her niece, who was injured in the attack, had been working on their farm, which is close to Gaza's eastern border with Israel.

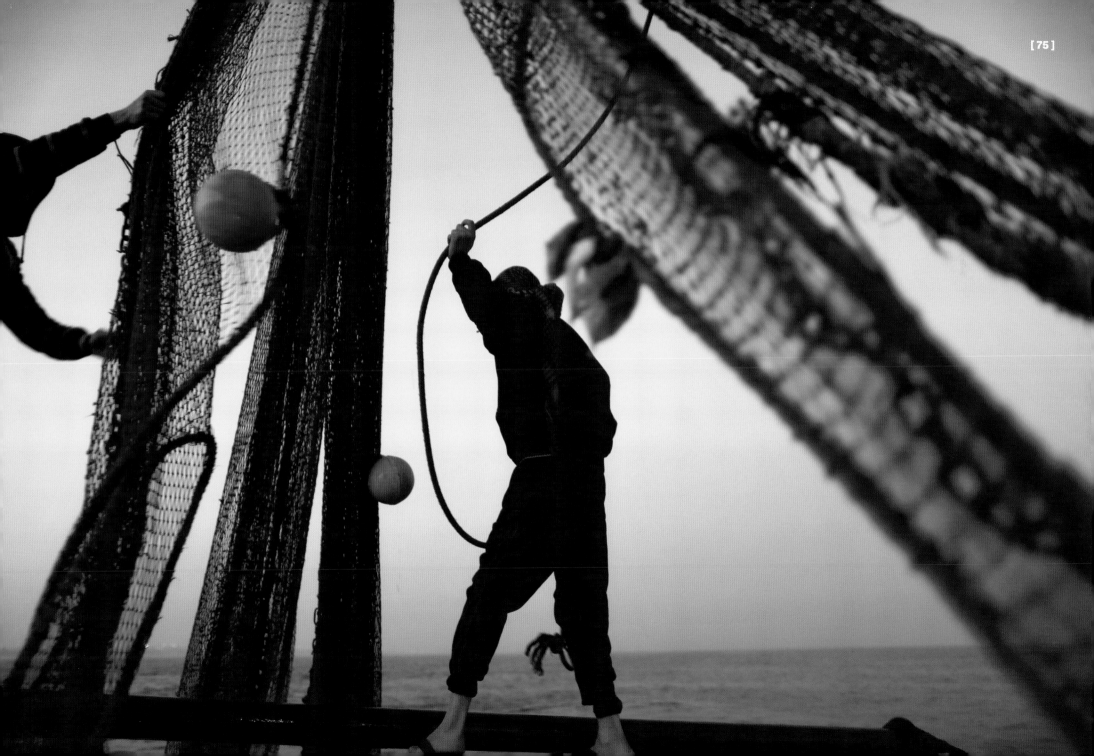

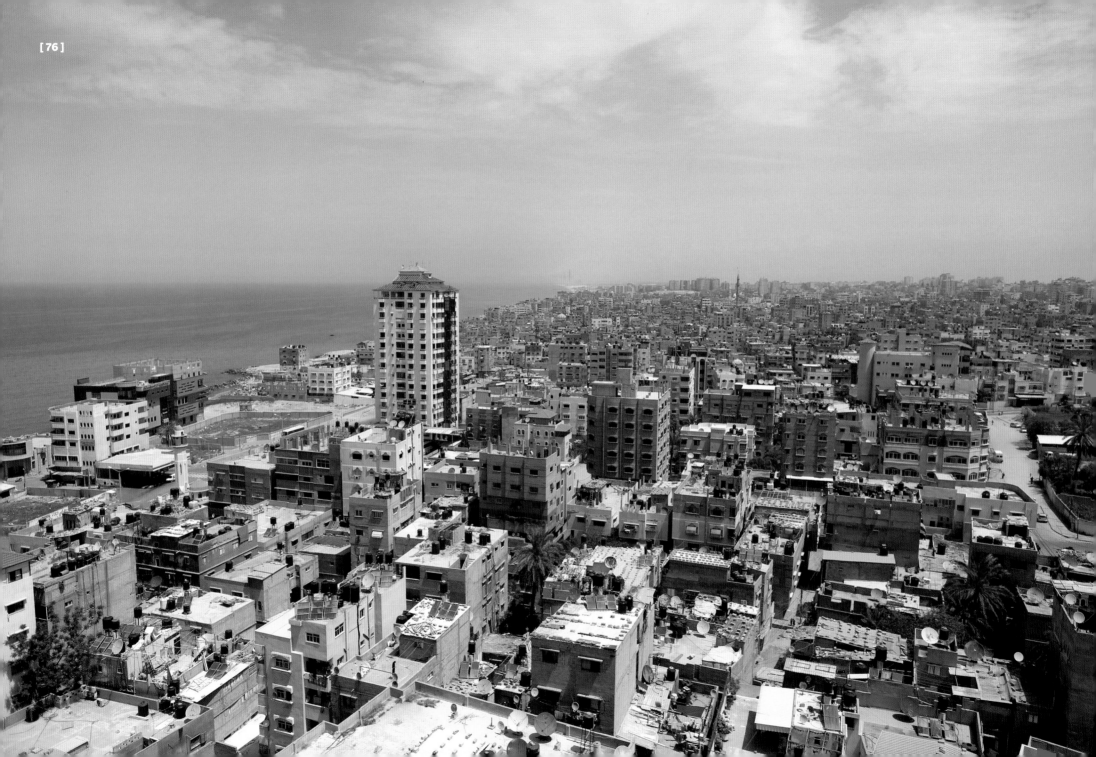

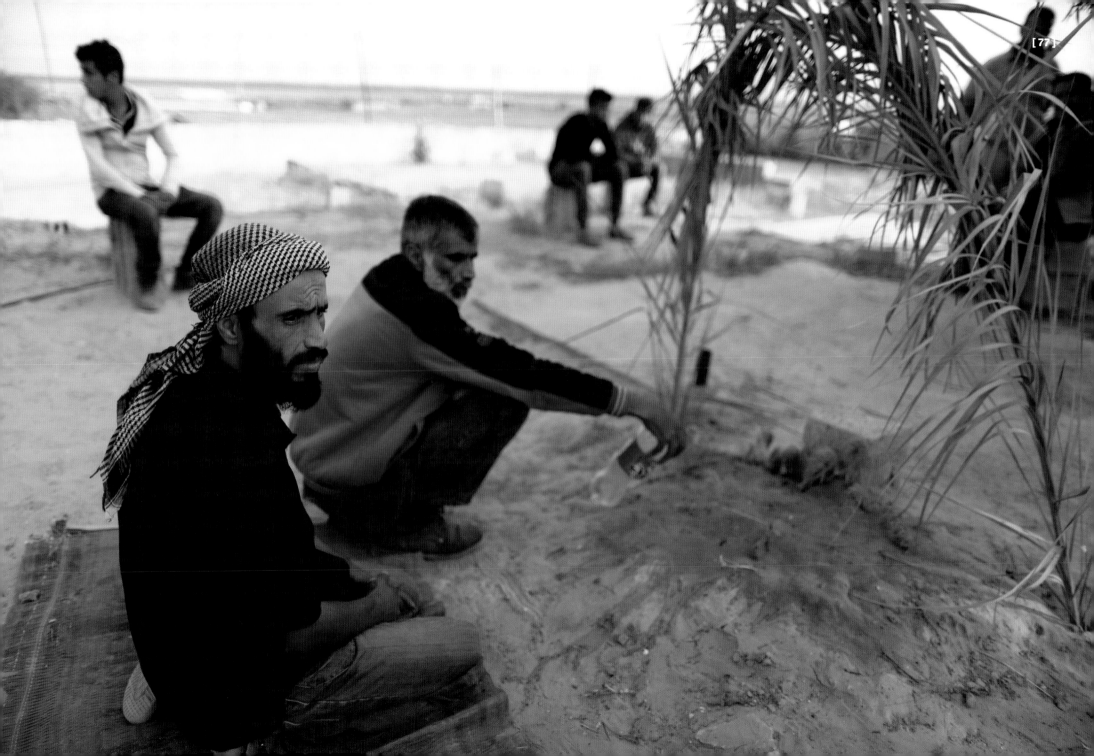

[78] <u>December 13, 2015, 3:45 p.m.</u> Zaina's brother, Zaher al-Amour (right), sits next to Zaina's son, Ghazi al-Amour, as they try to make sense of her death.

Following pages:

[79] <u>December 15, 2015, 10:54 p.m.</u> Hundreds of people in Abu Yousef al-Najjar Hall wait for their names to be called from a list approved by the Egyptian government. Those called are permitted to leave Gaza through Rafah's border with Egypt. Most are students, visa holders, Gazan residents returning to their homes abroad, and patients requiring treatment outside Gaza. The UN estimated that by the end of 2015, at least 30,000 Gazans with humanitarian cases were waiting for permission to cross Rafah.

[80] <u>December 16, 2015, 12:13 p.m.</u> A Gazan resident carrying his ID and travel papers waits in Abu Yousef al-Najjar Hall. He stands among hundreds of others also trying to leave Gaza. In the hall, you can see people's pain and desperation. They yell out their reasons for wanting to leave and how long they have been trying. Egypt closed the crossing in June 2007, in response to Hamas's takeover of the Gaza Strip, and it has been reopened and closed many times since.

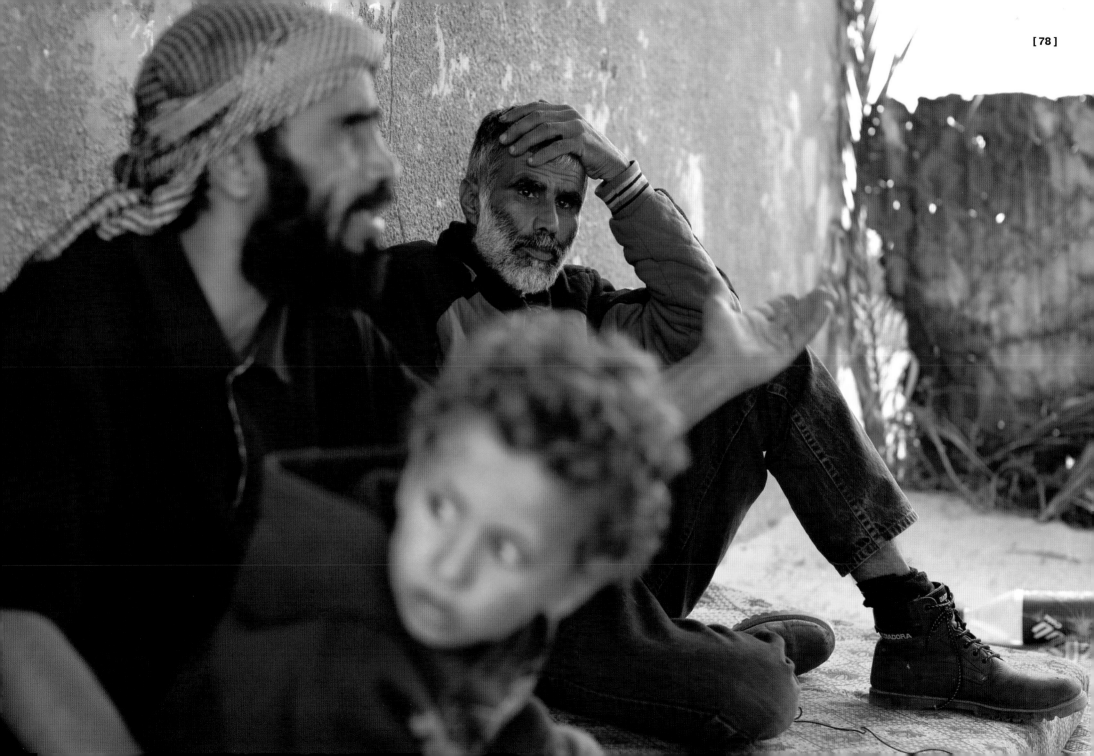

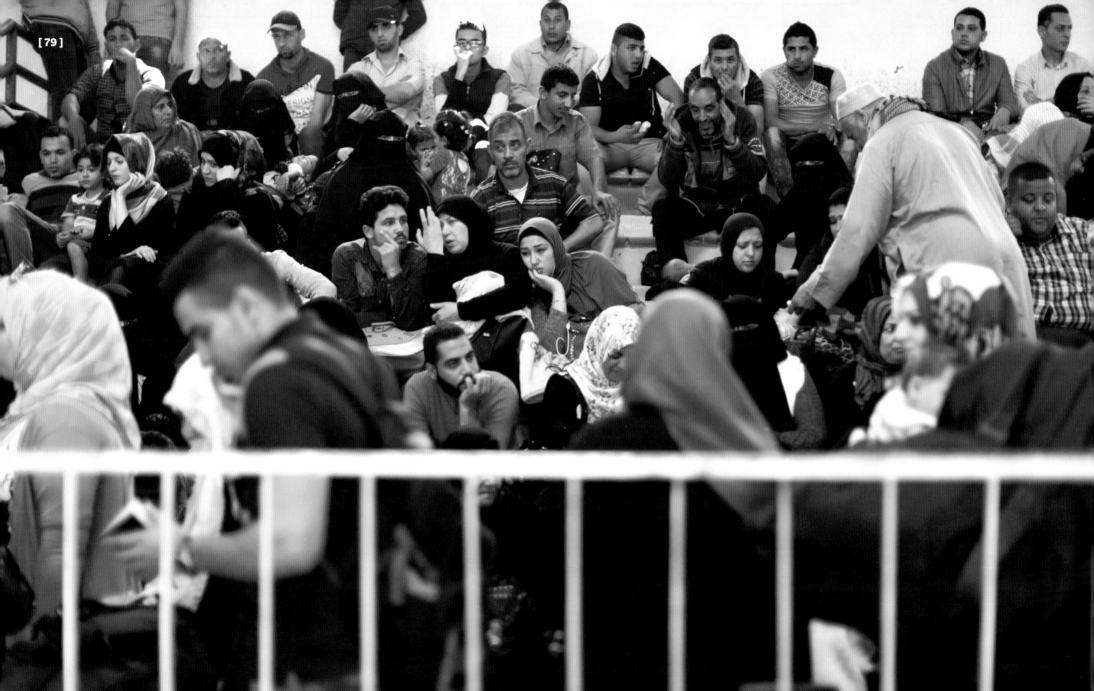

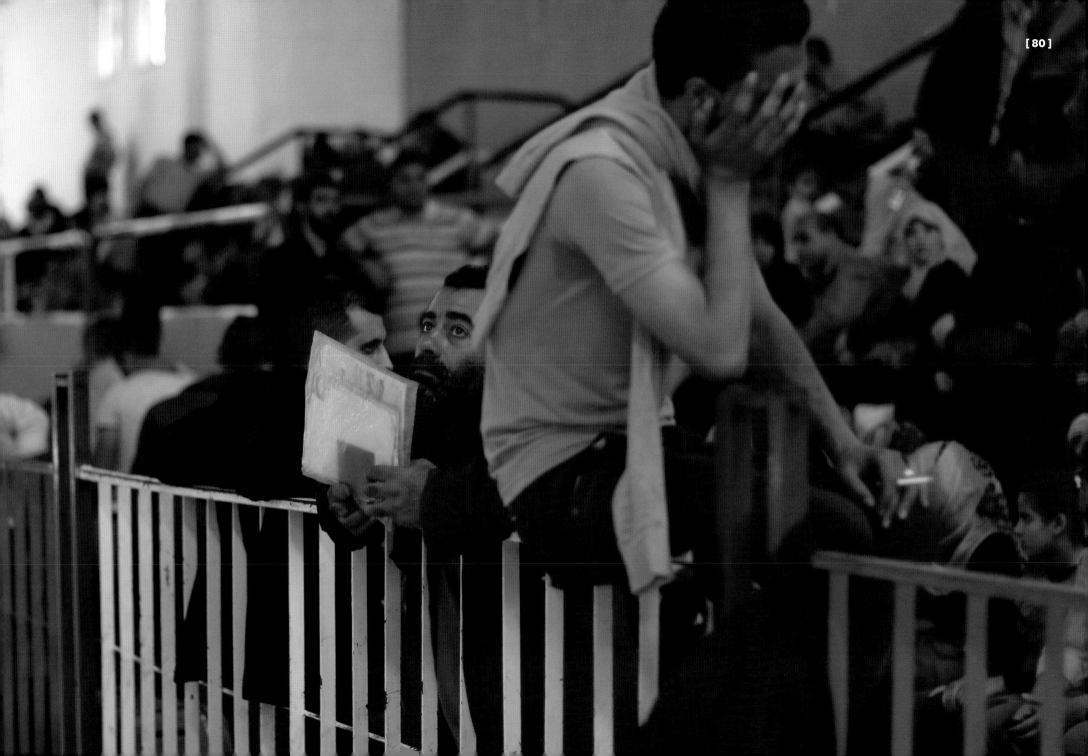

[81] **December 16, 2015, 12:24 p.m.** A distressed woman holds her baby and waits for her name to be called. She told me, through tears, that she had been stuck in Gaza for more than a year and desperately needed to return home to her husband before she lost her residency abroad.

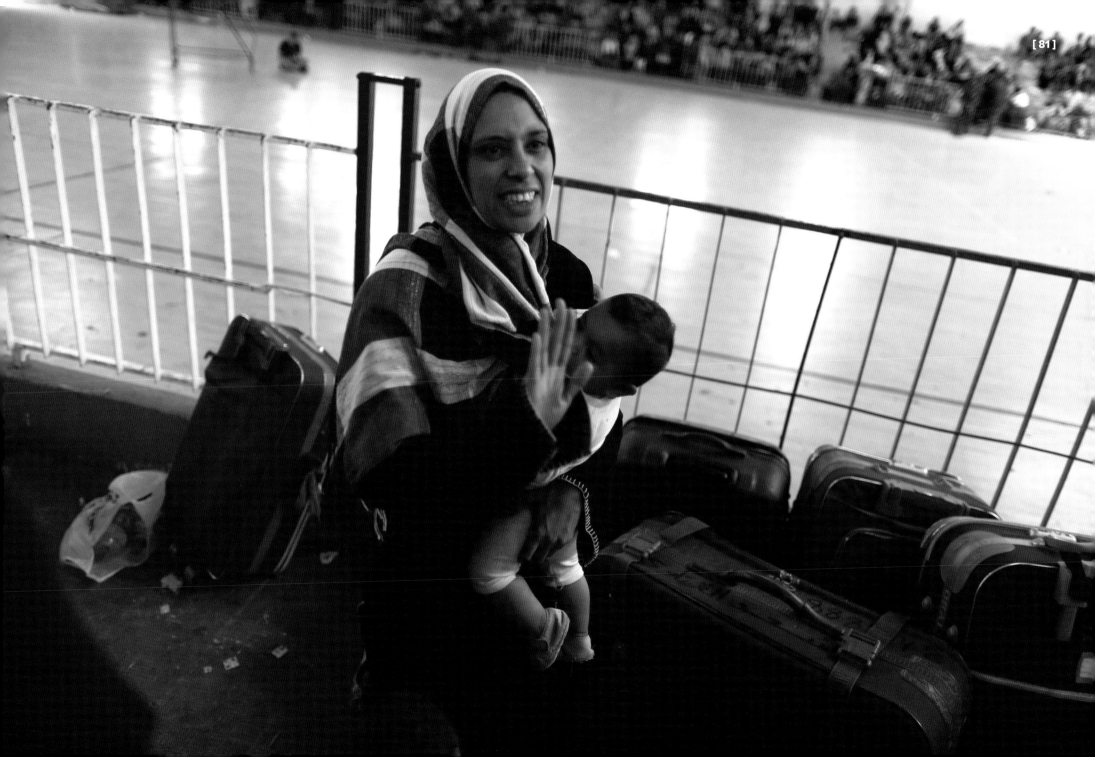

[82] December 15, 2015, 11:56 p.m. Palestinians wait for their names to be called. In the meantime, Hamas police hold the doors closed to restrict access to Abu Yousef al-Najjar Hall. In order to leave Gaza for the United States, my wife and I had to pay an Egyptian officer to get our names on the list, which the Egyptian government sends to Hamas. We sent a payment of $2,600 each through a broker who coordinates bribe payments.

Following pages:

[83] December 25, 2015, 4:51 p.m. A sewage pipe empties into the Mediterranean Sea. The pipe is near one of the most visited areas of Gaza City's beach. Many visit this area to escape power cuts in their homes.

[84] December 25, 2015, 4:54 p.m. A Bedouin man rides his camel on the beach in Gaza City. He offers people tours on his camel for five shekels.

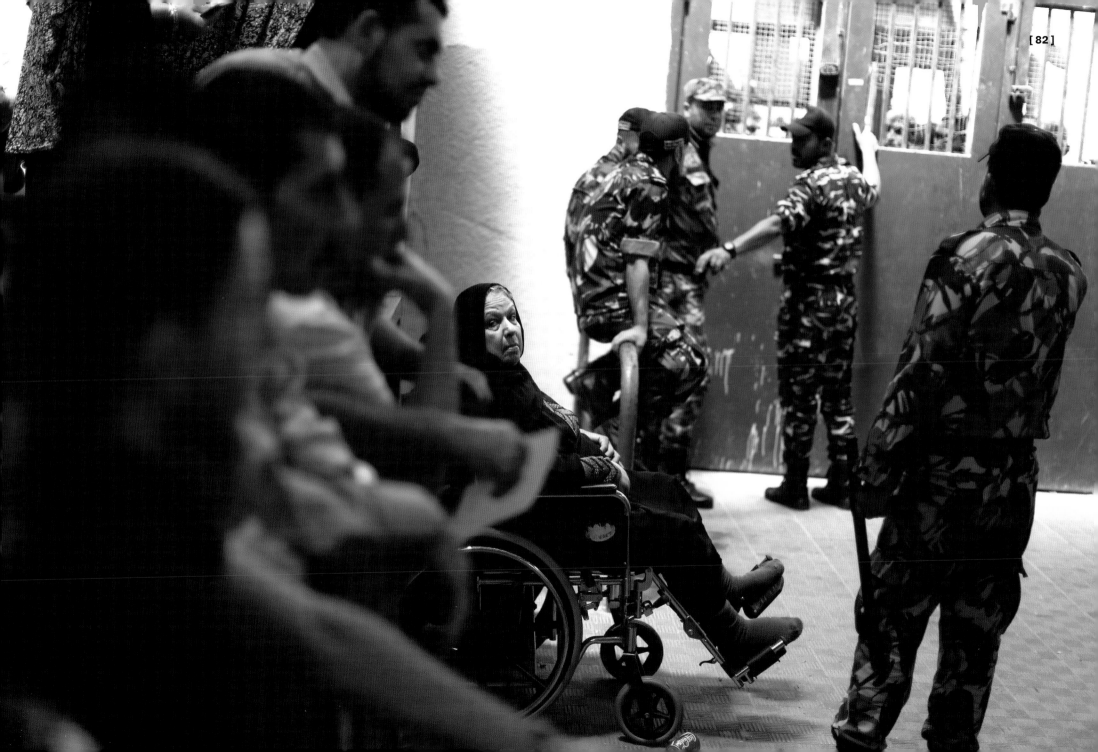

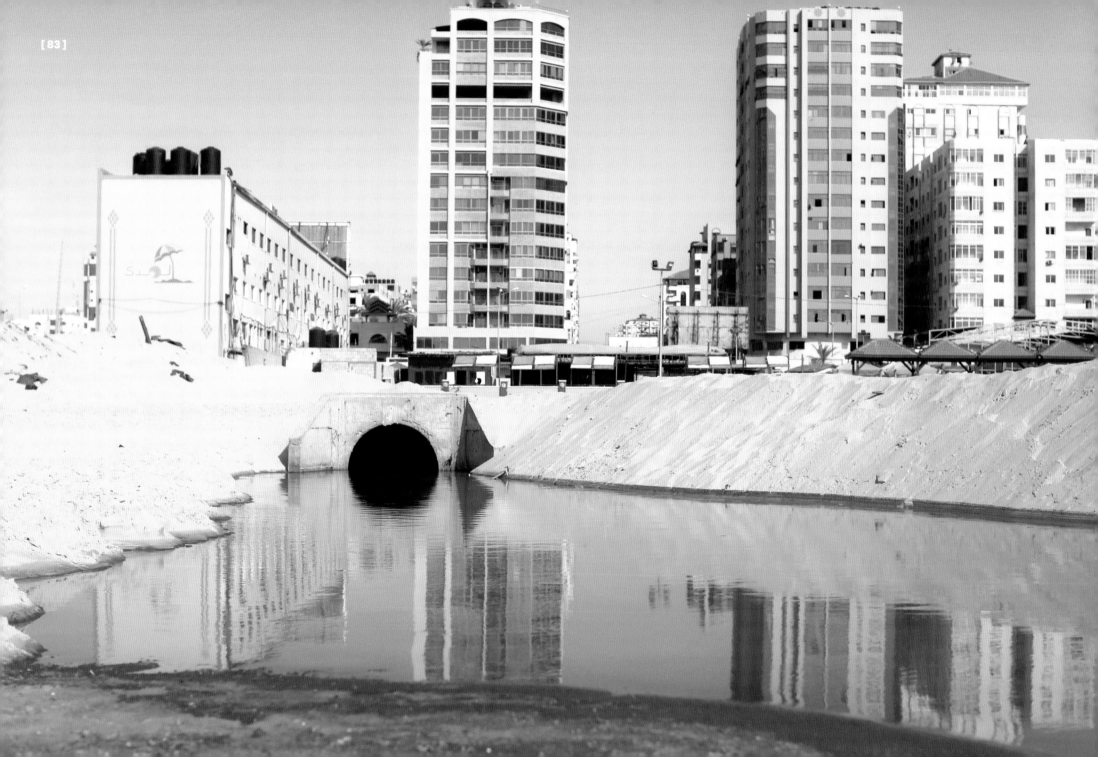

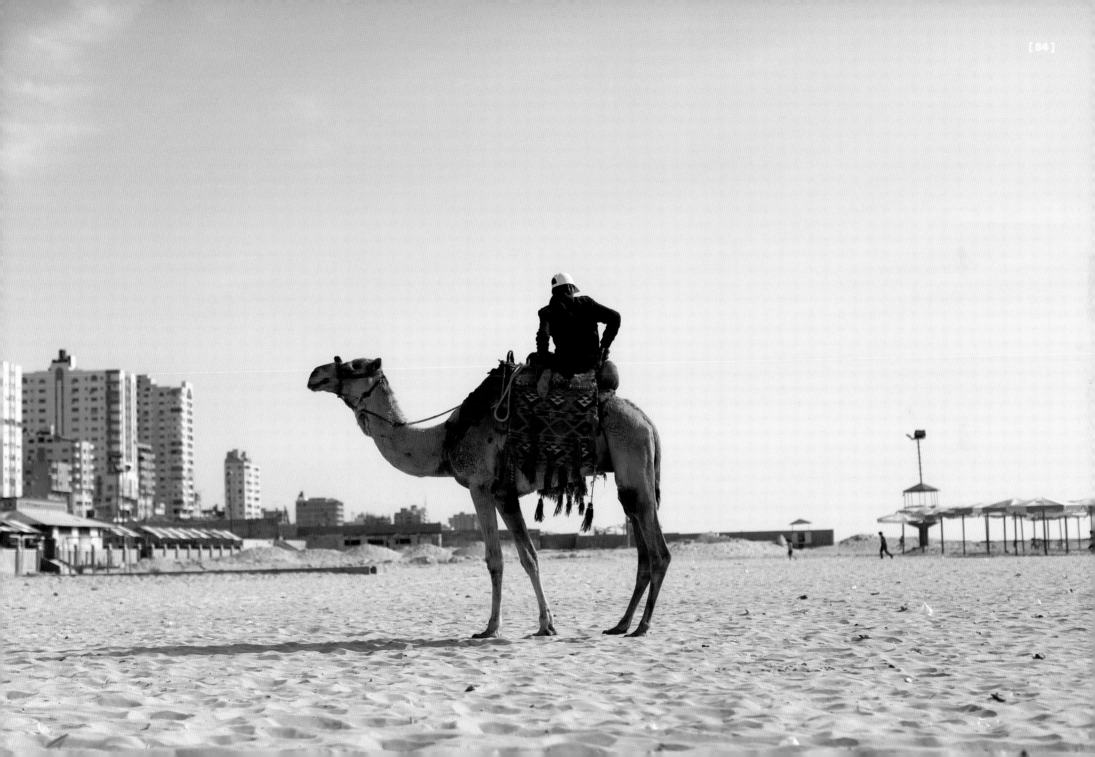

[85] **December 26, 2015, 8:17 p.m.** Vendors sell sweet corn on the coastal road in Gaza City. When the sun sets, vendors light fires and cook corn while visitors arrive at the shore of Gaza's sea.

Following pages:

[86] **December 26, 2015, 8:39 p.m.** A falafel cart is parked on the coastal road during a summer night in Gaza City. Summer heat and power cuts force Gazans to seek relief on the beach. Many unemployed young people use the opportunity to make money to support their families. The UN reported in September 2019 that the unemployment rate in Gaza was above 50 percent.

[87] **June 9, 2016, 8:59 p.m.** Children follow a Hantour horse cart through the al-Sheikh Radwan neighborhood during the month of Ramadan.

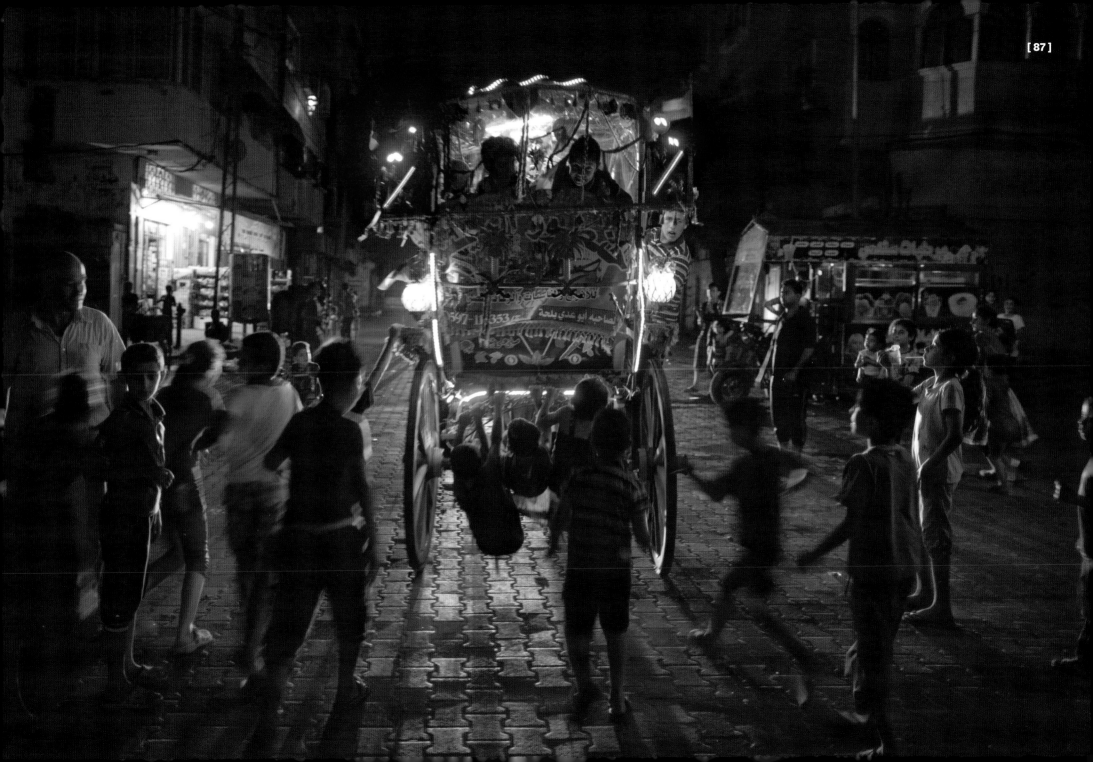

[88] <u>June 9, 2016, 9:41 p.m.</u> Palestinian kids play with burning steel wool, a common street activity for people across the Middle East in celebration of Ramadan.

Following pages:

[89] <u>June 19, 2016, 6:24 p.m.</u> A car parks on the newly built al-Rasheed Street in Gaza City. The construction of the street, which stretches along the coast, was funded by the Qatari government. The funding was part of Qatar's support of Hamas. Gaza's government relies largely on foreign aid to improve its infrastructure, but critics assert that Hamas spends too much of this aid on weapons, military infrastructure, and a network of internal surveillance.

[90] <u>June 19, 2016, 11:47 p.m.</u> Gazan youth display their skills on Rollerblades and bicycles. There are no designated spaces for such sports in the besieged city, which makes it difficult and dangerous to practice them.

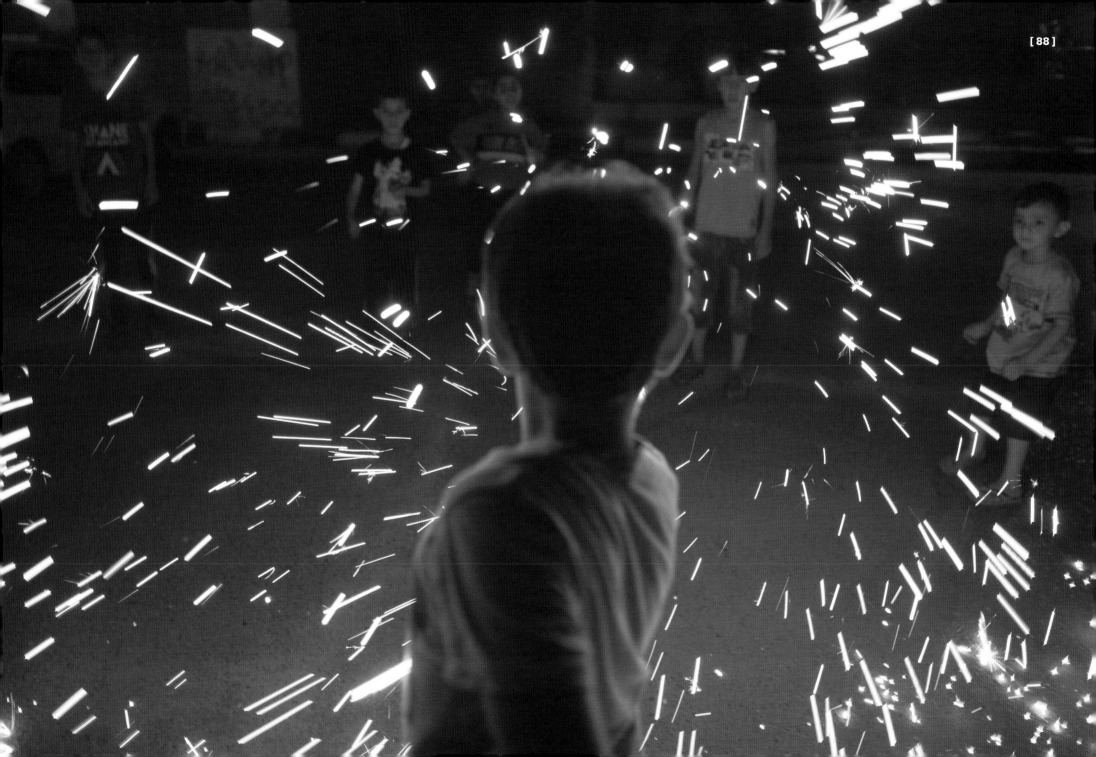

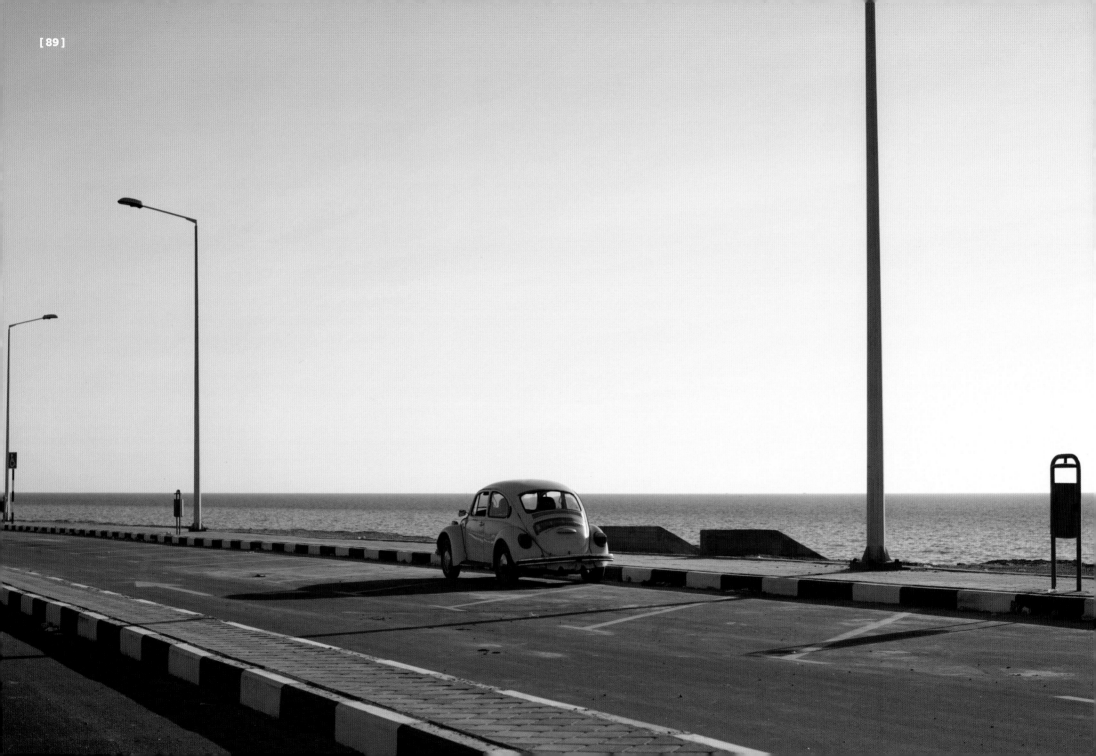

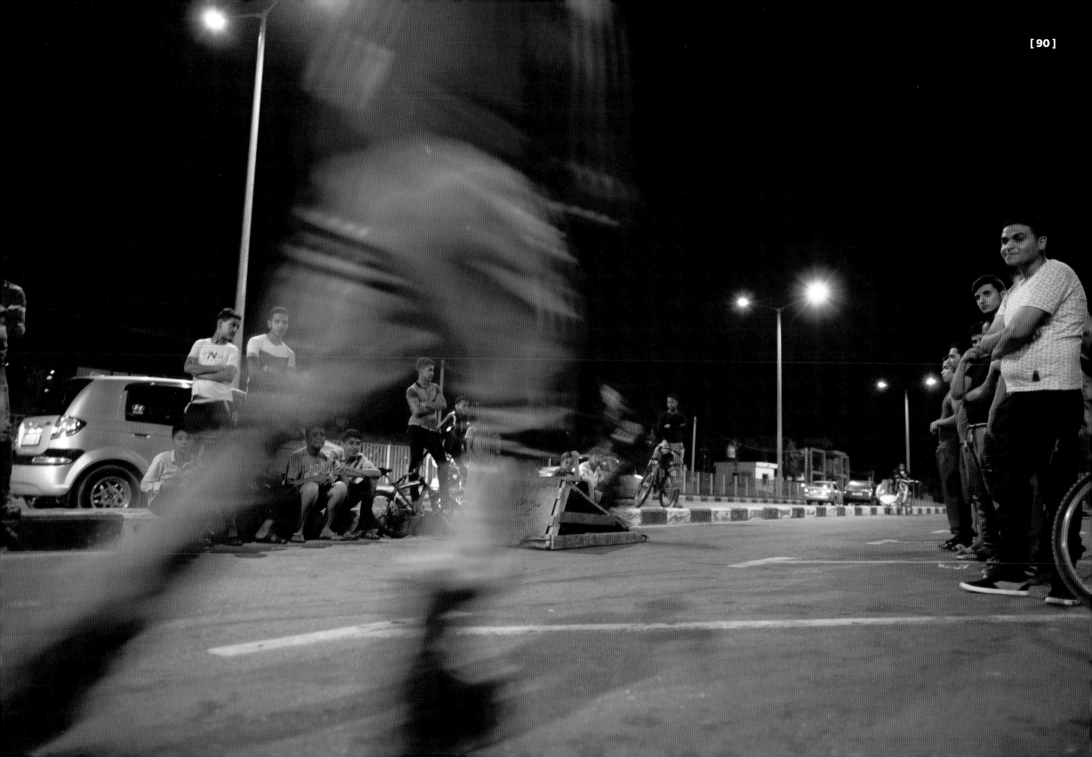

[**91**] **June 19, 2016, 11:45 p.m.** A crowd of people watch a bike show in the parking lot along Gaza's coastal road. On weekends, youth gather to show off their talents and they attract spectators from around Gaza.

Following pages:

[**92**] **June 25, 2016, 10:00 a.m.** Fishermen's children help to unload their haul from the previous night on the coast of Deir al-Balah, south of Gaza City. The young fishermen rush to the market early in order to maximize their sales for the day.

[**93**] **June 25, 2016, 1:33 p.m.** Palestinian fishermen pull their boat out of the Mediterranean Sea in the southern Gaza Strip. The Egyptian border is marked by metal poles. Israeli authorities claim that Hamas uses these maritime borders to smuggle in materials for weapons manufacture. In 2015, a video taken in this area showed a naked, mentally disabled man crossing the border and being shot at by Egyptian soldiers. The video ends with the man lying dead before soldiers come to remove his body.

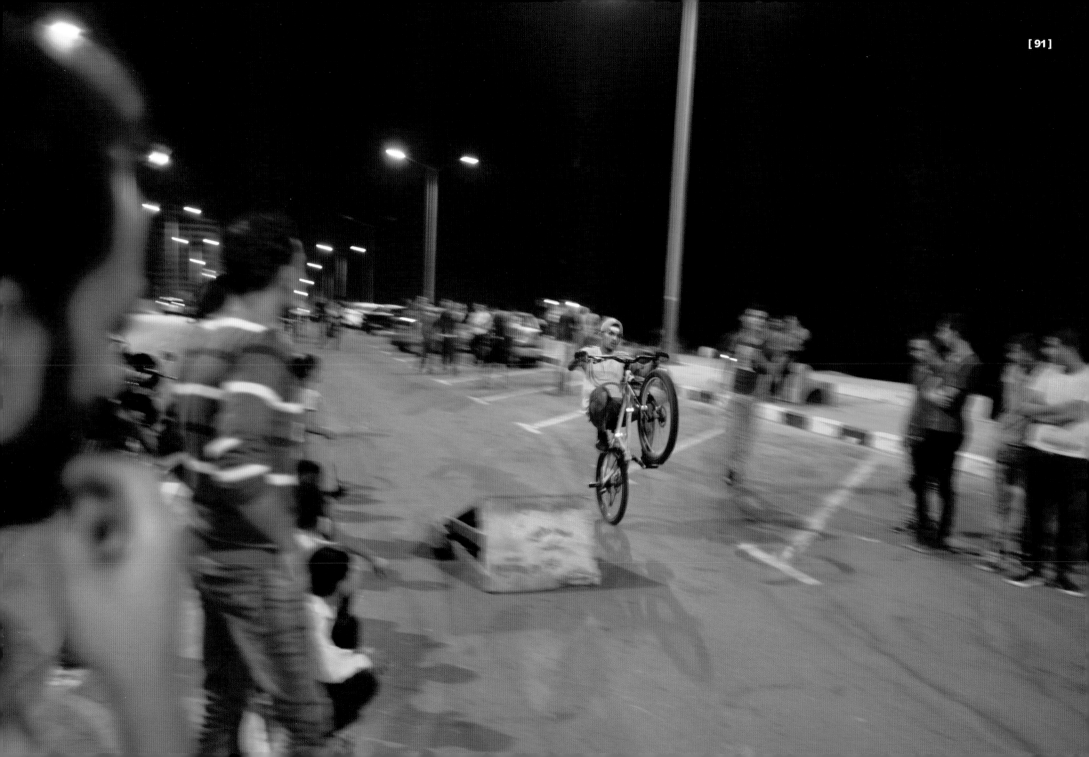

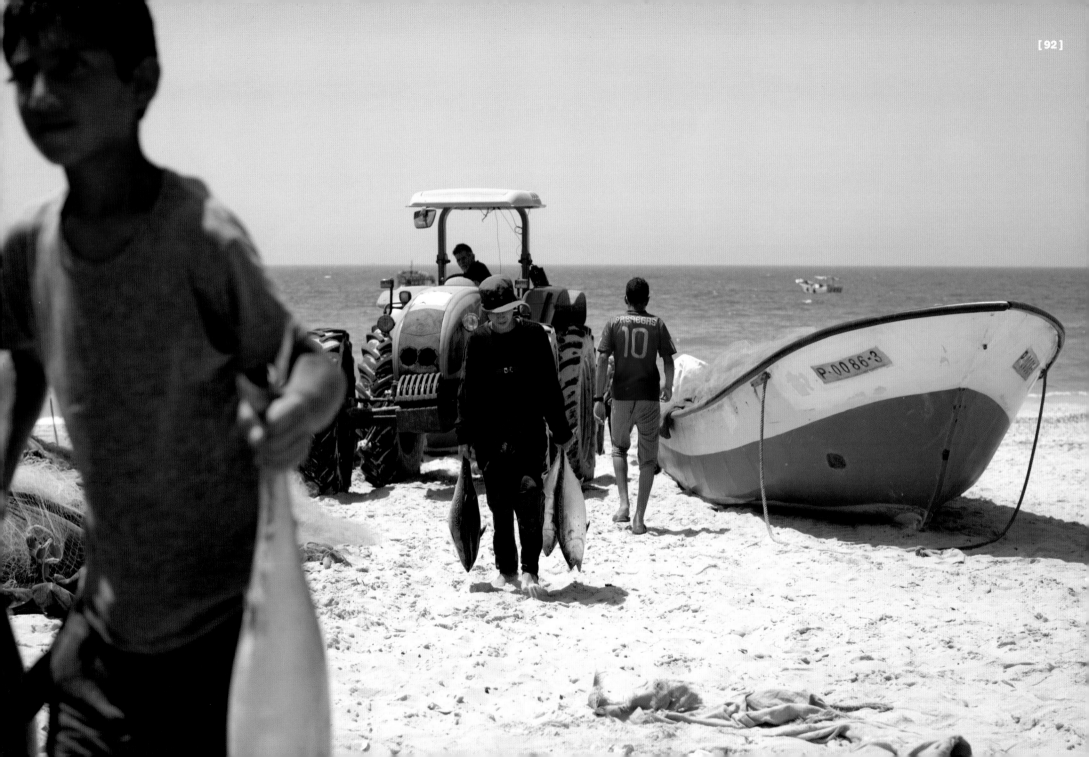

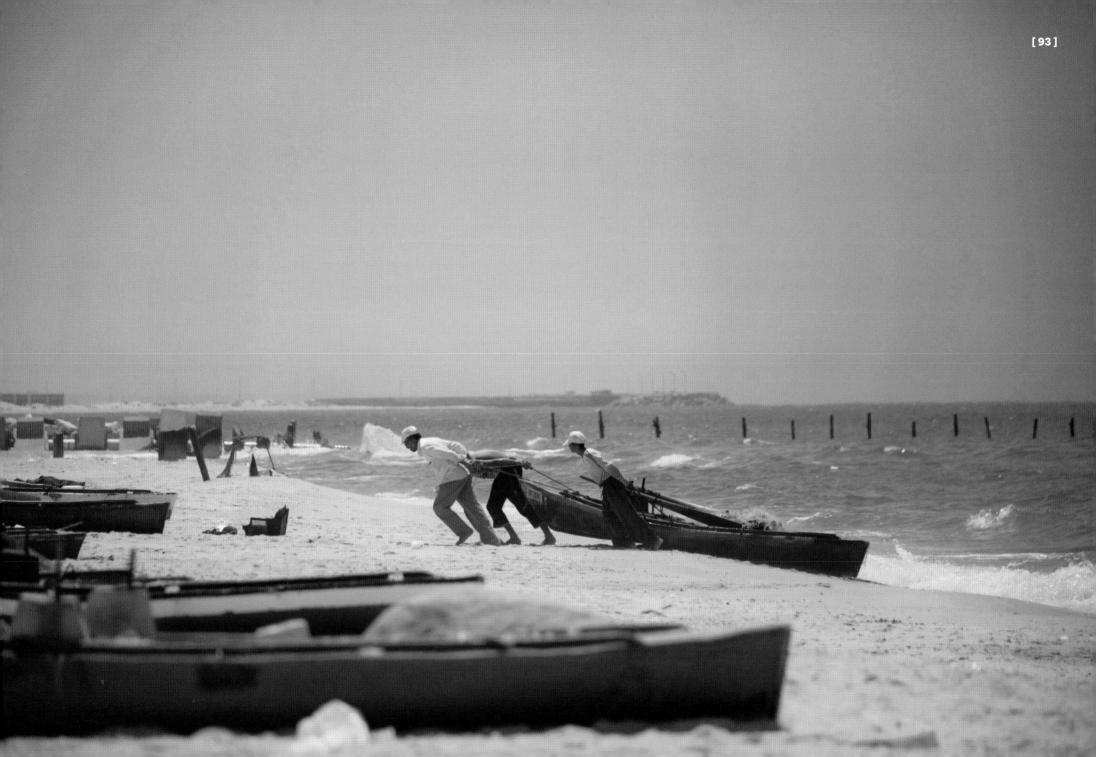

[94] **June 25, 2016, 3:04 p.m.** Children fly a homemade kite in front of their homes in the coastal area of the Deir al-Balah refugee camp.

Following pages:

[95] **June 26, 2016, 9:50 p.m.** The electricity crisis leaves Gaza residents in the dark during a power outage. Those who can afford to do so use car batteries to power small lights or to charge their phones.

[96] **June 26, 2016, 9:54 p.m.** A blackout covers Gaza after the city's only power plant runs out of fuel. Frequent blackouts are a symptom of Gaza's ongoing electricity crisis.

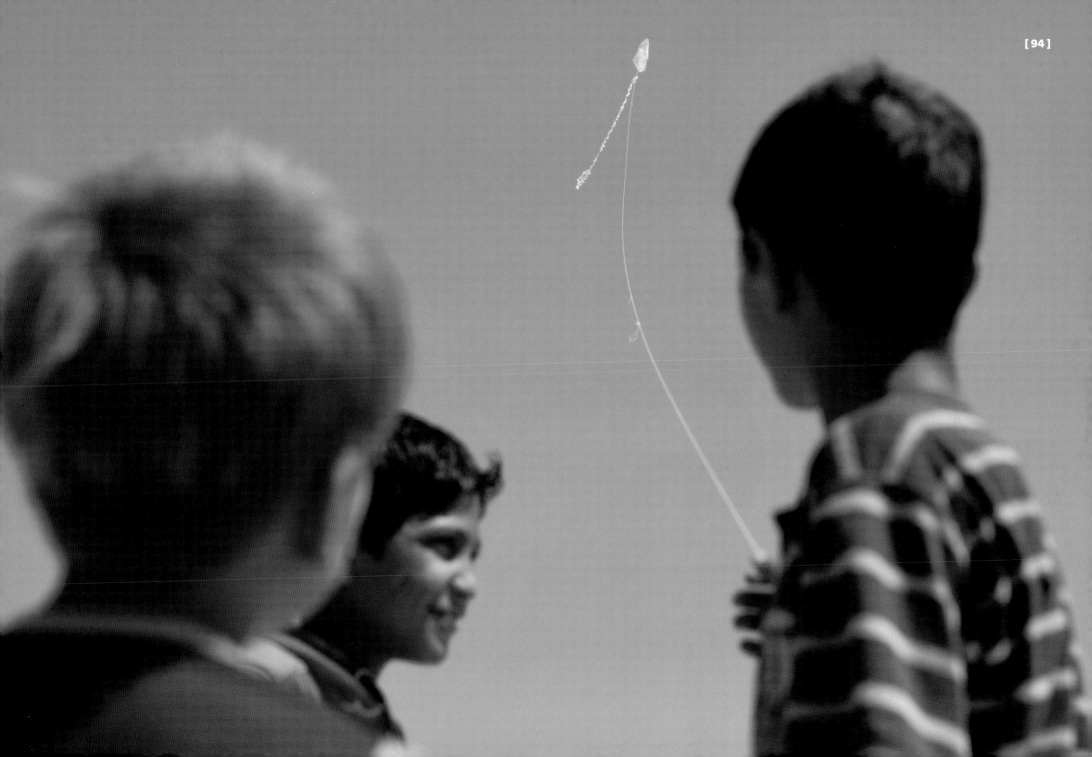

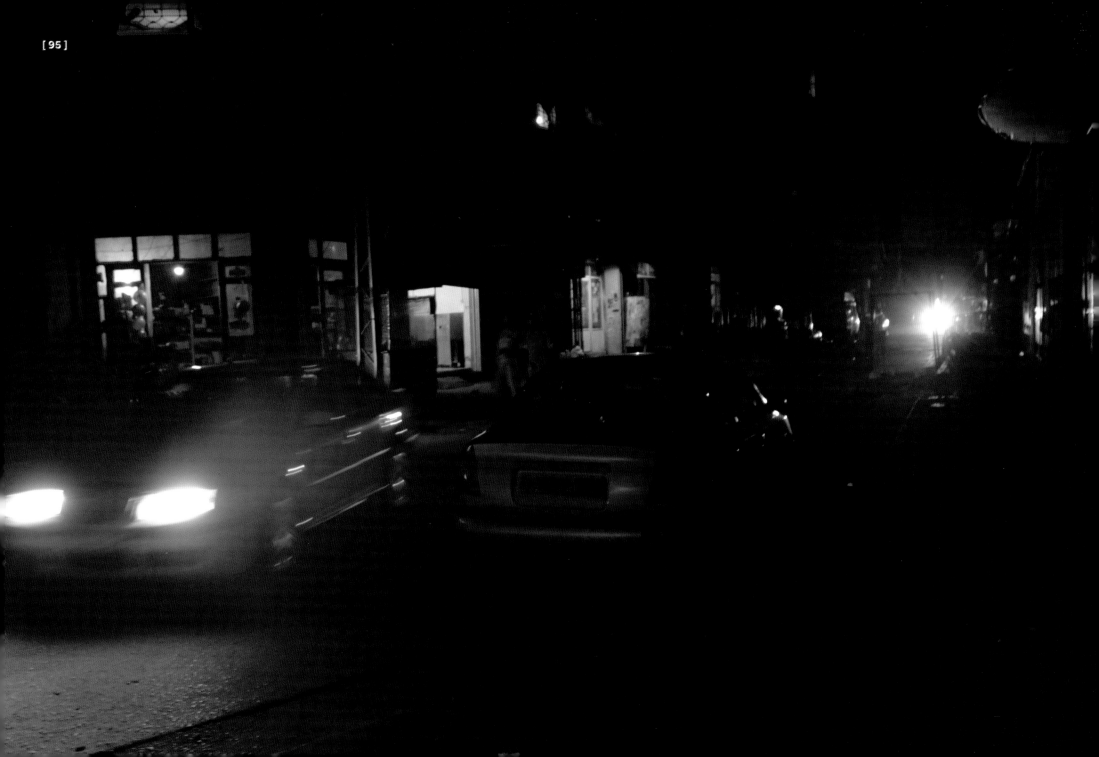

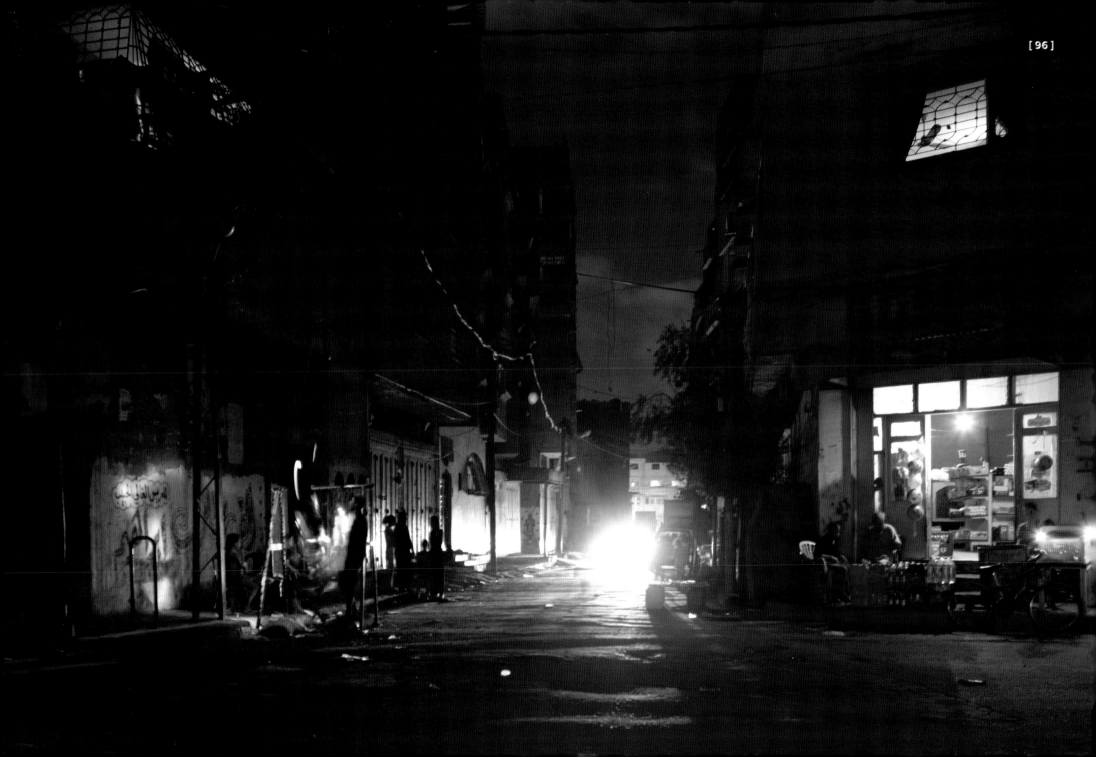

[97] **June 27, 2016, 4:12 p.m.** A Palestinian shepherd tends to his sheep near the buffer zone in the northern Gaza Strip. This area is a unilaterally enforced military no-go zone that extends 300 meters into Gaza, along its entire border with Israel. The UN estimates that the buffer zone eats into about 30 percent of Gaza's arable land. This shepherd has had many near-death encounters with the remote-control machine guns mounted on some of the Israeli watchtowers. The machine guns will shoot at anything that moves within a certain range.

Following pages:

[98] **June 27, 2016, 4:16 p.m.** Goats wander around looking for pasture. Behind them, an Israeli spy blimp performs routine surveillance of Israel's border with the Gaza Strip.

[99] **June 27, 2016, 4:21 p.m.** An Israeli watchtower mounted with a remote-control machine gun protects the buffer zone on Israel's northern border with Gaza.

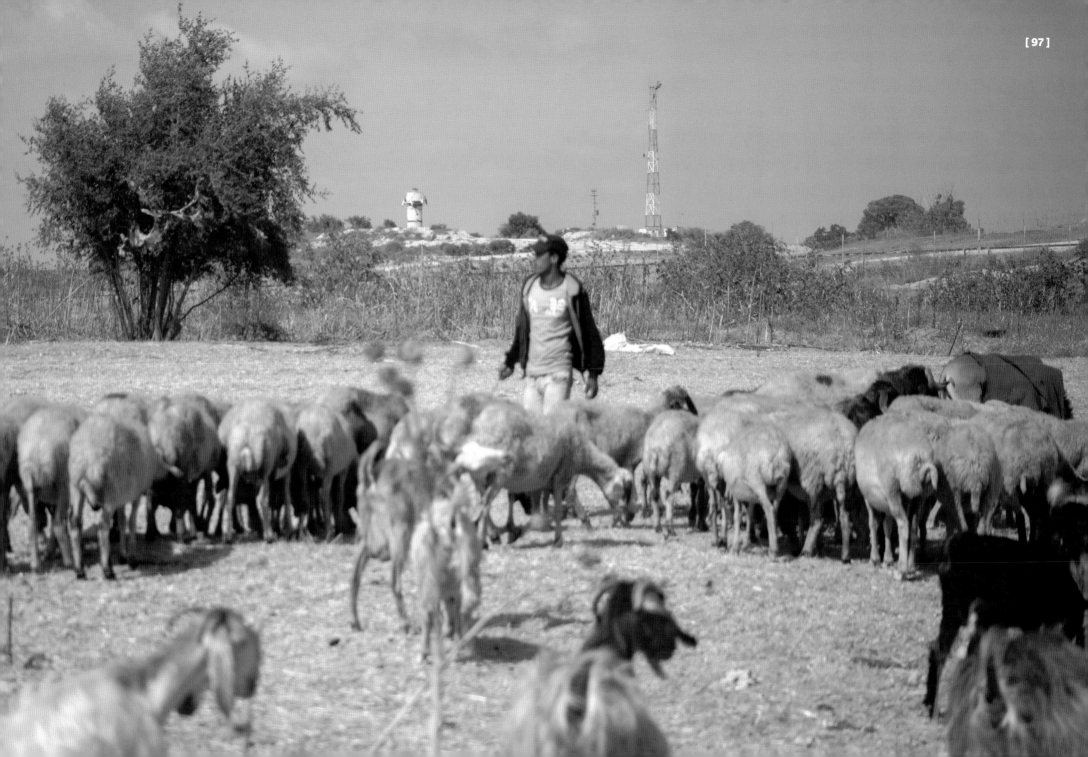

[100] **June 27, 2016, 4:24 p.m.** The enclosed walkway running along the bottom of this photo is the Erez Crossing corridor. It extends from the Israeli border wall on the right, through the buffer zone, and into the northern Gaza Strip. Palestinians frequently protest the Israeli siege in this area. Most Gazans don't qualify for exit permits through this crossing. Usually, the only people deemed eligible are international aid workers, patients who require treatment outside Gaza, and subjects of exceptional humanitarian crises.

[101] **June 27, 2016, 4:51 p.m.** Fadi shows off tomatoes he just harvested. The farm is next to the heavily militarized buffer zone on Gaza's northern border with Israel.

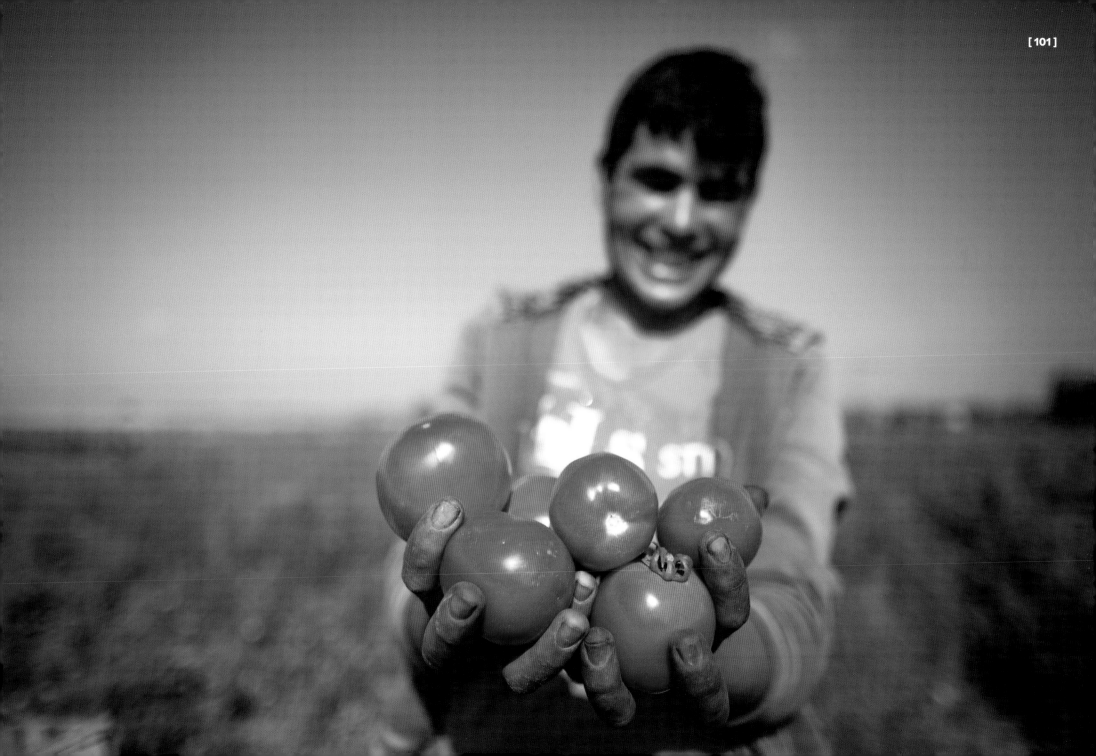

[102] **June 27, 2016, 4:55 p.m.** A Palestinian farmer checks his eggplant crop next to the Israeli buffer zone in the northern Gaza Strip.

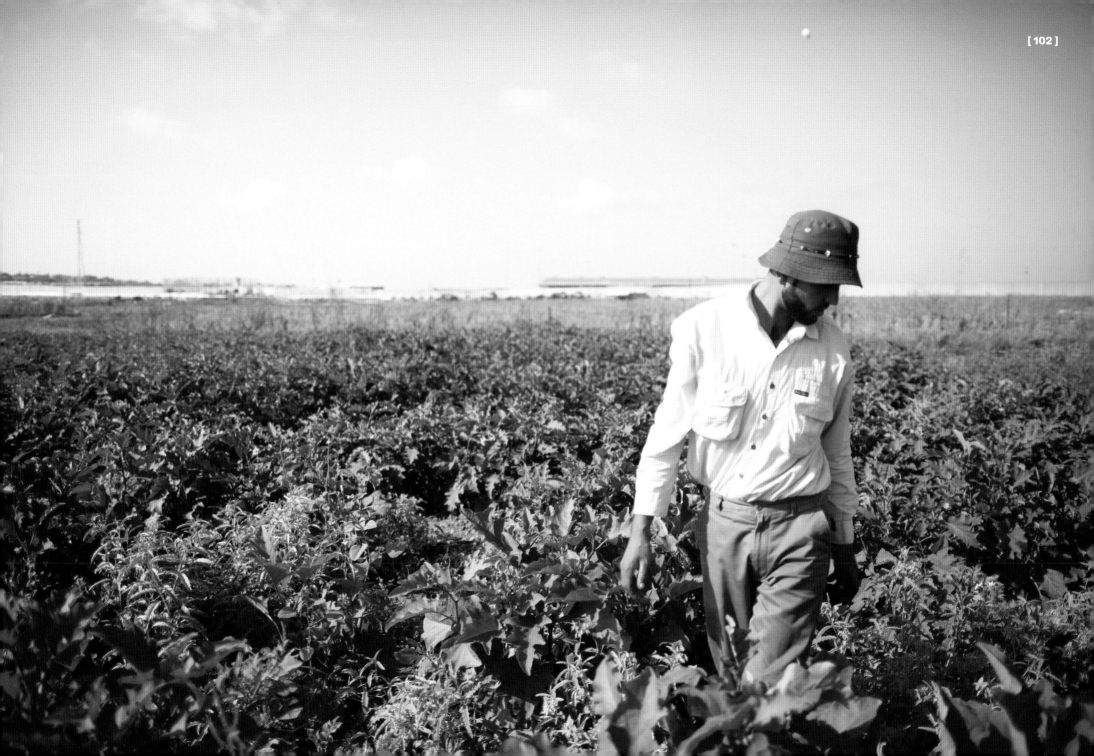

Acknowledgments

First and foremost, I would like to thank the most loving and courageous people in my life: My younger brother, Asad, and my sisters, Sarah and Leen. My mother, Sadeya al-Hourrani, who managed to raise me and my four siblings in Gaza, away from her family and despite all the hardships we faced. My older brother, Hamza, and my wife, Lara Aburamadan, who endured years of stress and difficult conversations so that we could develop our own opinions and beliefs. Thank you for your love and support, and for your unspeakable courage when I really needed it.

Getting to California would not have been possible without the generosity of the amazing people who offered us their time and trust. Those people have continued to inspire and teach us since our arrival in the US. Thank you, Dave Eggers, for coming to Gaza and for standing by and listening to us from the moment we met. Thank you, Cara Jobson, for your care in ensuring our safe arrival in the US and your invaluable legal guidance. Thank you, Christine Trost and Douglas Burnham, for being there for us from day one in California. Thank you to the beautiful couple Abhay Ghiara and Krista Gullickson for your Seven Stars' Institute Artist Residency and for your faith in us. Krista passed away recently, leaving her boundless, generous love behind for us to reflect on. Thank you, Sarah Anne Minkin and Jon Eldan, for listening and opening your hearts to us. Thank you, Atheer Ismail, for being an amazing person from whom I've learned so much. Thank you, Andrew Karney, for your enthusiasm and care. Thank you, Elissar Khalek, for being with us through this process. Thank you to Eric Cromie and Rachel Villa for your fantastic attention to detail and support of this project. Thank you to the amazing editor Claire Boyle for your tireless help navigating this book, word to word, with me. Thank you to designer Sunra Thompson, who really made this book shine. Thank you, Amanda Uhle, for your kindness and care.

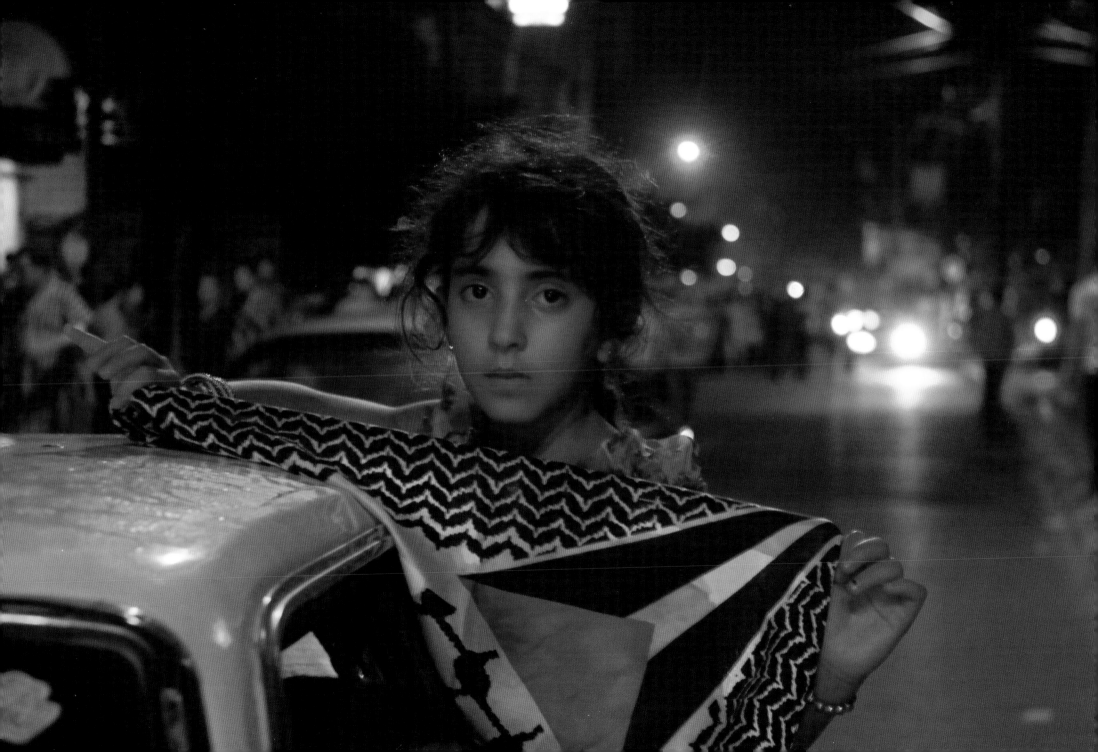

the 1948 Arab-Israeli War: A conflict between newly formed Israel and neighboring Arab nations that has shaped Israeli-Palestinian relations. Tensions were high between Jewish and Arabic residents of the British mandate in Palestine (1923–1948) leading up to the 1947 United Nations announcement of the partition of the region into a Jewish nation (Israel) and a state for the region's non-Jewish Arab population (Palestine). The Arab League, an organization of neighboring Arab countries, opposed the partition plan and declared war on Israel in May 1948, immediately after Israel's official declaration of statehood. The war between the Arab states and Israel lasted until armistice agreements were reached in the spring of 1949. During the war, more than 750,000 Palestinians were displaced from their homes, and Israel annexed 60 percent of the land that had been demarcated as Palestinian territory under the 1947 UN partition plan. Palestinians refer to the war and its aftermath as the Nakba, or "catastrophe," and much of Palestinian politics today is driven by the claimed right of families to return to lands they were expelled from in 1948.

buffer zone: A 300-meter military no-go area demarcated by a barbed wire fence and a metal "smart fence" that together form Israel's border with Gaza. Israel uses machine gun fire to make sure no one enters the buffer zone without authorization. The zone extends into the sea, limiting the area Palestinian fishermen and other individuals can travel through.

crossings: The gateways into Israel from parts of Palestine, and between Palestine and neighboring countries such as Egypt and Jordan. There are currently five crossings by land into the Gaza Strip: the Erez Crossing, the Karni Crossing, the Rafah Crossing, the Kerem Shalom Crossing, and the Sufa Crossing. Most have been closed or their use significantly restricted since the Israeli military blockade was imposed in 2007. There are seventy-three barrier-gate crossings from the West Bank into Israel, and Palestinians with permits have access to thirty-eight of them.

Eid al-Adha: Also called Eid Qurban and Festival of the Sacrifice; an Islamic holiday honoring Abraham's willingness to sacrifice his son at God's command. Families with the means to do so are expected to sacrifice a livestock animal and divide its meat in three equal parts: a share each for the home, the needy, and friends and neighbors. Eid al-Adha begins on the tenth day of Dhu al-Hjjah, the last month of the Islamic calendar, and continues for an additional three days. The first day is marked by the performance of communal prayer at dawn.

Erez Crossing: One of five border crossings into the Gaza Strip, located on Gaza's northern border with Israel. Besides being a cargo crossing, it is the only pedestrian land crossing between Gaza, the West Bank, and Israel. Palestinians are able to use it only in exceptional cases of humanitarian crisis, and they need a permit to do so. Exit permits were eliminated during the Second Intifada, in 2000, resulting in a sharp decrease in Palestinians leaving Gaza. Twenty-two thousand Palestinians left Gaza via the Erez Crossing in December of 2019, compared with roughly 500,000 each month in 2000.

F-16 Israeli warplane: A fighter aircraft originally developed for the United States Air Force and exported to other nations' militaries and known for its maneuverability and combat range. The Israeli Air Force owns 362 F-16s. Of sixty-seven deaths attributed to the F-16s worldwide, forty-seven have been attributed to the Israeli Air Force.

Fatah: A left-leaning political party that makes up the majority of the PLO coalition. Fatah was founded in 1959 largely by Palestinian refugees who had been displaced by the 1948 Arab-Israeli War. After its founding, Fatah had several militant wings and conducted a number of military actions against Israel, and Israel targeted military and nonmilitary factions of Fatah.

Gaza blockade: An Israeli military blockade restricting the movement of people and goods coming into and out of the Gaza Strip by air, land, and sea. It was first imposed in 2007, the year the political party Hamas seized full control of the Gaza Strip. Israel (as well as the United States, the European Union, Jordan, Egypt, and other nations) considers Hamas a terrorist organization.

Gaza electricity crisis: An ongoing power crisis in Gaza. Because of Israel's blockade of the Gaza Strip, Palestinians smuggled in fuel from Egypt via underground tunnels until 2013, when Egypt closed and/or destroyed the tunnels on its border with Gaza. Following this cutoff, Gaza's only power plant purchased its fuel from Israel at a high cost. Israel destroyed the plant's transformers in a 2006 air strike, then restricted the import of the materials necessary to repair it, leaving the plant operating at a lower capacity. Hamas depended on

the Palestinian Authority (PA) to pay Israel's import duties on this fuel, but tensions mounted when the PA refused to pay the duties, despite collecting taxes, and even though Hamas allocated significantly more funds to military operations than to energy efforts. As a result, in April 2017, the Gazan power plant ran out of fuel. In June of that year, Egypt and Hamas agreed that Egypt would supply Gaza with 500 tons of diesel fuel daily, which provides power for only a few hours each day. Rolling blackouts regularly affect Gaza's nearly 2 million citizens.

Gaza's tunnels: Approximately 1,200 tunnels dug beneath Gaza's border with Egypt. The tunnels were built to bypass the Rafah border crossing and were used to smuggle a variety of consumer goods, money, fuel, and medicine, as well as Palestinian citizens. The first tunnel was discovered by Israel in 1983, just after the Gaza-Egypt border had been redrawn through Rafah as part of the Israel-Egypt Peace Treaty. Egypt destroyed most of the tunnels between 2013 and 2014 by flooding them, sometimes with sewage water and poisonous gases.

Hamas: A Palestinian Sunni Islamist fundamentalist militant organization founded in 1987 as an offshoot of Egypt's Muslim Brotherhood. Hamas has since become a Sunni Islamist political party, and its stated aims are to liberate Palestine from Israel and establish an Islamic state in the region that now encompasses Israel and the occupied territories. Hamas gained greater influence in the early 2000s, surging to power alongside popular dissatisfaction with the Palestinian Authority, which many Palestinians viewed as corrupt and too willing to cede to Israel in peace negotiations. After winning parliamentary elections in the Gaza Strip in 2006, Hamas solidified its power in a series of violent skirmishes with the opposition party Fatah. By 2007, Hamas had effectively taken control of Gaza, ousting the Palestinian Authority from power there. Because Israel views Hamas as a terrorist organization, it imposed a crippling economic blockade on the Gaza Strip following Hamas's takeover. In the spring of 2014, Hamas and Fatah announced a political reconciliation, though to date Hamas remains the sole political power in Gaza.

the Ibrahimi mosque massacre: A shooting massacre carried out by Baruch Goldstein, an American Israeli member of the far-right Israeli Kach movement, that took place on February 25, 1994. Goldstein opened fire on Palestinian Muslims praying at the Ibrahimi mosque in Hebron, in the West Bank, killing twenty-nine and wounding 125. Goldstein was disarmed and killed on the spot by survivors, but as news of the massacre spread, additional confrontations broke out, resulting in the deaths of twenty more Palestinians.

Israel: A state founded in 1948 as a national home for the Jewish people. Today Israel has a population of over 8 million. About 75 percent of the population is Jewish and roughly 20 percent is Arab. Its capital is Jerusalem. Hebrew and Arabic were both official languages until 2018, when Arabic was downgraded to a language with "special status in the state."

Israel Defense Forces (IDF): An army formed from the paramilitary group the Haganah with the establishment of the state of Israel in 1948. Today, there are more than 170,000 active personnel and 445,000 reserves in the IDF. Military service starting at age eighteen is compulsory for most Israeli citizens. In practice, only about half of all eighteen-year-old Israelis end up enlisting in active duty. Israel's Arab population, which makes up about 20 percent of the total population, is exempt, but Arabs may serve if they wish. A number of other exemptions exist, though they change from year to year. They include physical or mental disability, engagement in religious studies, demonstrated moral objections such as a commitment to pacifism, and enrollment in alternative national civil service programs.

Israel-Gaza barrier: A wall between Israel and the Gaza Strip constructed in 1994 following the Oslo Accords. Much of it was destroyed during the Second Intifada, but it has since been rebuilt. An additional wall between Gaza and Egypt was built in 2005. The barrier has only five crossing points.

Israeli watchtowers: Towers built for observing and controlling the movements of Palestinians in the West Bank and Gaza. Israeli military personnel stand guard on some of the towers along the country's border and employ firearms; others are mounted with remote-control machine guns.

Izz ad-Din al-Qassam Brigades: The military wing of Hamas. It was created in 1991 with the intention of preventing negotiations for the Oslo Accords. It is considered a terrorist organization by the United States, the

European Union, the United Kingdom, Australia, and New Zealand, and has been criticized by the United Nations for war crimes that are at odds with the Geneva Conventions standards of war.

Kerem Shalom Crossing and Sufa Crossing: Smaller cargo crossings in southern Gaza, near the city of Rafah, which are used mostly for the import of humanitarian aid into Gaza.

Karni Crossing: A cargo crossing just southeast of Gaza City that has been completely sealed since the start of the military blockade.

Operation Cast Lead: A three-week invasion of the Gaza Strip by the Israel Defense Forces between December of 2008 and January of 2009. The stated reason for the invasion was to stop rocket attacks from Gaza and to prevent weapons smuggling into Gaza. Israeli jets bombed numerous military and administrative facilities in Gaza, including those in densely populated areas of Gaza City and Rafah. More than 1,400 Palestinians were killed in the invasion.

Oslo Accords: A series of negotiated agreements between the leadership of Israel and the PLO starting in 1993, during the height of the First Intifada. The goal of the accords was to institute a peace plan and create an interim Palestinian government in anticipation of eventual Palestinian statehood. The Oslo Accords led to the creation of the Palestinian National Authority (subsequently called the Palestinian Authority), a temporary governing body formed from the administration of the PLO.

Palestine: The name Palestine is derived from a term used in ancient Egypt for the region bordering the Egyptian Empire along the eastern coast of the Mediterranean Sea. Today, Palestine may refer to the entire region made up of Israel, the occupied territories, and territory under control of the Palestinian people, or to the areas of the West Bank and the Gaza Strip, defined as Palestine under the 1949 armistice agreements. It can also refer to the limited areas administered entirely by the Palestinian people, which make up all of the Gaza Strip and approximately 18 percent of the West Bank. The Palestinian population living in Palestine and abroad is hard to determine but numbered around 13 million in 2020. Though the Palestinian Authority claims Jerusalem as its capital, its de facto administrative capital is Ramallah.

Palestinian Authority (PA): A governing body for the Palestinian territories that was established as part of the Oslo Accords in 1993. The Palestinian Authority (formerly known as the Palestinian National Authority) was formed out of the administration of the Palestine Liberation Organization and was dominated in its early years by the political party Fatah. Initially, the PA was meant to be an interim governing body while Israel and Palestine worked toward a final peace agreement between 1994 and 1999. However, an agreement was never reached, and the PA has remained the internationally recognized governing body of the Palestinian people. In 2006, after popular elections in Gaza brought the political party Hamas to power, Hamas militias clashed with Fatah and representatives of the PA, ultimately driving the PA from power in the Gaza Strip. Though a reconciliation between Hamas and the PA was announced in the spring of 2014, the PA's authority continues to extend only to those parts of the West Bank not administered by Israel.

Palestine Liberation Front (PLF): A Marxist Arab nationalist movement started in 1961 and based in Ramallah. The PLF was a precursor of the Popular Front for the Liberation of Palestine.

Palestine Liberation Organization (PLO): A coalition of political organizations formed in 1964 during a meeting of the Arab League, with the aim of creating an independent Palestinian state. The PLO was composed of numerous political and military factions, including Fatah and the Popular Front for the Liberation of Palestine. Yasser Arafat led the PLO from 1969 until his death, in 2004. The coalition was considered a terrorist organization by Israel until 1991. After the negotiations known as the Oslo Accords began, in 1993, the PLO became the official representative and diplomatic body of the Palestinian people. In 1994, the Palestinian Authority was formed out of the organizational structure of the PLO and served as the interim government of Palestine for the duration of peace negotiations with Israel.

Permit system: A complex system of identification-card requirements within Israel and Palestine that governs where individuals can live, work, and travel. Residents of the West Bank must have permits to travel on most roads and to enter or work in Jerusalem and Israel. Palestinians in East Jerusalem must have IDs to prove their resident status. The permit system restricts most Palestinians

from using numerous roads, border crossings, and checkpoints in the West Bank that are limited to Israeli settlers or the Israeli military. Israeli citizens must obtain special permits to enter a portion of the West Bank under control of the Palestinian Authority and are not permitted to enter the Gaza Strip. Gazan citizens are not permitted to enter Israel, except with certain permits obtained for medical or humanitarian reasons.

Rafah Crossing: One of five border crossings into Gaza, and the sole crossing on the Egyptian border. It is only for pedestrian movement. It was closed by Egypt following Hamas's expulsion of Fatah, in 2007, and it has been opened and closed numerous times since, due to political tensions between Egypt, Israel, and Hamas. Since 2016, the Rafah Crossing has been open for 560 days and closed for 961 days, and has allowed almost 195,000 Palestinians to exit Gaza.

Ramadan: The ninth month of the Islamic calendar, observed by Muslims to commemorate Muhammad's first revelation. For the entire month, all Muslims are obligated to fast from sunup to sundown and to devote themselves to prayer and charitable deeds.

refugee camps: There are fifty-eight active Palestinian refugee camps throughout the West Bank, the Gaza Strip, and neighboring Arab states.

right of return: A principle of international law that grants peoples displaced from their homes by war or other humanitarian crises the right to return home if they so desire. The right of return has been a point of contention between Israelis and Palestinians since the 1948 Arab-Israeli War, which displaced more than 750,000 Palestinians, and the 1967 Six-Day War, which displaced hundreds of thousands more (some of whom had also been displaced during the 1948 war). In 1948, the United Nations passed General Assembly Resolution 194, which reads, in part: "[The General Assembly] resolves that the refugees wishing to return to their homes and live at peace with their neighbors should be permitted to do so at the earliest practicable date, and that compensation should be paid for the property of those choosing not to return and for loss of or damage to property which, under principles of international law or in equity, should be made good by the Governments or authorities responsible." Subsequent UN statements further supported a Palestinian right of return to lands annexed by Israel in 1948. However, Israel

disputes this right, and most major peace initiatives since the Oslo Accords have not seriously addressed right-of-return claims.

Sinai Peninsula: A 23,000-square-mile peninsula that separates Egypt from Israel and the Gaza Strip. The Sinai Peninsula was occupied by Israel as a buffer zone with Egypt following the Six-Day War, in 1967, and was returned to Egypt in 1979. The Sinai was a major route for goods smuggled into Gaza during the blockade imposed by Israel starting in 2007, though this route was largely shut down by the Egyptian military in 2013.

United Nations Relief and Works Agency for Palestine Refugees in the Near East (UNRWA): An organization established in 1949 by a UN charter to provide material aid to Palestinians after the Arab-Israeli conflict, and especially to the 750,000 individuals that the UN identified as having been displaced from their homes by the conflict. UNRWA began providing housing and infrastructure as well as services such as health care and education in designated refugee camps throughout the Gaza Strip, the West Bank, and neighboring Arab states. This aid is still provided to descendants of those original refugees, as well as to refugees from the 1967 Six-Day War. Today, UNRWA

operates fifty-eight camps with over 1.5 million residents and provides services to millions of designated refugees living outside the camps. In the Gaza Strip, 1.4 million Palestinians are designated refugees (74 percent of the total population). In the West Bank, 774,000 residents are designated refugees (24 percent of the total population). Over 2 million designated Palestinian refugees live in Jordan, 550,000 designated Palestinian refugees live in Syria, and 475,000 designated Palestinian refugees live in Lebanon.

West Bank: The territory west of the Jordan River that has been occupied by Israel since the Six-Day War in 1967. The prospective peace plan known as "the two-state solution" would make much of the West Bank part of an independent state along with the Gaza Strip and East Jerusalem. The population of the West Bank is approximately 3,280,000 (including East Jerusalem), with around 2,345,000 Palestinian Arabs, 389,000 Israeli settlers, an additional 375,000 Israelis in East Jerusalem, and a few thousand members of other ethnic groups.

This glossary originally appeared in Palestine Speaks: Narratives of Life Under Occupation *(Voice of Witness, 2014). It has been adapted and reprinted with permission.*

Jehad al-Saftawi is a documentary journalist, photographer, and videographer dedicated to social justice and human rights storytelling. His work has been featured in *Reuters*, *AJ+*, *BuzzFeed*, *Mic*, *Al Jazeera*, the *Huffington Post*, and elsewhere. He arrived in the US from Gaza in 2016 and is currently seeking asylum. He is internationally recognized for setting up one of the few live streams documenting the 2014 Israeli offensive on Gaza.